For
Allen Staley who taught me about British art
and
Susan Fisher Sterling for her mentoring and friendship

Jordana Pomeroy

Intrepid Women

Victorian Artists Travel

Edited by Jordana Pomeroy

ASHGATE

Published by
Ashgate Publishing Limited
Gower House
Croft Road
Aldershot
Hants GU11 3HR
England

Ashgate Publishing Company
Suite 420
101 Cherry Street
Burlington
Vermont, 05401–4405
USA

Ashgate website: http://www.ashgate.com

British Library Cataloguing in Publication Data
Intrepid Women: Victorian Artists Travel.
 1. Art, Victorian – Great Britain. 2. Art, British – 19th century. 3. Women artists –
 Great Britain – Travel. 4. Travel in Art. 5. Great Britain – Colonies – In art.
 I. Pomeroy, Jordana, 1962– .
 704'.042'0941'09034

US Library of Congress Cataloging in Publication Data
Intrepid Women: Victorian Artists Travel / edited by Jordana Pomeroy.
 p. cm.
 Includes bibliographical references and index.
 1. Art, Victorian – Great Britain. 2. Art, British – 19th century. 3. Women artists –
 Great Britain – Travel. 4. Travel in art. 5. Great Britain – Colonies – In art.
 I. Pomeroy, Jordana, 1962– .
 N676.5.V52I57 2005
 704'.042'094209034—dc22 2005002551

ISBN 0 7546 5072 3

This book is printed on acid-free paper.

Typeset by IML Typographers, Birkenhead, Merseyside.
Printed and bound in Great Britain by MPG Books Ltd, Bodmin, Cornwall

Contents

List of figures

List of contributors

SUSAN P. CASTERAS is Professor of Art History at the University of Washington, Seattle.

MARIA H. FRAWLEY is Associate Professor of English at George Washington University, Washington, D.C.

BARBARA T. GATES is Alumni Distinguished Professor of English and Women's Studies at the University of Delaware, Newark.

CAROLINE JORDAN is an Australian Research Council Postdoctoral Fellow at the Australian Centre, the University of Melbourne, Australia.

DIANNE SACHKO MACLEOD is Professor of Art History at the University of California, Davis.

JORDANA POMEROY is Curator of Painting and Sculpture before 1900 at the National Museum of Women in the Arts, Washington, D.C.

ROMITA RAY is Curator of Prints and Drawings at the Georgia Museum of Art, the University of Georgia, Athens.

JEFF ROSEN is Associate Dean of Humanities, Arts and Sciences, and the Summer Session, at the University of Chicago's Graham School of General Studies.

ANN B. SHTEIR is Professor of Women's Studies and Humanities at York University, Toronto, Canada.

Preface

Intrepid Women: Victorian Artists Travel has its origins in an exhibition idea for the National Museum of Women in the Arts in Washington, D.C. Rarely exhibited works of art held in repositories in the United States, Canada, Ireland, the United Kingdom, Australia, and India convey the experiences of nineteenth-century women travelers. Many of these works are as brightly painted and pristine as the day they were created, having been relegated to museum storerooms, libraries, and attics. These oils, watercolors, and drawings portray in vivid color the lives of Victorian women who lived abroad. In this volume of essays, it becomes evident that the conceit of home and hearth is, in fact, England itself, to which nearly all our traveling artists returned. For those who became permanent members of the colonies, England was transported to the far reaches of the Empire and, through their works of art, the Empire was made that much more understandable, knowable, and controllable by those at home.

The work under discussion in this volume is uneven in quality, revealing the artists' varying degrees of talent, length of formal training, and intentions for their works of art. Some of the artists exhibited at the Royal Academy, while others made drawings and sketches to please themselves and to narrate to others their experiences abroad. The authors who have contributed to this volume rarely distinguish between professional and amateur work per se, for it is not the motivating force for studying such a large body of art. These visual legacies function as travel diaries that amplify on a day-to-day basis the building of the British Empire. For even greater effect, some travelers combined their art with journal entries, such as Lady Charlotte Elizabeth Canning, who wrote on January 12, 1859:

Made my last sketches of the gardens of the Khomooagh and the entrance to there. Just outside them is a sort of market or Serai within gates and a magnificent tamarind tree which is divided into 6 or 7 stems ... Numbers of people with gay coloured clothes and

caps to sell and a bazaar of all kinds of things. Beyond is the gate with towers at the sides and a very high arched keep & the arched gateway below. It would make a fine picture.[1]

Canning meticulously kept a multivolume journal and produced copious watercolors that are rarely seen outside of Harewood House, where they are kept.

While Empire building continued apace, those who lived abroad encountered clashing cultural values, mores, and expectations. Women—even those from the upper class such as Canning—formed brigades of these foot soldiers, living lives that brought them into close contact with locals and immersed them in the surrounding landscape. If they were taught to paint chipmunks in the backyard, they used these talents to portray lion hunts in India. While a female version of the swashbuckling hero Lawrence of Arabia has yet to emerge, it is unlikely that a woman of that time would have had the opportunity or motivation to promote her ambitions. The accomplishments of women living in the outposts of the Empire may not have been on the policy-making level of statecraft, but keen observation and recording of their surroundings—from exotic plants and animals to the customs of native tribes—contributed to the phenomenon we now call globalization.

This study has been a collaborative project that has benefited from incisive interdisciplinary scholarship. I am indebted to the National Endowment for the Humanities and the Paul Mellon Centre for Studies in British Art for grants, without which this book could not have been completed.

The National Museum of Women in the Arts, where I am the curator of painting and sculpture before 1900, provided a tremendously supportive environment for me as this endeavor shifted from being an exhibition to a book. I should particularly like to thank the director, Judy L. Larson, for encouraging me to complete this volume.

I wish to express my gratitude to an outstanding editor, Laureen Schipsi, who read my manuscript with critical acumen and offered me and the other contributors guidance when needed. I would also like to recognize Erika Gaffney, who oversaw the manuscript through the process of publication.

The germ for the exhibition concept sprang from a conversation with Lisa Lodeski, whose own Master's thesis at the University of San Francisco addressed Orientalism in Victorian art. I cannot adequately thank her for her dedication and unflagging support of this project as well as for her exuberant laughter.

I could not have anticipated the enthusiasm expressed by the scholars I approached to contribute to this study. I should like to thank them and, on their behalf, the innumerable libraries and archives we consulted during our research. I am pleased to single out Jim Burant, an archivist at the National Archives of Canada, who shared with me his work on Mary Millicent Chaplin

as well as other British women artists who traveled in Canada. Lastly, I wish to thank my parents, who cultivated in me an interest in living in cultures besides my own, and my husband and children, who share with me a love for travel.

Note

1. 12 January 1859, Papers and Journals of Lady Canning, Leeds District Archives.

Introduction: Women's artistic passages

Dianne Sachko Macleod

Throughout the Victorian period, an ever-increasing number of British women left home equipped with brushes, pencils, easels, and reams of watercolor paper and yielded to the experiences of the world that overflowed onto their picture planes. The fragility of the works on paper they produced, many of which remain in Britain's former colonies, partially explains why they are so little known today. Thus the illustrations in this volume provide an unparalleled visual record of the Victorian woman traveler's grasp of life in foreign and domestic climes that encompassed everything from daily events to ethnography, geography, and the natural sciences. The artistic voyager has not yet benefited from the recent proliferation of publications about Victorian women's travel writing.[1] This book rectifies that gap in the literature by drawing attention to the visual and verbal legacy of these adventurers—oil paintings, watercolors, sketches, and illustrations, along with letters, diaries, memoirs, and scientific studies. Taken in tandem, they present an intriguing insight into the prototype for today's self-assured female global trekkers who, according to a recent study, continue to write more travel diaries and paint more watercolors than men.[2]

Even though the practice of tourism was imported from Britain into Europe and North America, the pioneering British woman traveler has been overshadowed by the "three hundred years of foreplay" conducted by masculine teams of explorers, soldiers, missionaries, and anthropologists.[3] Compared to this list of male professionals, the amateur status of the itinerant female artist has too readily led her to be downgraded from thoughtful traveler to superficial tourist. Yet as Dean MacCannell persuasively argues in his influential study *The Tourist*, "all tourists desire [a] deeper involvement with society and culture to some degree; it is a basic component of their motivation to travel."[4] None of the women in the present volume were casual observers. Jordana Pomeroy, in her essay in this collection, pithily remarks

that there was no Lawrence of Arabia type in this group, but neither were there any shrinking violets. While their degree of involvement with their subjects fluctuated between familiarity and formality, each was genuinely committed to expanding her self-awareness and independence through travel. Sheltered at home, Victorian women spread their wings on their travels. The essays in this volume chart their passage from provincial Victorian "ladies" to worldly women.

A desire for professional recognition was one of the most pervasive motives for inducing women artists to leave the predictable security of their homes. Louisa Twamley Meredith enjoyed no small measure of satisfaction when she published firsthand observations of antipodean species in five illustrated books about Tasmania that corrected existing opinions of the importance of bushfires to the Aborigines, the intelligence of Marsupialia, and the confusion between Australian emus and African ostriches. As Barbara Gates notes in her essay on Meredith, this naturalist and illustrator may not have been a taxonomer like her male peers who relished naming new species, but she was a scrupulous gatherer, observer, and recorder. Meredith's achievements in this exotic locale won her a scientific status that she would have been unable to attain had she remained at home. Female botanical illustrators in Britain, on the other hand, found it difficult to be recognized as more than mere technical assistants. Ann Shteir elaborates this point in her essay on female illustrators within the British Isles. She describes the professional barriers encountered by Sarah Anne Drake whose scientific contributions have only recently come to be appreciated, despite the precise watercolors of orchids she painted in order to illustrate the largest book published in the Victorian period, John Bateman's lavish *Orchidaceae of Mexico and Guatemala* (1837–43). Although Drake traveled only as far as Kew Gardens, she succeeded in transporting her readers to a remote and exotic world. The botanical illustrator Elizabeth Twining shared this ambition, but she was also motivated by a desire to inspire working-class gardeners to expand their knowledge of natural history. A member of the family whose name became synonymous with the tea trade, Twining's artistic motivations were shaped by the upper-middle-class moral philosophy of the stewardship of wealth. In the 160 instructional plates she produced for *Illustrations of the Natural Orders of Plants* (1849–55) she invited her viewers to join her vicarious expeditions to far-flung locales to learn about nature's bounty from the rice fields of North and South Carolina to the mango groves of the East Indies. The professional standards exhibited by scientific illustrators such as Meredith and Twining, along with the skilled efforts of Marianne North, Anna Pratt, and Anna Maria Hussey, proved that women were active partners in the modernist enterprise of documenting and explicating the natural world. Pride in their work empowered them to move beyond the restrictive definition of Victorian womanhood.

Marianne North is a stellar example of the independent woman traveler. She embarked on a solo around-the-world journey in 1876, intent on illustrating botanical sites for the Royal Botanic Gardens at Kew. North produced several hundred paintings which are today rotated on display in a special gallery dedicated to her at Kew. Two essays in this volume track her accomplishments in the outer reaches of the British Empire. Jeff Rosen examines North's intriguing encounter in Ceylon with the photographer Julia Margaret Cameron in 1876, from the perspective of both women's contradictory endorsement of the civilizing colonial agenda and yearning for primitive simplicity. Romita Ray picks up North's story two years later in India where she produced an evocative sketch of the Taj Mahal that also betrays her imperialist tendency to tame the exotic. She absorbed it into the Western canon by rendering it within the aesthetic of the picturesque. Yet as Ray suggests, Marianne North may have feminized her image of the Taj Mahal to distinguish her travels from the typically masculine practice of "roaming the landscape of India." Nonetheless, she was unwilling to desist: after returning to England from her world journey, North soon set off again for Australia, New Zealand, South Africa, and the Seychelles.

A measure of freedom was somewhat easier to achieve by women who traveled abroad where more relaxed social conventions allowed them greater leeway in charting their own identities. Susan Casteras, in her essay on the effects of travel on Victorian women artists, contends that it sparked a redefinition of femininity as "active, strong, working, and self-determined." She points to the satirical drawings of the irreverent Claxton sisters who humorously targeted the social customs of both the Northern and Southern hemispheres on their travels to Australia, India, Egypt, and the Holy Land with their artist father. Both turned the prevailing notion of feminine subjectivity upside down by featuring headstrong, independent women. Equally as audacious, Frances Anne Hopkins defied the social caste system by representing herself in the intimacy of a canoe with métis Indians in the Canadian wilds. Her stunning depiction of herself as the focus of her painting, *Canoe Manned by Voyageurs Passing a Waterfall* (Fig. 3.2), presents a revealing glimpse of a woman artist's moment of liberated self-discovery.[5] By putting distance between themselves and the mother country's stultifying definition of Victorian womanhood, these voyagers succeeded in expanding the frontiers of their identities.

Identity formation, however, is a fragmentary and contradictory process that is contingent on early childhood experiences, education, and ever-evolving personal interactions. While Victorian women travelers may have traipsed over the artificial barriers that defined gender, they nevertheless carried a good deal of cultural baggage with them. One of the more unfortunate items among their personal effects was the imperialist gaze.

While artists like Hopkins and the Claxtons made a concerted effort to avoid viewing the colonies from the perspective of the colonizer, others found it more difficult to discard the burden of their upbringing. Charlotte Inglefield, as Pomeroy notes, freely stereotyped the people she sketched during her stay in the Levant as the "Jewish girl" or the "Moorish woman" in a manner that expressed British superiority over members of foreign ethnic groups. Similarly, according to Rosen, Julia Margaret Cameron's staged photographs of "madonnas of the tropics" asserted her scopic superiority over her subjects. Likewise Emma Macpherson dismissed many of the Aborigine customs she observed in the Australian outback as childish. In analyzing the illustrated book that Macpherson produced of the year she spent in this country, Caroline Jordan concludes that her perceptions were preconditioned by her class, nationality, race, and gender. The commonality of gender, however, did not help Inglefield, Cameron, or Macpherson overcome their bias toward seeing natives as types rather than individuals. Charlotte Canning, on the other hand, allowed a degree of compassion to lessen the anthropologic distance from which she viewed the people she encountered. As the wife of the Governor General of India, she was ostensibly an official representative of British imperialism; yet she privately empathized with the subservient position of women in Indian society. She revealed her equivocal position when, as Pomeroy tells us, she cast her artistic eye on the members of her own sex. She observed that Indian women were "very wretched looking creatures" who bedecked themselves with silver toe rings and "enormous amulets as if to hold prison chains." Canning's vision, in other words, shifted between the dominant position of the colonizer and the powerless position of the colonized.

A contradictory tendency was not unusual among women whose struggle to define a new conception of selfhood was in conflict with the social conditioning of their upbringing. This assessment goes a long way in explaining the racist tenor of some of these travelers' written commentaries. Characterizations such as "savage" and "primitive" ring alarms in our twenty-first-century ears. Maria Frawley addresses these insensitive appellations in her essay in this collection, noting that such phrases were embedded in the language of British imperialism which women travelers had been taught to speak from an early age. She wisely cautions, however, that it would be misleading to conclude that such remarks were a simple reflection of imperialist policy. The fluctuating meaning of these terms and the ongoing public debate about territorial domination during the modern period produced a variety of perspectives. Indeed, a shift in attitude between colonizer and colonized can be detected among Victorian adventurers such as Mary Kingsley whose opinion of West Africa progressed from condescension to wonderment in a very short time. Kingsley exclaimed: "At first you see nothing but confused stupidity and crime; but when you get to see—well! As

in the other forest,—you see things worth seeing." Cultural conditioning caused Kingsley to reel between disdain and admiration when confronted with the untidiness of life away from the manicured British Isles. But while her contemporaries Isabella Bird and Marianne North continued to defend imperialist policies, Kingsley managed to cast her eye beyond the stereo-typical and take pleasure in the extraordinary spectacle of difference.

Of all the Victorian women travelers discussed in this book, Barbara Leigh Smith Bodichon perhaps went furthest in assimilating herself into native culture. During her extensive stays in Algeria she wore Arab vests over her blouses, collected Kabyle pottery and embroideries, decorated her home there in the Moorish style, and ventured out into the deserts of the Maghreb where she found material for her many paintings and sketches. Dedicated to female emancipation, Smith Bodichon focused part of her formidable energy on modernizing Algerian women. In her book, *Women and Work* (1857), she argued that the route to freedom for Algerian middle-class women rested in paid work and Western dress.[6] In concluding that Muslim women had fewer liberties than their British counterparts, Smith Bodichon differed significantly from other women travelers. Lady Mary Montagu who traveled to the Ottoman Empire in the early eighteenth century and later Victorian adventurers such as Julia Pardoe and Fanny Blunt envied Turkish women's right to divorce, own property, sign contracts, and refuse conjugal sex at a time when British women were mounting their long struggle to win these privileges. As a sign of solidarity with Muslim women, these women returned to Great Britain wearing slim trousers and draped "harem" pants as an emblem of freedom.[7] Although Smith Bodichon vigorously campaigned for passage of the Married Women's Property Act, she refused to romanticize the women of the seraglio, no doubt because of their lack of educational and religious freedom.

Barbara Leigh Smith Bodichon's experiences with the women of Algeria were markedly dissimilar to Macpherson's insensitive interactions with the indigenous people of Australia. Jordan applies Mary Louise Pratt's theory of the "contact zone"[8] where people of different cultures meet and interact, to assess Macpherson's disapproval of the Aborigine customs of face and body painting, nocturnal dance rituals, and dietary taboos. Jordan credits her, however, with at least admitting that the natives she encountered sometimes objected to Macpherson's attempts to probe and intervene in their lifestyle.

These contrasting points of view underline the fact that women travelers did not share a common female gaze, but exhibited a diversity of spectatorship stances.[9] Their viewing positions ranged from the condescending gaze of the memsahib to the clinical stare of the natural scientist and anthropologist, to the empathetic eye cast on sisters in subjugation. This multiplicity of gazes reveals that British women travelers were both powerful and powerless.

Casteras effectively summarizes this predicament when she writes that the female gaze "unavoidably reflected the different ways women experienced places while simultaneously mirroring the biased (that is racist) imperial mentalities and colonial realities that shaped their vision." In addition to these inhibitors of the gaze, the woman artist had to leap the added hurdle of transcribing what she saw according to Western visual conventions.

A case in point is Emily Eden's *Portrait of Maharaja Shere Singh* (Fig. 1.2). It pays lip service to traditional forms of representation, but is enlivened by innovative qualities inspired by the character of her subject. Eden, like Charlotte Canning, viewed life from the top of the social pyramid in India after her brother, George, Lord Auckland, was appointed Governor General in 1835. Her privileged position may explain why she was not intimidated at the prospect of asking a maharaja to pose for her. Eden's first impression of her sitter exposes her allegiance to the imperialist gaze in that she viewed him as a scientist would look at a specimen in a laboratory. Pomeroy applauds Eden's inventive disregard of the clichés of Western portraiture, both in her image of Shere Singh and in the subsequent portraits she published in her book, *Portraits of the Princes and People of India*, in 1844. Eden's art, then, was directly affected by her firsthand experiences in India. Yet her first impression of her subject reveals that she could not escape the exigencies of the imperialist gaze. In that regard, Eden was subject to the cultural conditioning that affected her sisters of the brush wherever they traveled.

The picturesque aesthetic proved to be a convenient trope for British artists abroad whose training did not offer them an alternate visual vocabulary that was flexible enough to encompass what they experienced away from Great Britain's manicured shores. It offered Marianne North the pictorial means to transcribe the Taj Mahal as a wistful garden ornament. As Rosen notes, the British both literally and figuratively practiced "colonization by gardening" in a fashion that attempted to bring order to the incomprehensible and untamable. He contends that Marianne North and Julia Margaret Cameron merged the picturesque with the primitive in a way that allowed them to portray their subjects as timeless relics untouched by the industry and technology of colonialism.

In *Beyond the Frame: Feminism and Visual Culture, Britain 1850–1900* Deborah Cherry reflects on the dilemma that women artists faced abroad. As her title suggests, she adopts the trope of "framing" to describe the incongruence between female artists' actual experience in the field and their vision, which was shaped within the framework of Western visual conventions. She concludes that the images they produced were "equivocations of desire and denial, seduction and repudiation, visuality and opacity, irresolutions between familiar and strange, home and away."[10] All of these factors work together to explain why there is no distinctive aesthetic element in the visual

vocabulary of the Victorian woman artist traveler, even between those who were well trained at home and those amateurs who struggled with the unfamiliar tools of the artist's craft for a first time in a foreign setting. Smith Bodichon, for instance, studied art at the Ladies College in Bedford Square before she left London for Algeria, but even she could not divest herself of the ground rules of the Western landscape tradition or the Victorian art world's preference for pleasant subjects. Despite her progressive politics, she eliminated downtrodden farm laborers and miners from her landscapes.[11] Like Eden, North, and Cameron, Smith Bodichon could not entirely shirk the aesthetic and social standards she carried with her on her travels.

The tension between their backgrounds and their experiences in the field forced women travelers to make emotional adjustments once they left home. Cut off from friends and their extended families and anxious to discover new activities to fill their time, many wives, sisters, and single women experienced psychological depression. If women as talented as the prolific art historian Anna Jameson and as privileged as Charlotte Canning complained of feeling isolated and bereft, one can only imagine the loneliness less fortunate women suffered. Pomeroy notes how both of these travelers turned to creative outlets to overcome their feelings of aloneness. While Jameson busied herself in Toronto with verbal sketches of winter sports and the indigenous people of Canada's First Nation, Canning visually gave vent to her feelings. Her stark drawing of her private sitting room in Government House (Fig. 3.1), lacks the people and props of the typical Victorian domestic scene and resounds with the emptiness that Canning described feeling. This transgressive image exposes a tension between authority and identity and speaks volumes about the emotional cost of the colonial enterprise. Because of the overriding stringencies and complexities of the colonial discourse, however, most women travelers were caught up in a rhetoric of identification and differentiation with the people and places they visited.[12]

While written descriptions of life abroad may be more explicit, visual impressions often bridge the gap between the knowable and what could be said, and convey what words cannot communicate. Both word and image, however, are contested spaces where systems of knowledge and social power vie with the conventions of their respective genres. Maria Frawley contends that women travelers' visual and verbal accounts are interwoven. She cites the written "sketches" in such works as Anna Jameson's *Visits and Sketches Abroad and at Home*, noting that it and other graphically written texts share the techniques of the painter when they employ such devices as perspective, color, and shade. Jordan also considers Emma Macpherson's pictorial writing as a form of visual stocktaking of her experiences or aide-memoire, which allowed her to lock her perceptions in her mind for later contemplation. Whether women travelers turned to the rapidly executed watercolor drawing

or the spontaneous journal entry, they relied on visual devices to help them sort through the barrage of stimuli they experienced in situ.

The visual image contributed to the discourses generated by the Victorian production of knowledge in a way that was at once intertextual and ideological. Both the written word and the painted image transform objects into images which, in turn, collapse the distinction between printed page and framed sketch. Both expose their subjects' place in society. Both forms of representation—visual as well as verbal—encode authority and identity.

The intrepid women travelers described in this book may not have breached the gap between colonizer and colonized, but through their efforts both were changed in the process of their encounters. Some, like Smith Bodichon, permanently affected the lives of the subjugated women they encountered. Others, like Meredith, altered the thinking of male colonialists through their serious contributions to scientific scholarship. These adventurers broadened their personal horizons and nudged the calcified category of "proper Victorian lady" into a more expansive stratum.

Victorian women travelers were trailblazers who paved the way for even bolder Edwardian painters and writers, budding photographers, and, ultimately, for Hollywood's love affair with the indomitable heroine who succeeds against all odds in the furthest outposts of the Empire. Who can forget the unflappable missionary played by Katharine Hepburn in *The African Queen* or Holly Hunter's fearless performance as a mail-order bride in *The Piano*? Glorified and dramatized, these women of celluloid are composites of the lesser-known Victorian adventuresses who preceded them. Little did these pioneering voyagers realize when they forfeited the security of home and hearth that their writing would provide such rich fodder for the entertainment industry. Traveling female artists, however, are still awaiting discovery. Unlike the glass cathedral manufactured by Cate Blanchett's character in *Oscar and Lucinda*, the art that women produced away from home has not been filmed for posterity. Almost as fragile as Lucinda's magnum opus, their watercolors, drawings, and sketches are, unfortunately, not as free to travel as their makers were. Rescued from museum storerooms and illuminated here for the first time, these captivating works of art illustrate how effectively the visual intermeshed with the verbal creations of Victorian women travelers.

Notes

1. For an overview of recent Victorian travel writing, see Donald Ulin's review of Marjorie Morgan, *National Identities and Travel in Victorian Britain* (New York, Palgrave: 2001) in *Victorian Studies* 44:2 (Winter 2002), 307–309. See also the comprehensive bibliography of Victorian women travelers at: http://www.indiana.edu/~victoria/wtravelbibnotes2.pdf

2. Ovar Löfgren, *On Holiday: A History of Vacationing* (Berkeley, University of California Press: 1999), 5. Löfgren also traces the history of tourism to its origins among the British.

3. Dean MacCannell, *The Tourist: A New Theory of the Leisure Class* (1976; rpr., Berkeley, University of California Press: 1999), xxii.

4. MacCannell, *The Tourist*, 10.

5. For a full discussion of this painting, see N. N. Feltes, "Voy(ag)euse: Gender and Gaze in the Canoe Paintings of Frances Anne Hopkins," *ARIEL* 24:4 (October 1993): 7–19.

6. On Smith Bodichon, see Deborah Cherry, *Beyond the Frame: Feminism and Visual Culture, Britain 1850–1900* (London, Routledge: 2000), 65–73; Pamela Hirsch, *Barbara Leigh Smith Bodichon, 1827–1891: Feminist, Artist and Rebel* (London, Chatto & Windus: 1998); and Candida Lacey, ed., *Barbara Leigh Smith Bodichon and the Langham Place Group* (New York, Routledge: 1986).

7 See Dianne Sachko Macleod, "Cross-Cultural Cross-Dressing: Class, Gender, and Modernist Sexual Identity," in *Orientalism Transposed: The Impact of the Colonies on British Culture*, Julie F. Codell and D. S. Macleod, eds. (London, Ashgate: 1998), 63–85.

8. Mary Louise Pratt, *Imperial Eyes: Travel Writing and Transculturation* (London: Routledge, 1992), 6–7.

9. On the question of the female gaze and plurality of vision, see Indira Ghose, *Women Travellers in Colonial India: The Power of the Female Gaze* (Delhi, Oxford University Press: 1998) and Dianne Sachko Macleod, "Pre-Raphaelite Women Collectors and the Female Gaze," *Journal of Pre-Raphaelite Studies*, 5 (Spring 1996): 42–52. Repr. in *Collecting the Pre-Raphaelites: The Anglo-American Enchantment*, ed. Margaretta Frederick Watson, ed. (London, Ashgate Press: 1997), 109–20.

10. Cherry, *Beyond the Frame*, 100.

11. Cherry, *Beyond the Frame*, 88.

12. The phrase is Lisa Lowe's. See *Critical Terrains: French and British Orientalisms* (Ithaca, Cornell University Press: 1991), 40.

With palettes, pencils, and parasols: Victorian women artists traverse the Empire

Susan P. Casteras

On their journeys beyond the proverbial parlor as well as beyond their homeland, Victorian women artists balanced and negotiated the conflicting and sometimes contradictory challenges of simultaneously being female and an artist. The period of Victoria's rule was rife with post-Industrial Revolution changes of many sorts: social, political, and economic upheavals abounded, and throughout these decades the struggles continued for women's suffrage and increased rights along all fronts, artistic and otherwise. During this tumultuous era, the Empire expanded significantly and consolidated into monolithic colonial sovereignty. As the British Empire spread, so too did the reach of countless military personnel, natural historians, authors, scientists, and ordinary travelers who trekked all over the globe. Some went in search of conquest of various sorts, others for sheer adventure, and some in hopes of financial gain if they produced favorably received narratives or art for British audiences eager to learn more about different cultures and worlds. The growth of travel was a phenomenon that benefited Victorian middle- and upper-class women, whose money, status, and leisure enabled them to experience more places and potential adventures. British women expressed a passion for travel and were sometimes seen in precisely these terms, the *Quarterly Review* declaring that other nations lacked "the same well-read, solid-thinking, early-rising, sketch-loving, light-footed, trip-wasted, straw-hatted specimen of women…".[1] Travel abroad often allowed them to pursue their interests and aspirations more than if they had remained in Great Britain. Because travel abroad—with reservations—was culturally sanctioned, they potentially had greater freedom to indulge their inquisitiveness and to write or make art about alien lands and sights.

Whereas in the last two decades scholars have started to scrutinize the tourist literature of the period and the travel writing of Victorian women, the contributions of female artists who ventured to foreign climes in particular

have been less closely examined. Like their literary counterparts, women artists' fates related both to the cultures they left behind and to the new ones they saw, and sometimes embraced. In the process of their journeys, women mapped their own identities, internalizing and processing their experiences in ways that led in multiple directions. England and its art schools served as mere way stations or points of departure for many women, whose destinations and artistic destinies proved far less predictable and more invigorating than anything they might have previously imagined. This essay traverses some of the territories they covered and highlights key artists who represent diverse backgrounds as well as divergent perspectives and approaches to traveling and observing in their own nation and abroad.

For those privileged women of the higher classes who took far-flung voyages as well as for their counterparts who stayed at home, the overall situation throughout Victoria's reign remained restrictive because of the oppressive realities of patriarchal authority and the rigid doctrines inculcated by society. First and foremost, middle- and upper-class women were saddled with overriding assumptions that they would gladly eschew careers in order to serve as dutiful wives, mothers, and daughters. There was a place in this bourgeois hierarchy for making art, but it belonged within highly gendered spheres and notions of male and female roles and abilities. On the home front, art was an integral part of the legendary feminine accomplishments that young ladies were supposed to acquire—some training in non-academic subjects such as music, dancing, needlework, and art.[2]

As countless sources have affirmed, creating art was deemed a source of edification, entertainment, and beauty, a suitable undertaking or genteel hobby for young women; it was not, however, intended as pre-professional, serious training for an aspiring artist. Making art was part of the initiation process of becoming a lady, a prerogative of class as well as an activity that heightened and emphasized a woman's supposedly inherent refinement and sensitivity. Some women were satisfied with foregoing a vocation as an artist, others accepted their amateur status and balanced this with motherhood and other responsibilities, and still other women vigorously strove for independence and professional careers or managed to attain a blend of several lifestyles.

Mary L. Gow's 1875 painting *Listening to the Sea* (Fig. 1.1) strikingly embodies, on a number of levels, some of the foregoing preconceptions and internal conflicts that women faced, especially that between armchair and actual travel. Gow (1851–1929), whose family included many artists, was a former student at the School of Art and Heatherley's School in London. Prolific in output, she exhibited from the late 1860s until about 1921 at the Royal Academy, the Society of British Artists, the Royal Institute of Painters in Watercolours, and a number of commercial galleries. Overall, she enjoyed a

modicum of success but never became as famous, for example, as Kate Greenaway or Helen Allingham.

In this painting, a Victorian woman sits center stage in a beautifully upholstered armchair that complements a handsomely appointed middle-class setting. The room is aesthetically furnished with assorted signs of good taste, notably paintings and shelves of books that form a wall or barrier behind her. The figure's back is turned to these objects as she tends to her lacework (and likely toiled on the nearby embroidery), these very tasks apt emblems of socially endorsed feminine accomplishments. As she keeps busy, a child wearing a pinafore (presumably a girl, given the toy cradle and doll) stands on tiptoe and presses a seashell to the woman's ear. With the sounds of the remote seashore reverberating, perhaps even beckoning, the lady suspends her lacemaking efforts. She seems momentarily motionless, psychologically apart from the homey clutter of objects, and does not regard the child or look out at the garden burgeoning outside the windows. The expression on her face seems rather wistful; perhaps she is thinking of distant shores or times enjoyed in the past. Whether or not the child has shared this seaside memory is not evident; perhaps she too is a captive of the elegant surroundings, or perhaps she might simply be construed as a future traveler.

On the surface, this image seems disarmingly sentimental, and yet other possibilities resonate, such as how the notion of being at or returning home— or how the contrast between the familiar and the strange—is underscored. Does this image underline the value and stability of the known or the allure of the unknown, or both? To its original viewers, the painting probably appealed to both sexes as an attractive vignette, unmarred by what modern viewers might deem an enclosed, even suffocating, life in a parlor that, although sheltering women from external strife, simultaneously precluded their freedom of choice, travel, and self-assertiveness. To modern viewers, the scenario raises other questions about how one experiences the recollection or intense wonder of travel. That Gow chooses to codify a moment of such vicariousness and detachment from active adventure in the form of a middle-class lady is itself revealing. The exotic and the remote, along with any sense of longing to connect with these feelings, are safely distanced and envisaged in the cozy confines of home, the woman and even her powerful gaze kept separate from the original sight and site. The focus is on the artifact and its associations, on the power of a thing to exert actively meaning from the past onto the present. Whether or not the artist herself traveled greatly is irrelevant (and unknown, although Gow's family was wealthy); she does not judge the relative merits of vicarious versus direct contact as she adheres to prevailing cultural suppositions by portraying a dewy-eyed drawing-room occupant as a passive recipient rather than as a fearless seeker of adventure. Everything "real" or potentially threatening has been filtered out, and the shell and the

travel it symbolizes have been relegated, even domesticated, to coexist with the decorum and familiarity of all the other objects in the room. The degree to which artists sanitized what they saw or felt when traveling is thus one quality that might be weighed when studying the images that Victorian women produced. Another is whether they were repeatedly drawn to focus more on domestic elements in foreign scenery as if to forge a link with their own lives or perhaps to predicate the implicit contrast between home and abroad, "civilization" and the Other. A third consideration is whether—and even why—women usually screened out the repellent or disturbing, avoiding anything that smacked of trauma, bloodshed, or political controversy. For men as well, the gritty authenticity, rigors, and shock of travel did not always translate into seamless verisimilitude in art. Another issue not easily resolved is the degree to which women consciously participated in the imperial gaze; for example, did they, or at least some female artists, find other ways of looking and translating their perceptions into paint? Did women possess or convey a powerful naivety that somehow shielded them from reasonable expectations to represent "the truth" about what they saw in their travels? As with Gow's seemingly simple genre picture, the ways in which women "normalized" and "familiarized" the exotic are particularly important to explore, although firm answers are frequently not readily available.

For Gow as for all women artists/travelers, previous training affected their work and attitude to new stimuli and was an underlying issue that varied greatly in type, depending upon the individual, family finances, and the quality of instruction available. Some women were self-taught, whereas others had been exposed to art either by drawing masters or more protracted and formal arrangements. Women also read books on drawing by John Ruskin and others, or sought similar advice in manuals and women's magazines, which often touted the suitability of applied arts such as embellishing tiles, teacups, and shells. Women most often chose subjects that reflected their own worlds. They wanted and needed to appeal to potential buyers and critics, and thus producing art that conformed to the mainstream of taste was as much a priority for them as for their male counterparts. In addition to more conventional themes that appealed to viewers or purchasers, such as contemporary constructions of motherhood, childhood, romance, work, leisure, home, still lifes, portraits, animals, and literary sources, some women artists tackled more ambitious, revered, and demanding topics, including history and religious painting, mythology, landscape, and scenes of the exotic.[3]

Beyond the realms of domesticity, an area that women artists often cultivated was that of nature and natural surroundings, first and foremost in their own native land. The impact of Ruskinian and Pre-Raphaelite beliefs from the 1850s fostered a widespread interest in direct confrontation with and

representation of lowly local plants and intimate corners of nature in hyper-clear, microscopic detail. Ruskin's words encouraged women in this endeavor, and untold numbers followed this artistic creed and produced often compelling results. In a related way, the field of botanical illustration opened up to women, presumably because of their supposed affinities with nature and talents at reproducing fine details. It seems fitting that women were drawn to such subjects, which were similarly modest, small-scale, and often rendered anonymously, or at least with low visibility (compared with the higher profiles of male artists).

Scientific and botanical illustration fortuitously coalesced with Ruskinian ultra-realistic tenets that explicitly venerated natural foliage from the tiniest blossom to the broadest panorama. One stellar practitioner of this genre was Elizabeth Twining (1805–89), daughter of the director of the East India Company and head of the family's tea-trade dynasty. Twining produced remarkable original drawings and watercolors of plant specimens—flowers, fruits, and vegetables. In her youth she copied pictures from *Curtis Botanical Magazine*, and as a young woman traveled abroad with her father and sisters. In Britain, she made many pilgrimages to the gardens of the Royal Horticultural Society. By 1849 her landmark two-volume *Illustrations of the Natural Order of Plants* was published, and in 1868 *The Chief Natural Order of Plants*. Twining wrote proudly of native flowers and plants, and works such as *The Plant World* of 1866 were based on specimens at the Royal Botanic Gardens in Kew. Sometimes she worked from foreign specimens that had been sent to her, and these too resulted in extraordinary botanical portraits of lasting quality, appeal, and scientific worth.[4] Perhaps such women did not regularly travel thousands of miles to depict their subject, but it was their skill, not the distance traveled, which gave their work lasting value, especially in the scientific community.

Travel abroad was one source of excitement and provided novel artistic material for women artists, but it was not the most likely alternative. In terms of sheer numbers, the joys of excursions into the English countryside attracted more women.[5] While some decided to travel extensively abroad, others, such as Twining, elected to stay in England to record nature. However, whether on British home soil or elsewhere, the liberation of sketching alone outdoors was potent, especially for women like Helen Paterson Allingham and Barbara Leigh Smith Bodichon. Deborah Cherry has described the merger between the boundaries of landscape painting and travel as comprising a distinctly separate category that "constitutes a feminine subject position for enjoying and experiencing landscape." She astutely notes that landscape painting flourished as a profitable luxury commodity which, combined with tourism and travel literature, "created the countryside as a knowable, recognizable, and distinct domain, fundamentally different from, and often contrasted with,

urban life, society, and work."[6] The very word "picturesque" and its connotations of decorative, culturally sympathetic or comfortable scenery helped to promote the appeal of viewing landscape as an aesthetically pleasurable enterprise.

One artist who made major contributions to this picturesque genre was Helen Paterson Allingham (1848–1926), whose nostalgic renditions of rural England continue to rate highly even today with collectors as well as with gift, card, and poster manufacturers and merchants. Her "home-grown" images of the British countryside proved more appealing to the public than those she created of Venetian scenery after a trip to Italy. Encouraged by her aunts (including Laura Herford, the first woman to enter the Royal Academy schools), Allingham first took lessons at the Birmingham School of Design, then studied at both the Royal Female School of Art and from 1868–72 at the Royal Academy Schools, and finally worked at the Slade School. After supporting herself and her mother with commercial illustrations for periodicals and books, Allingham was hired to work as an illustrator and reporter for the newly founded, urban-centered *Graphic* magazine, a rare opportunity for a woman.[7] Following her marriage to the poet William Allingham, she concentrated on watercolor painting and was the first female ever accorded full membership (in 1890) in the Royal Society of Watercolours. Favoring the nearby locations around their home in Surrey, Allingham preferred to paint out of doors. By 1886 she merited her first of seven solo shows at the Fine Art Society; when her husband died in 1889, she supported herself and her children with her art, often traveling by train to seek out new countryside locations to paint.

In effect, Allingham became almost a one-woman embodiment of a literal and metaphorical "cottage industry," generating scores of watercolors of prettified cottages, gardens, and villages. There seemed to be no end to the demand for Allingham's watercolors: she enjoyed fame abroad—even as far as St. Petersburg, Russia—and labored long hours six days a week in order to provide the public with an abundant supply of traditional images of English cottages and hamlets, seemingly forever pristine, bathed in sunlight, and pleasantly nestled in non-threatening, flower-laden fields, woods, and lanes. Even among her contemporaries her work was rated charmingly old-fashioned, upholding a bucolic artifice of what her biographer praised as "lasting memorials of the fast-vanishing beauty of our countryside … visions of a lost Fairyland."[8] Modern critics, although occasionally unappreciative, have sometimes tempered their remarks by acknowledging in her idealized nationalistic images "an element of realism, in that she was trying to capture a way of life and a type of vernacular architecture that were disappearing even as she painted."[9] Reinforcing that spirit of realism, her biographer ironically noted that Allingham's lovely images required some decidedly unlovely

physical discomfort and strain: "She sat at the bottom of a damp ditch, knee-deep in nettles, or poised precariously on a pigsty wall, using her open umbrella as an easel."[10]

As the plates in *Happy England* and similar books attest, Allingham deliberately chose to depict "home," not a distant "elsewhere," although seemingly more for marketability rather than for any verifiable reasons relating to national identity. Yet in her own way, she reinforced the kind of soothing impact, armchair comfort, and nostalgia underlying Gow's image. Allingham's artificial British idylls nonetheless competed for audiences simultaneously with images of faraway, exotic places in the art market, but there was room for both types of art, as well as hybrids of both poles, to be appreciated. One genre was not more important than the other, and in fact both coexisted without friction. Yet perhaps on some subconscious level, Allingham contributed to the over-saturation of images of British suburban and agricultural charm, possibly helping to fuel the already strong curiosity about little-known places outside of the British Isles, new virgin territory to be vicariously seen, enjoyably experienced, and consumed. Along these lines, Deborah Cherry has suggested that such curiosity not only strengthened the viewing of landscape as a "leisure activity in which seeing, enjoying, and picturing country scenery were separated from seeing land as property," but also empowered "bourgeois women as spectators, writers, and picture-makers of landscape."[11]

Some Victorian women artists/travelers had a greater desire, coupled perhaps with more opportunity, to transcend the boundaries of home and explore new regions of the world. When they moved beyond the comforts of the parlor, family, and friends, they left behind in varying degrees the normative feminine role as domestic guardian of the hearth and focused on being artists embarking upon alien worlds and sights. Not surprisingly, most were members of the middle and upper classes and thus could afford to enjoy these opportunities of, and exposure to, global differences. Some expressed ambivalence toward the double standard, but others did not; however, few qualified as liberated Bohemians or ardent feminists, although they all manifested independent thinking, action, and decision making. Smith Bodichon was among the progressive exceptions and is the best example of a feminist activist who struck out of the established order in both her goals and her lifestyle, yet also managed to retain her respectability as a lady.

Raised in unorthodox circumstances as the daughter of a radical M.P., Smith Bodichon exhibited at the Royal Academy, the British Institution, and other highly esteemed venues. She clearly savored the freedom and autonomy of her private income as well as of travel, venturing abroad at age 21 with a friend and conspicuously without a chaperone. In a letter to a male colleague she said she yearned not for "English genteel family life" but rather "to be off

on some wild adventure ... It is quite natural that my life abroad and out of doors should make me more enterprising for boat punts or painting excursions than for long sojourns in stifling rooms with miserable people."[12] As such remarks convey, painting outdoors increased mobility for this artist and other women, and excursions of all sorts—countryside as well as abroad—contested reigning stereotypes of females as weak and dainty, sharpened women's powers of observation, and enlarged their range of subject matter. Producing landscapes could be a liberating experience in other ways as well, showing off to women's advantage their proficiency in domains other than the predictable venues of portraiture, genre pictures, and representations of children and flowers.

Throughout her life Smith Bodichon was a tireless reformer, campaigning in the late 1850s for liberalization of the rules at the Royal Academy as well as for passage of an overhauled Married Women's Property Act. Among her most outstanding achievements, she wrote *A Brief Summary in Plain Language of the Most Important Laws Concerning Women* in 1855, established the *Englishwoman's Journal* in 1858, and co-founded Girton College, Cambridge, in 1891. In her private life, she moreover sustained an unusual marital relationship with her husband, Eugene Bodichon, a former French army surgeon, fellow idealist, and anti-abolitionist who encouraged her separate identity and pursuits. The couple split their time between two continents, England and Africa, and their Algerian home became the basis for Smith Bodichon's series of North African landscapes (totaling about 150, or more than half her publicly exhibited work), which in 1861 were displayed at Gambart's French Gallery in London.[13] In their personal lives, from the outset the spouses were also revolutionary: in a decided role reversal, Dr. Bodichon did not interfere with his wife's career and amicably did the housekeeping, marketing, and cooking when the pair lived in New Orleans.[14] During an extended honeymoon trip in 1857–58, while in the United States, husband and wife proceeded by steamboat and train throughout the South and were disgusted by the horrific conditions of slavery. As a feminist crusader and an artist, Smith Bodichon was an iconoclast who did not hesitate to report what she saw. She interviewed freed blacks and slaves alike and wrote scathingly of the tyranny of slavery. She also filled sketchbooks with impressions of Southern life, topography, and animals. Smith Bodichon did not shrink from delineating such a hard-hitting subject; in her opinion, travel to the American South involved a descent into a pestilent jungle where savagery was the main attribute of slave owners.

On her junkets abroad and in her homeland, Smith Bodichon liked to go out on her own to draw, and subsequently recalled how this penchant for solitude was perceived as shocking, especially because she wandered about "recklessly" in masculine attire. Much as the French nineteenth-century artist Rosa Bonheur was disparaged for donning male garb when she frequented

slaughterhouses, so too was Smith Bodichon upbraided by one man for supposedly flaunting herself as "a young lady ... who thinks nothing of climbing up a mountain in breeches or wading through a stream ... in the sacred name of pigment."[15] This borrowing of male attire and persona, however, was a characteristic of many Victorian women travelers such as Isabel Burton, Laurence Hope (pseudonym of Adela Florence Cory), and Isabel Gunn, all of whom "found it practical to disguise themselves as men, especially in countries where women were forbidden to travel."[16] Perhaps it also enabled them to divest themselves, if only temporarily, from some of the prejudices that complicated their lives when they wore the expected mantle of a respectable Victorian lady.

A contemporary of Smith Bodichon was Adelaide Claxton (later Turner, *c.*1840–*c.*1905) who, although not rich, also traveled widely abroad. As a child she accompanied her father, artist Marshall Claxton, on a long trip to Australia, where he escorted an early expedition of British paintings for exhibition. This globetrotting continued from 1850–57/8 in India, Egypt, and the Holy Land as Claxton, her sister, Florence, and their mother traveled around the world. During this time the two sisters honed their talents and became more skilled at producing satirical works that lampooned the "social follies of both hemispheres," as one critic remarked.[17] Adelaide Claxton then began a career as an illustrator for prominent magazines such as the *Illustrated London News*, *London Society*, and the *Illustrated Times*, in addition to producing paintings which were exhibited at the Royal Academy, the Society of Women Artists, and the Society of British Artists. She even had a London office as a draughtsperson before her marriage in 1874. One of her drawings, *Philipines* [sic] captured the excitement, even latent romance, of transcontinental voyages; it moreover conveys a hint of humor that is fairly rare in women's art of this period but not unusual in the Claxton sisters' œuvre. The artist's handwritten text explained what the scene represents, namely the intricacies of a shipboard pastime, which involved finding a double almond in its shell from others put on the table:

This represents the game of Philipines [sic], which is one of the greatest amusements of a long sea voyage. The capitan, [sic] if he is a goodnatured one, always encourages as many of this kind of [game] as possible, otherwise people shut up together for 3 or 4 months are sure to quarrel, and sometimes a duel on landing has been talked about if the attention of the passengers has not been distracted by dancing, games, etc.

As this inscription conveys, sometimes women travelers chose to depict not the diverse denizens, architecture, or scenery to which they were exposed, but instead the ways that the British coped with the boredom, isolation, and privations of long journeys. In comparison with images that convey a quasi-documentary quality or point, this drawing seems quite casual and refreshingly amusing, in word and image replete with hints of the self-mockery that often pervaded Claxton's illustrations.

In Smith Bodichon's and Claxton's cases as well as others, those women artists who did travel extensively relied on their own firsthand experiences of life abroad to command an effect of authenticity and experimented with various ways of presenting their material, including subjective sketches, documentary reportage, and subtle humor. As evident in the examples already cited, itineraries did not simply comprise Western European countries, but also more exotic locales such as South America, India, Egypt, North Africa, the Holy Land, and Ceylon. These travels were not unique in the history of women, but their increased numbers and artistic production were nevertheless significant. As Cherry has articulated, belonging to this privileged category necessitated "professional practices as a landscape artist [that] not only required specialist training, but also facilities for travel and outdoor work, and, at mid-century, some familial encouragement."[18] Some participants took landscape painting to more radical heights, with Smith Bodichon principal among those who, wearing sturdy, reformed garb, blended travel and outdoor work, immersed themselves in exploring new scenes and places, and thus helped to redefine femininity as "active, strong, working and self-determined."[19] Traveling also redefined other parameters: by facing the risks of disease, injury, wild animals, and unknown hazards abroad, women proved their stamina and bravery even as they enlarged the frontiers of landscape painting, scientific knowledge, ethnography, and other fields.

In general, outside the island of Great Britain, women tended to be subjected to less supervision or surveillance and thus enjoyed enhanced possibilities for physical and other forms of emancipation. Whatever place they visited offered a unique chance at originality and sometimes even voyeurism; in the Middle East, for example, visiting harems was all the rage, and some men urged their wives to make such a visit so that they could report on what they saw.[20] At times the experience proved utterly unparalleled; women such as Frances Anne Beechey Hopkins (1838–1918) were able to penetrate areas—the Canadian backwoods, for example—to which English-men were newcomers. This opportunity to see unfamiliar places like the Canadian wilderness or Ojibwa Indian encampments and to register one's responses was eye-opening as well as thrilling. Hopkins's *Shooting the Rapids* of c. 1879 is a dramatic tour de force, a large-scale canvas virtually symbolizing the bravery of women artists cum explorers.[21] The subject shooting the rapids is obviously far removed from the security of plush parlors: instead, Hopkins portrays a head-on encounter fraught with extreme hardship and treacherous waters.[22] The composition symbolizes the navigation of the unknown and the perils of survival. Hopkins's experience of the thirty-odd-foot long birch bark canoe plunging into the currents is undeniably authentic, and she includes, amid the skilled voyageurs and others, a self-portrait (with her husband) in

the middle of the craft. Hopkins inherently refuted notions of feminine delicacy by displaying "masculine" traits of perseverance and the courage to be party to this dangerous journey.[23]

It is evident that, by the very nature of their voyages outward, women like Hopkins were not content to be immobilized on ideological pedestals as housebound captives of fair womanhood. Overcoming institutional as well as cultural obstacles, they shifted the boundaries of landscape to new limits, created works of art in locations all over the map, and discovered openings for self-expression, despite the doors and opportunities that had been closed to them at home.

Initially, many women, at least partly, qualified as passive passengers accompanying their husbands or male relatives on business, government, or military missions, although some ironically turned that dependent status into an asset. Masquerading as "just" a wife or sister, they used the prospect of travel as an entrée to new worlds, art, and ways of seeing. Among women who journeyed abroad because of their husbands' careers were Maria Rawstorne Mathias, who flourished in the 1850s and toured the Middle East in that decade, keeping a diary and making sketches of landscape and archaeological ruins; Mary Anne Broode Cust (*c*.1799–1882), wife of a general and a watercolorist of West Indies sights; and the celebrated Elizabeth Thompson, Lady Butler (1846–1933), who accompanied her soldier husband to live in Egypt and later Palestine. Thompson's experiences gave a ring of authenticity (extolled by Ruskin) not only to her unprecedented, if jingoistic, "masculine" treatment of war in scores of battle paintings, but also to her illustrations for an 1891 edition of *Travels to the Holy Land*.[24]

Beyond the spousal category, the unmarried Emily Eden (1797–1869) was the Whig hostess and political advisor to her powerful brother, Lord Auckland, who served as Governor General in India from 1835–42. Eden's sojourn in India resulted in a number of publications including two novels, a compilation of her letters to one of her sisters (*Up the Country* in 1866), and an entire volume of commentary and images lithographed by Lowes Dickson and published in 1844 as *Portraits of the Princes and People of India*. For this volume she produced both text and large-scale watercolors that mixed the familiar—domestic groupings—with the unfamiliar (indigenous landscape, cultural and religious practices). In one of these images she portrayed *The Maharaja Shere Singh* (Fig. 1.2) in slightly Anglicized contexts. Eden commented on British racism and was attracted to India's quintessential foreignness, exclaiming in a letter that there "everything is so picturesque and utterly un-English."[25] For her, travel was a means of self-definition and in the process of reforging the picturesque to accommodate these distinctive non-English qualities, she, like other women, utilized her art not as a mere accomplishment but as a documentary instrument or tool.

In addition, some women were not subordinates to or extensions of male travelers at all—they paid for their own trips and actively undertook quests for adventure. One such individual was Marianne North (1830–1890), a self-taught artist who used her own inherited funds to travel around the world and who painted more than 800 studies of botanical specimens, many hitherto unknown to scientific experts. In her memoirs, North chronicled the rigors and travails of penetrating the western United States and vast areas that were then only territories, but nothing deterred her from also going to Jamaica, Brazil, Japan, Java, Southeast Asia, Australia, India, and the Himalayas to paint flowers in their natural habitats.

In their role as English citizens and yet outsiders to the foreign places they visited, women were inherently part of the colonialization process of Empire building, but in more discreet, often overlooked, ways. They went mostly to colonized countries not as official policymakers, but sometimes as artists (or as tourists or appendages or a mixture of these). Yet despite their status as strangers, they proved to be active agents who preserved how they perceived what they saw, whether people, places, customs, flora, or fauna. Through direct contact and observation, at times they subtly transferred and transposed the notion of domesticity into other cultures, typically depicting women—as mothers, consumers, and workers in daily life. Like the female authors who wrote about their foreign exploits, they too experienced and communicated some of their awe, fear, and anxiety in their artistic constructions.

The Victorian imperial eye was thus clearly not just masculine; it also encompassed the female gaze, which unavoidably reflected the different ways women experienced places while simultaneously mirroring the biased imperial mentalities and colonial realities that shaped their vision. As such a statement implies, women artists could not elude the tainted ideologies of nationalistic hegemony and the inscription of colonialism into their tastes and art, but neither did they play critical roles within the masculine hierarchies of power. As Antoinette Burton has noted, women produced an imperial aesthetic vision that was markedly gendered

in ways that echo what British men did by more official means ... For late Victorian women travelers who were also artists, empire offered a uniquely gendered challenge. In order to satisfy the public's desire for picturesque images of empire ..., they had to compete with an already well-established, largely male body of travel literature which had mapped out much of the known world ... Women like C. F. Gordon-Cumming, Amelia Edwards, and Marianne North had to prove the distinctiveness of their vision *and* the originality of their particular trajectory from metropole to colony, from the so-called center of civilization to its outposts. They had to demonstrate ... that their "eye" was as sophisticated, discerning, and authoritative as that of the male tourist or traveler, if not more so.[26]

As purveyors of imperial hegemony women artists sometimes transmitted biased messages about native cultures, but their images were not likely conceived of as vehicles for any organized body of ideas or issues such as imperial power. While mostly women shared common ground as tourists, at times what they experienced was radically different for other reasons: for example, women such as Lady Butler gained access to places that men were specifically prohibited from entering, such as a harem or zenana (women's quarters). Women artists' motivations also were distinctive: their works were not necessarily meant for mass publication or other forms of public consumption, but instead for personal pleasure or documentary purposes or a combination of factors. The worth of their efforts is also distinguished for its variability, for what was deemed in the past as so-called amateur investigations in botany, photography, or ethnography, and so on, is now typically held in much greater esteem. In addition, in retrospect it is evident that women such as Smith Bodichon straddled or blurred the often artificial lines between amateur and professional and helped to shape a new composite of the two.

What else did Victorian women artists/travelers achieve? The highly independent Smith Bodichon and North were able to break with convention in various ways, to satisfy their own desires, aims, and needs. Their colleagues found new inspiration as well as freedom in their dynamic adventures, and through the rigors of travel attained a deepened sense of self-identity, purpose, inventiveness, and self-worth. Autonomy, escape, a sense of wonder were all obvious gains, too, even when conveyed in a lighter vein, as Claxton did. Travel, especially to uncharted, non-European locales, dissolved traditional stereotypes and frontiers, allowing women to experience and work out firsthand their individual degrees of inquisitiveness, valor, and ambition. Some travelers even found their own lives and identities forever reconfigured in the process of living or voyaging beyond the safe threshold of England.

The production of art by these women might also be considered as a way to "possess" the places in question, a means to exercise a measure of authority over these, if only visually. As dual eyewitnesses and cultural filters, they produced art that belonged to its own special category of pictorial "domination" and subjective fiction. Women were not exempt from the bias of their national backgrounds; nor could they escape their individual subjectivity in responding to a scene or interpreting its various levels of reality and meaning to an outsider. Their conquest was not of a male political or military sort, but it was empowering and substantive nonetheless, projecting a highly personalized and subtle vision of how they came, saw, and visually conquered a place.

Art enhanced by travel furthermore permitted women to deploy their talents and shift from the creation of more conventional art to documentary and other modes of self-expression. Confronted with the new and the remote,

they discovered less need to apologize for their alleged female inadequacy as artists. Travel functioned as a vehicle to foster independence, to gain relief and release from the status quo, and to shed cloying stereotypes, even to adopt male attire. As they responded to novel territories or practices, some women realized that their art was sometimes trailblazing, recording a place, practice, or flower for the first time in Western art. Travel furthermore conspicuously encouraged women to test themselves, to try on new selves, attitudes, and customs, and to reveal these to others. At the same time, the resulting art both gave contemporary viewers a means to visualize remote lands and proved that women could be as bold as men.

For female artists fortunate enough to travel extensively, the voyage itself became a metaphor for life and art, inscribed with meaning about what they experienced and chose to remember or record. Travel also fulfilled a yearning for change that many women undoubtedly harbored. In the end, most seemed to thrive upon change, even adversity, perhaps because, as they moved from place to place, they were able to react more freely than in England, without as many traditional constraints upon their actions. Transplanted from familiar settings, women discovered and developed untapped qualities of adaptability, assertiveness, self-confidence, and resourcefulness.

For those who traveled great distances, the surrender of security was balanced by the stimulation of unfamiliar cultures, peoples, and paths. Forging a professional identity as artists was arduous enough for women, but travel actually seems to have conferred a sense of worth as well as helped many reach a degree of self-actualization, beyond a measure of independence. Ultimately, the fruits of feminine accomplishments yielded major cultural results; with palettes, pencils, parasols, and passports, these Victorian artists created sketches, illustrations, and paintings that today are valued as landmark contributions to nineteenth-century history and culture.

Notes

1. As quoted in Barbara Hodgson, *No Place for a Lady: Tales of Adventurous Women Travelers* (Berkeley, Calif.: Ten Speed Press, 2002), 3.

2. See, for example, Deborah Gorham, *The Victorian Girl and the Feminine Ideal* (London: Croom Helm, 1982), 21, 38, 50, 52 and also Judith Rowbotham, *Good Girls Make Good Wives: Guidance for Girls in Victorian Fiction* (Oxford: Basil Blackwell, 1989), 115–18. On earlier traditions of this phenomenon, see Ann Bermingham, *Learning to Draw: Studies in the Cultural History of a Polite and Useful Art* (New Haven, Conn.: Yale University Press, 2000).

3. On the subject of women artists, see, for example, Cherry, *Painting Women: Victorian Women Artists* (London: Routledge Press, 1993) 120–40, and Susan B. Casteras and Linda H. Peterson, *A Struggle for Fame: Victorian Women Artists and Authors* (New Haven: Yale Center for British Art, 1994), 24–7.

4. On this subject, see Ann B. Shteir, *Cultivating Women, Cultivating Science: Flora's Daughters and Botany in England, 1760 to 1860* (Baltimore: Johns Hopkins University Press, 1996) and also Barbara T. Gates, *Kindred Nature: Victorian and Edwardian Women Embrace the Living World* (Chicago: University of Chicago Press, 1998).

5. On this phenomenon of mounting numbers of women painting rural England, see Cherry, *Painting Women*, 165–75.

6. Cherry, *Painting Women*, 165.

7. On this artist, see Ina Taylor, *Helen Allingham's England: An Idyllic View of Rural Life* (Exeter, U.K.: Webb & Bower, 1990).

8. W. Graham Robertson, *Time Was: The Reminiscences of W. Graham Robertson* (London: H. Hamilton, 1933), 61.

9. John Christian, "Helen Allingham and the Cottage", in *The Markey Collection of Watercolours by Helen Allingham* (London: Christie, Manson & Woods, 1991), 16.

10. Robertson, *Time Was*, 155.

11. Cherry, *Painting Women*, 169.

12. As quoted in Shirley Foster, *Across New Worlds: Nineteenth-Century Women Travelers and Their Writings* (New York: Harvester Wheatsheaf, 1990), 49.

13. Pam Hirsch, *Barbara Leigh Smith Bodichon 1827–1891: Feminist, Artist and Rebel* (London: Chatto & Windus, 1998), 132.

14. Hirsch, *Barbara Leigh Smith Bodichon*, 113.

15. As quoted in Oswald Doughty and J. R. Wahl, eds. *The Letters of D. G. Rossetti* (Oxford: Clarendon Press, 1965), vol. i, 163.

16. Hodgson, *No Place for a Lady*, 119.

17. As quoted in Rodney K. Engen, *Dictionary of Victorian Wood Engravers* (Cambridge: Chadwyck Healey, 1985), 47.

18. Cherry, *Painting Women*, 170.

19. Ibid.

20. Hodgson, *No Place for a Lady*, 55.

21. The best source on Hopkins is Janet E. Clark and Robert Stacey, *Frances Anne Hopkins, 1838–1919: Canadian Scenery* (Thunder Bay, Canada: Thunder Bay Art Gallery, 1990). Fellow countrywoman Anna Jameson also sketched cities, outposts, and Indian encampments, and an excellent source is Judith Johnston, *Anna Jameson: Victorian, Feminist, Woman of Letters* (London: Scolar Press, 1997).

22. One author, Lilias Campbell Davidson, in her 1889 book *Hints to Lady Travellers at Home and Abroad* not only equated travel with physical dangers, but also with sexual ones. See Sara Mills, *Discourses of Difference: An Analysis of Women's Travel Writing and Colonialism* (London: Routledge, 1991), 100.

23. Nineteenth-century writer Anna Martineau was another Englishwoman who was among the first European females to trek into the Canadian interior, in her case mastering an arduous 1500-mile trip.

24. The best source on Lady Butler is Paul Usherwood and Jenny Spencer-Smith, *Lady Butler, Battle Artist 1846–1933* (London: National Army Museum, 1987).

25. As cited in Khushwant Singh, "The Great Maharah of Punjab", http://www.tribuneindia.com/2001/20010407

26. Antoinette Burton, written remarks entitled "Looking like an Imperialist: Empire-Building and the Woman Artist's Eye," curatorial files, Symposium 21 and 22 April 2000, National Museum of Women in the Arts, Washington, D.C.

Borders and boundaries, perspectives and place: Victorian women's travel writing

Maria H. Frawley

In 1884, the traveler Constance Gordon Cumming wrote an article titled "A Lady's Railway Journey in India" for *Macmillan's Magazine* that begins with this sardonic comment: "In these days of rapid travelling, the journeys which, to our elder brothers were serious undertakings, have become to us, their younger sisters, mere pleasure-trips wherewith to beguile the tedium of winter, and escape its rigours."[1] Well known for works such as *Fire Fountains: The Kingdom of Hawaii, Its Volcanoes, and the History of Its Missions* (1876), *A Lady's Cruise in a French Man-of-War* (1882), *From the Hebrides to the Himalayas: A Sketch of Eighteen Months' Wanderings in Western Isles and Eastern Highlands* (1876), and *At Home in Fiji* (1881), Cumming's travels were anything but "mere pleasure-trips." Yet by emphasizing her generation's sense that they were the beneficiaries of a remarkable technological advance that facilitated travel throughout many parts of the world, her remarks capture quite accurately the appeal and intrigue of travel to many Victorians. Playfully deferential in her rhetorical role as "younger sister," Cumming clearly enjoyed the fact that rail travel had enabled women to inherit opportunities hitherto available primarily to men. Her class-laden references to leisure help to underscore the fact that for the Victorians, travel was all about the boundaries (between classes, sexes, and nations) that structured their experiences. The women who opted to write about their experiences abroad oriented their accounts around these boundaries as well. By showcasing their adventures overseas, sharing their ideas about foreign cultures, and cultivating their own authority and expertise, they helped to expand women's participation in the public sphere, in essence to redraw some of the discursive boundaries of their own culture.

However relative was Cumming's sense of the ease and rapidity of travel (she goes on in her essay to describe leaving England "one bleak November morning" and arriving in Calcutta "ere Christmas morning"), there can be no doubt that throughout the nineteenth century the wider world became

increasingly accessible to a broader spectrum of Victorians. The end of the French Revolution boosted commerce abroad, and evangelicalism fostered missionary activity throughout many portions of the world. Such forces, central features of British imperialism, acted in combination with the introduction of steam locomotion and railways in the nineteenth century to make it possible for many in the middle and upper classes to explore national regions and foreign cultures once perceived as remote. While some men and women contented themselves with explorations of the "hidden corners" of the United Kingdom, many others crossed the channel to Europe or journeyed overseas—exploring parts of Africa, the Middle East, North and South America, Asia, Australia, and New Zealand in their quest to get off the "beaten track." The arrival of the travel entrepreneur Thomas Cook on the scene—and the proliferation of travel guides such as the ubiquitous *Baedeker*—help to mark the birth of the travel and tourism industry.

Travel and tourism inevitably had particular ramifications for nineteenth-century women, associated as they were with an ideology of domesticity that linked them to the private sphere. As Paul Fussell has written, any travel book is "an implicit celebration of freedom."[2] Given this association, it is no surprise that the figure of the Victorian woman traveler would spark societal discussion and debate. Often described in contemporary accounts as "intrepid," a handful of women travelers became known as adventuresses, an identity attracting public attention precisely because it seemed so subversive of the domestic ideal. Mary Kingsley (who traveled in what she referred to as the "wildest and most dangerous part" of West Africa),[3] Isabella Bird Bishop (whose expeditions included parts of North America, North Africa, China, Japan, and the Middle East), Florence Dixie (author of *Across Patagonia*), and Cumming were among this select group, and each published lively accounts of their experiences that made much of the various dangers encountered in exotic, "untrodden" and "unexplored" lands. In "Letter 28" of her *Unbeaten Tracks in Japan* (1880), for example, Bishop provides her readers with this vivid account of being lashed to the pack-saddle as her team attempts to cross a stream during driving rains:

The great stream ... crashed and thundered, drowning the feeble sound of human voices, the torrents from the heavens hissed through the forest, trees and logs came crashing down the hillsides, a thousand cascades added to the din, and in the bewilderment produced by such an unusual concatenation of sights and sounds we stumbled through the river, the men up to their shoulders, the horses up to their backs. Again and again we crossed. The banks being carried away, it was very hard to get either into or out of the water; the horses had to scramble or jump up places as high as their shoulders, all slippery and crumbling, and twice the men cut temps for them with axes. The rush of the torrent at the last crossing taxed the strength of both men and horses, and, as I was helpless from being tied on, I confess that I shut my eyes![4]

Such moments stand out for obvious reasons, but Kingsley, Bishop, Dixie, Cumming, and others packed their travel accounts with wide-ranging and detailed information on the demography, history, climate, landscape, flora, fauna, customs, sites, and cultural phenomena of foreign lands, and their works contributed to the expanding fields of geographic and ethnographic study, botany, and natural history, among others. As Kingsley stated simply at the beginning of a paper read at an 1896 meeting of the Geographical Society in Edinburgh, "My aim in visiting West Africa this time was to get together a general collection of fishes from a West African river north of the Congo, for the terrific current of this river makes a great impression on distribution."[5] The contributions made by women travelers to a range of scientific disciplines were ultimately as influential in helping to alter cultural attitudes about the proper role of women as were their vivid accounts of hardships and dangers encountered along the way.

However much they contributed to emerging fields of study, "female globe-trotters" were simultaneously celebrated for their achievements and scorned as anomalies. W. H. Davenport Adams concluded his 1883 study *Celebrated Women Travellers of the Nineteenth Century* with the observation that "delicately nurtured women now climb Mont Blanc or penetrate into the Norwegian forests, or cross the Pacific, or traverse sandy deserts, or visit remote isles, in company with their husbands and brothers, or 'unprotected.'"[6] Yet more celebratory was W. G. Blaikie, who concluded a *Blackwood's Magazine* essay on "Lady Travellers" in 1896 with the remark that "it goes without saying that our story reflects high credit on the courage, the perseverance, and the benevolence of the gentler sex; it is a record of which women may well be proud."[7] Their enthusiasm cannot be said to be representative, however. In 1893, after complaining in a letter to *The Times* that meetings of the Royal Geographic Society were "flooded with the feminine element," Member of Parliament George Curzon described the "genus" of the woman traveler as "one of the horrors of the later end of the nineteenth century."[8]

Alert to the mixed messages surrounding public reception of their experiences abroad, many women travel writers made overt efforts to assure their readerships of their essential femininity. After eliciting attention in *The Times* for apparently wearing "masculine habiliments" while riding horseback during her North American travels, Isabella Bird (she had not yet married John Bishop when she authored this work) prefaced the second edition of her *Lady's Life in the Rocky Mountains* with a note "for the benefit of other lady travelers" explaining that her riding dress included a jacket, a skirt "reaching to the ankles," and "full Turkish trousers gathered into frills falling over the boots." It was, she explained, in fact "a thoroughly serviceable and feminine costume for mountaineering and other rough travelling, as in the Alps or any other part of the world."[9] Moreover, as Dea Birkett reports in *Spinsters Abroad*,

"the women's fervent and frequent denials that they exhibited improper or challenging behaviour often broadened into active opposition to women's rights and suffrage," a stance that Birkett sensibly argues should be seen "in light of their attempts to gain social and later political respect and even power."[10]

Perhaps because the figure of the adventuress so commanded public attention in the nineteenth century, she has in some respects overshadowed the formidable population of women travelers who more quietly ventured abroad throughout the century recording their experiences of foreign lands (in works such as Elizabeth Eastlake's *A Residence on the Shores of the Baltic, Described in a Series of Letters* (1841), Isabella Trotter's *First Impressions of the New World* (1859), and Lady Mary Anne Barker's *A Year's Housekeeping in South Africa* (1877)). Although Annie Brassey took note of the various "alarms" that occurred during her cruises to Cyprus and Constantinople, many of the diary-like entries in her *Sunshine and Storm in the East* (1880) record the quotidian, as in this record of "Saturday, October 3rd": "The north coast of Africa was in sight the whole day. We saw turtles floating on the sea and basking in the sun, and some flying-fish came on board. Distance at noon, 137 miles. Latitude 37°, 40' W., longitude 6° 38' E. The wind continued to blow with considerable force from the westward, accompanied by a heavy side swell from the Gulf of Lyons (Fig. 2.1) ."[11] Brassey's diary-like entries and sedate style are representative of numerous travel accounts published in the period and suggest that there were readers aplenty eager to absorb un-embellished records of day-to-day life experienced while journeying abroad.

Many women travelers read widely about the lands and cultures they visited and supplemented their accounts of day-to-day life with more scholarly commentary on the countries they explored. They produced hybrid accounts of their journeys—books and essays in which diary-like entries documenting daily activity and personal impressions are juxtaposed with information gleaned from a wide range of sources. Those women travelers most interested in cultivating their own authority sought to compare their impressions and discoveries to those of established scholars. "My principal authorities have been Gibbon, von Hammer, Lamartine, Theophile Gautier, Gallenga, and Amicis, Meyer's 'Türkei und Griechenland,' a most valuable book, an article by H. E. Sir Henry Elliott on Abdul Aziz in the 'Nineteenth Century' and various Handbooks, English and German," wrote Frances Elliott in the ironically titled *Diary of an Idle Woman in Constantinople* (1893). Elliott's laundry list of names and titles is indicative of a deep desire for her "diary" to be treated like the serious scholarship it was.

Travel diaries and notebooks often became the basis for published accounts that served purposes at once educational and entertaining and that blurred the boundaries between the professional and the amateur. Not all such accounts

took the form of a travel book or guide. Popular, middle-class weekly and monthly magazines from the Victorian period are filled with articles about foreign life based on the author's travels abroad; editors and publishers alike were clearly anxious to satisfy the demands of the "arm-chair traveler" at home. "If people cannot visit strange places, they have at least the satisfaction of being able to read about them," wrote an essayist on "Recent Travellers" for *Fraser's Magazine* in 1849.[12] Women travelers both participated in and benefited from this burgeoning market. Indeed, in an address to readers of her book *Cities of the Past*, Frances Power Cobbe exemplifies well the way rhetorical style could be deployed in the service of those arm-chair travelers at home: "Will you follow me, reader, as I enter Cairo, and strive to convey the impressions of a ride through those dim, wonderful streets?" she wrote.[13]

Whether achieving renown for their adventures abroad, helping to add to coffers of new knowledge about foreign lands and cultures, or simply publishing accounts of an occasional journey, Victorian women who wrote about their experiences abroad left a rich record of their impressions of the world beyond England. Despite the enormous range and variety of this record, certain themes, techniques, and tropes recur so frequently in their writing as to merit attention. The special care that many women travel writers took to evoke the sensory and sensual qualities of the natural environment is especially noteworthy. "The rushing river was blood-red, Long's Peak was aflame, the glory of the glowing heaven was given back from earth," Isabella Bird exclaimed in *A Lady's Life in the Rocky Mountains*.[14] (Fig. 2.2) Writing of the "unsurpassed loveliness" of Rio de Janeiro in *Across Patagonia*, Florence Dixie evocatively described "the awful work of the volcano; the immense boulders of rock which lie piled up to the clouds in irregular masses," that to her eyes seemed "clothed in a brilliant web of tropical vegetation, spun from sunshine and mist."[15] And in *Untrodden Peaks and Unfrequented Valleys*, an account of her "Midsummer Ramble in the Dolomites," Amelia Edwards offers this poetic description of one scene:

Dark firs and larches, growing thicker and closer as the dell dips deeper, make a green gloom overhead. Ferns, mosses, and wild flowers grow in lush luxuriance all over the steep banks, and carpet every hollow. Gaunt peaks are seen now and then through openings in the boughs, as if suspended high up in the misty air. And ever the descending path winds in and out among huge boulders covered with bushes and many-coloured lichens.[16]

In different ways, each of these women—and many others like them—sought to capture nature's beauty in their texts, and their descriptions manifest what in *Kindred Nature* Barbara Gates calls a "female sublime," an aesthetic that "emphasized not power *over* nature but the power *of* nature in a given place."[17]

If spectacular scenery seemed to demand that women travel writers make the most of their descriptive arsenal, other dimensions of the experience abroad elicited quite different rhetorical tools. Particularly evident in writing of the period are two related tropes, both of which have imperialist overtones: the traveler's encounter with that which cannot be described and the encounter with that which has not yet been described. More than a few women stressed the thrill of going where no Englishwoman had gone before. In the 1883 book *Winter Studies and Summer Rambles in Canada*, Anna Jameson describes herself as "thrown into scenes and regions hitherto undescribed by any traveller, (for the northern shores of Lake Huron are almost new ground,) and into relations with the Indian tribes, such as few European women of refined and civilised habits have ever risked, and none have ever recorded."[18] In a similarly effusive manner, Dixie gushed at the beginning of *Across Patagonia* that "Scenes of infinite beauty and grandeur might be lying hidden in the silent solitude of the mountains which lie beyond the barren plains of the Pampas, into whose mysterious recesses no one as yet had ever ventured. And I was to be the first to behold them!"[19] The sexual rhetoric Dixie in particular deploys to represent her desire "to penetrate into vast wilds, virgin as yet to the foot of man" exposes especially well the capacity of some women's travel writing to co-opt a masculine rhetoric of conquest (more typically associated with imperialist writing) in order to challenge nineteenth-century assumptions about women's essential nature and bodily fragility.[20] Women travelers, such as Florence Dixie, would have found echoes of their own language in writings about them; in *Celebrated Women Travellers of the Nineteenth Century*, W.H. Davenport Adams bestowed lavish praise on the women who "penetrate into regions hitherto untrodden by civilized man and add new lands to the maps of the geographer."[21]

Assumptions about "civilized" man and woman and a rhetoric of mapping are not the only way that Victorian women's travel writing reveals its connections to British imperialism and imperialist attitudes. References to "throngs of natives" and "savages," and discussions of the "primitive," "simple," and "unchanged" qualities of those encountered abroad can be found in travel accounts throughout the period. "I believe that the physique and life of the modern Fellah is almost identical with the physique and life of that ancient Egyptian labourer whom we know well in the wall-paintings of the tomb," wrote Edwards in the preface to *A Thousand Miles Up the Nile*.[22] Describing Africa as a "country of raw material," Mary Gaunt proclaimed at the end of *Alone in West Africa* (1911) that "it should be England's duty so to work that country that it be complementary to England, the great manufacturing land."[23] Britain's colonial presence is pointed to relatively uncritically in the many references to dining at English embassies, visiting English churches, and waiting for the English mail, which occur in the pages

of much travel writing from the period. In "A Lady's Railway Journey in India," Cumming nostalgically writes of hearing "the old familiar anthems chanted in a cathedral" in Calcutta, "where wide open windows and swinging punkahs told of a climate very different from that which we are wont to associate with Christmastide."[24] Adopting an ethnographic rhetoric and stance is yet another way that some travel writing reveals its colonial context. Many women travelers sought to immerse themselves in the cultures they explored, and they constructed themselves as "participant–observers" of these cultures. "I have eaten many odd things with odd people in queer places, dined in a respectable Nubian family (the castor-oil was trying), been to a Nubian wedding—such a dance I saw," Lucie Duff Gordon wrote in her *Letters from Egypt*.[25] As Bishop wrote in *Unbeaten Tracks in Japan*, "It is extremely interesting to live in a private house and to see the externalities, at least, of domestic life in a Japanese middle-class home."[26] Not all women travel writers maintained the air of detached objectivity that this particular comment of Bishop suggests. In *Travels in West Africa*, Kingsley makes the following comment:

As it is with the forest, so it is with the minds of the natives. Unless you live alone among the natives, you never get to know them; if you do this you gradually get a light into the true state of their mind-forest. At first you see nothing but confused stupidity and crime; but when you get to see—well! as in the other forest,—you see things worth seeing.[27]

While it would be a mistake to minimize the significance of the association of women's travel writing with the imperial activity that often surrounded—and in some cases supported—it, it would be as wrong to oversimplify that writing by viewing it as a transparent reflection of imperialism at work. Many recent scholars of colonial history have sought to move beyond models of domination and subordination to incorporate more focused analyses of the political and economic complexities of particular locations at any given historical moment.[28] In *Place Matters*, for example, Susan Morgan acknowledges "the impossibility of drawing clear boundaries not only between colonizer and colonized but between imperial and colonial," in part because of "the variety of kinds of British presences and/or forms of British territorial control, the sheer range of imperial meanings being constructed in the region, along with the instability of those meanings and the ongoing public debate concerning them."[29]

Variations in the personalities and beliefs of Victorian women travel writers, to say nothing of their very different motivations for traveling (that is, some for health, others for escape, some as missionaries, and still others for vocation) acting in combination with the crucial differences in the locales about which they wrote, seem to have ensured extraordinary range and variety in this writing.

This range is evident in a record both textual and visual, for many women documented their encounters with sketches, drawings, paintings, and, later in the century, photographs. Some of these became the basis for engravings and woodcut illustrations that supplemented their published travel books and others stood singularly and spectacularly on their own (one thinks, for instance, of Marianne North's botanical paintings and of Julia Margaret Cameron's photographs of Indian subjects). In watercolor paintings such as Lady Charlotte Canning's *Two Views of Alexandria* (1855), oil paintings such as Frances Anne Hopkins's *Shooting the Rapids*, pencil sketches such as Barbara Leigh Smith Bodichon's drawings of Segovia, and sepia ink works such as Margaret Oldfield's *Mountain Landscape, Nepal* (1857), Victorian women artists who traveled produced an extraordinary array of works to document and interpret their discoveries of the world for audiences at home. After North's paintings were exhibited in 1882, a local newspaper gleefully reported that she "went into sunny countries, painted blue sky and light, and brought it home to the poor people of London, who never saw it, and did not know what it was like."[30]

Far from being mutually exclusive techniques, the textual and visual are alike crucial to the experience of the Victorian woman who traveled and are interwoven in women's travel writing from the period. Victorian women travel writers made abundant use of the verbal "sketch" to impart information, as titles of works such as Jameson's *Visits and Sketches Abroad and at Home* indicate. Kingsley's comment in *Travels in West Africa* typifies the woman traveler's use of a rhetoric of sketching.[31] Beginning a section on Calabar, she wrote:

I have always been fascinated with the island, on account of its intense beauty and the high ethnological interest of its native inhabitants, and I have had during my previous voyage, and while staying in Cameroon, rather exceptional opportunities of studying both these subjects. I will therefore sketch the result of my observations here.[32]

Perhaps more significantly, the "sketches" offered by many travel writers deployed perspective, horizon, distance, color, and shade in ways designed to evoke visual images of their subjects and to control the gaze of their readers. Consider, for example, this description of the village of Caprile rendered by Edwards in *Untrodden Peaks and Unfrequented Valleys*:

The view from here is fine, considering at what a moderate elevation we stand. The Civita rises before us, grandly displayed; five valleys open away beneath our feet; and the slated roofs of Caprile and Rocca glisten in the morning sunshine hundreds of feet below. A greenish-blue corner of the lake gleams just beyond the last curve of the Val d'Alleghe; while between that point and this, there extend, distance beyond distance, the fir-woods, the pastures, and the young corn-slopes of Monte Pezza.[33]

Edwards explicitly addresses the interconnectedness of the verbal and textual in numerous ways in her work. In her preface to the book, she laments her

supposed descriptive limitations (writing, "Why had I not Mr. Ruskin's power to create landscapes with words?") and proclaims, "could I have dipped my brush, TILTON, like you, in the rose and gold of Southern sunsets, what sketches mine would have been, and how nobly this book would have been illustrated!"[34] Later in the narrative she reintroduces her readers to the subject by exclaiming: "The Dolomites! It was full fifteen years since I had first seen sketches of them by a great artist not long since passed away, and their strange outlines and still stranger colouring had haunted me ever since."[35] She also calls explicit attention to how artists would render the various scenes she attempts verbally to describe, as when she writes of the view from Lago di Serravalle:

Two tiny white houses with green jalousies and open Italian balconies at the head of the lake, a toy church on a grassy knoll, and a square mediaeval watchtower clinging to a ridge of rock above, make up the details of a picture so serene and perfect that even Turner at his sunniest period could scarcely have idealized it.[36]

The descriptive techniques that Edwards and many others like her brought to their representations of the wider world helped to make more integral to their texts the physical illustrations that accompanied them. These illustrations took many forms. They often included maps, for example, many of which would highlight the author's route (Fig. 2.3). Edwards's *Untrodden Peaks* includes nine full-page illustrations of such sites as "Titian's Birthplace" and "The Rosengarten, From Botzen" (based on her own sketches) as well as numerous smaller illustrations. Illustrations were clearly part of the appeal of travel books to armchair travelers at home, and savvy publishers marketed their holdings with title-page reference to the illustrations. *Across Patagonia*, for instance, was published "By Lady Florence Dixie, with Illustrations from Sketches by Julius Beerbohm, Engraved by Whymper and Pearson." The title page of Brassey's *Sunshine and Storm in the East* noted the "upwards of 100 illustrations, Chiefly from Drawings by the Hon. A.Y. Bingham" to which readers could look forward. Similarly, *A Thousand Miles Up the Nile* was published "By Amelia B. Edwards ... With Upwards of Seventy Illustrations Engraved on Wood by G. Pearson, After Finished Drawings Executed On the Spot by the Author." (Fig. 2.4) Edwards devoted substantial space in the "Preface to the First Edition" to honoring the work of the engraver; "no one so fully as myself can appreciate how much the subjects owe to the delicacy of his pencil, and to the artistic feelings with which he has interpreted the original drawings," she wrote.[37] And Bishop helped to broadcast the appeal of her travel books by stressing her role in the process of preparing illustrations. The preface to *Unbeaten Tracks in Japan* notes that "the illustrations, with the exception of three, which are by a Japanese artist, have been engraved from sketches of my own or Japanese photographs."[38] Bishop illustrated almost all of her works with engravings based on her own sketches and, in her later

works, with photographs that, Marion Tinling reports, were "taken on the spot and developed by dipping the film in a river using the night as her darkroom."[39]

The dual images of Bishop taking photographs "on the spot" and developing them in a makeshift darkroom beside a river convey something of the urgency and earnestness that Victorian women travel writers brought to their quest to document and authenticate their experiences abroad. If art was, in part, a traditional feminine accomplishment, using that art to record and present the new experiences and new subject matter made possible through travel was undeniably empowering. The illustration of travel, working as it did to reinforce the verbal rhetoric of sketching so carefully deployed by travel writers, may well have served concrete marketing purposes and facilitated the circulation of travel books within the reading public at home, but its function was not simply pragmatic. Venturing beyond borders at once geographic and ideological, Victorian women travelers yoked the powers of verbal and visual representation to display the wonders of their journeys. If in doing so they provided entertainment and education for a nation of arm chair travelers at home, they clearly reaped more important, if intangible, rewards for their efforts. For most of these women, a sense of personal accomplishment must have been considerable. When Dixie contemplated her "wild life in Patagonia," she itemized "many a discomfort—the earthquake, the drenching rains, the scorching sun, the pitiless mosquitoes, and the terrible blasting winds," and then concluded "it was a very happy time, and a time on whose like I would gladly look again."[40] Yet whatever they managed to experience individually, Victorian women travelers also quite clearly helped, collectively, to broaden societal assumptions about a woman's areas of competency and the kinds of experiences that should, consequently, be available to her.

Notes

1. Constance Gordon Cumming, "A Lady's Railway Journey in India," *Macmillan's Magazine* 49 (May 1884): 301.

2. Paul Fussell, *Abroad: Literary Traveling Between the Wars*, (New York: Oxford University Press, 1980), 203.

3. Mary Kingsley, *Travels in West Africa. Congo Francais, Corisco and Cameroons*, 1897, repr. (Boston: Beacon Press, 1995), 103.

4. Isabella L. Bird, *Unbeaten Tracks in Japan*. 1880, repr. (Boston: Beacon Press, 1984), 195.

5. Mary Kingsley, "Travels on the Western Coast of Equatorial Africa," *The Scottish Geographical Magazine* (1896): 113.

6. W. H. Davenport Adams, *Celebrated Women Travellers of the Nineteenth Century* (London: W. Swan Sonnenschein & Co., 1883), 383.

7. W. G. Blaikie, "Lady Travellers," *Blackwood's Magazine* (July 1896): 66.

8. George Curzon, "Ladies and the Royal Geographic Society," letter to the editor of *The Times* (31 May 1893): 269.

9. Isabella L. Bird, *A Lady's Life in the Rocky Mountains*, 1879. Repr. (London: Virago Press, 1986), ix.

10. Dea Birkett, *Spinsters Abroad: Victorian Lady Explorers* (Oxford: Basil Blackwell, 1989), 199, 202.

11. Annie Brassey, *Sunshine and Storm in the East, or Cruises to Cyprus and Constantinople* (New York: H. Holt, 1880), 27.

12. "Recent Travellers," *Fraser's Magazine for Town and Country* (September 1849): 245.

13. Frances Power Cobbe, *Cities of the Past* (London: Trubner and Co., 1864), 55.

14. Bird, *A Lady's Life in the Rocky Mountains*, 94.

15. Florence Dixie, *Across Patagonia* (London: Richard Bentley and Son, 1880), 27.

16. Amelia B. Edwards, *Untrodden Peaks and Unfrequented Valleys: A Midsummer Ramble in the Dolomites*, 1873. Repr. (Boston: Beacon Press, 1987), 147.

17. Barbara T. Gates, *Kindred Nature: Victorian and Edwardian Women Embrace the Living World* (Chicago: University of Chicago Press, 1998), 170.

18. Anna Jameson, *Winter Studies and Summer Rambles in Canada* (London: Saunders and Otley, 1838), vi.

19. Dixie, *Across Patagonia*, 3.

20. For an astute analysis of the language of sexual domination and economic conquest in travel discourse and its limited applicability to women's travel writing, see Chapter 1 of Susan Morgan's *Place Matters: Gendered Geography in Victorian Women's Travel Books about Southeast Asia* (Brunswick, N.J.: Rutgers University Press, 1996), 1–30.

21. Davenport Adams, *Celebrated Women Travellers*, 12.

22. Amelia Edwards, *A Thousand Miles Up the Nile*, 2nd edn. (London: Routledge, 1889), xii.

23. Mary Gaunt, *Alone in West Africa* (London: T. Werner Laurie, 1911), 897.

24. Constance Gordon Cumming, "A Lady's Railway Journey in India," *Macmillan's Magazine*: 301.

25. Lucie Duff Gordon, *Letters from Egypt: To Which are Added Letters from the Cape* (London: Macmillan, 1876), 38.

26. Bird Bishop, *Unbeaten Tracks in Japan*, 57.

27. Kingsley, *Travels in West Africa*, 103.

28. As Steve Clark has written, "Narratives of encounter are undeniably dominated by the viewpoint of the mobile culture, yet it is possible to exaggerate the degree of superiority implied." Steve Clark, *Introduction to Travel Writing and Empire: Postcolonial Theory in Transit*, ed. Steve Clark (New York: Zed Books, 1999): 5.

29. Morgan, *Place Matters*, 8.

30. Quoted by Dea Birkett in "A Victorian Painter of Exotic Flora," *The New York Times* (22 November 1992): 30.

31. In an article titled "The Power of the English Nineteenth-Century Visual and Verbal Sketch: Appropriation, Discipline, Mastery," Richard Sha argues that the sketch reveals the desire to appropriate is basic to the colonial encounter. The article appears in *Nineteenth-Century Contexts* 24, 1 (March 2002), 73–100.

32. Kingsley, *Travels in West Africa*, 42.

33. Edwards, *Untrodden Peaks and Unfrequented Valleys*, 185.

34. Ibid, xxxvi–xxxvii.

35. Ibid, 2.

36. Ibid, 23.

37. Edwards, *A Thousand Miles Up the Nile*, xii.

38. Bird Bishop, *Unbeaten Tracks in Japan*, 3.

39. Marion Tinling, *Women into the Unknown: A Sourcebook on Women Explorers and Travelers* (Westport, Conn.: Greenwood Press, 1989), 47.

40. Dixie, *Across Patagonia*, 250–51.

"We Got Upon Our Elephant & Went Out After Subjects": capturing the world in watercolor

Jordana Pomeroy

Victorian women who traveled abroad encountered experiences they would have never imagined back home in their English parlors. The copious watercolor sketches and writings they produced during their travels reflect an immediacy that comes with new daily life experiences and unanticipated adventures. Most who went abroad came from the upper classes, and many were amateur artists—although amateurs with strong artistic training and interest in their new surroundings. Unlike oil painting or photography, both of which required cumbersome equipment, watercolor was a versatile tool for recording and communicating the changes in these women's lives.

From the early nineteenth century, watercolor and British artistic identity were inextricably intertwined. Throughout that century, watercolor's greatest practitioners were the British who refined the technique of painting layers of transparent washes that permitted light to reflect from the surface of the paper. They developed specialized papers and ready-made cakes of water-color for the purpose. Whereas topographers dominated the field in the late eighteenth century, by the mid-nineteenth century watercolor served a broader purpose. A stepchild to oil painting, watercolor nevertheless gained so many adherents as to warrant the founding in 1804 of the Society of Painters in Water-Colours. The evolution of watercolor in Britain presents close parallels to the advancing status of British women artists who were taught watercolor as a less serious medium for "lovely countrywomen"[1] but ended up contributing significantly to its respectability as a medium for serious artists.

Watercolor pigments and brushes were lightweight and portable, and, in general, papers were physically smaller than canvases. The ease of using this medium enabled artists to capture fleeting images of people, places, flora, and fauna. The transparency and luminosity of the medium particularly lent itself to the depiction of landscapes—subject matter in which women received

tutoring and which they pursued extensively. From the mid-eighteenth century, artists published instruction manuals on drawing and watercolor that were used widely by women who sometimes had formalized basic instruction, and with these manuals could continue to experiment and improve on their own. Like a cottage industry, watercolor allowed women to be productive at home—although the results of their efforts were not usually meant for the art market. For women whose homes were temporarily abroad, watercolor images served as tools that enabled them to come to terms with their surroundings and ultimately to communicate this knowledge back home to people in Britain.

For Victorian women who lived within closely proscribed cultural and social constraints at home, travel abroad provided new situations daily that stretched their identities as women. While this may have been "liberating" and a "release to experience enjoyment and to enrich themselves spiritually and mentally," the physical discomforts and fear women felt while navigating unfamiliar territory and uncharted cultural waters were considerable.[2] From 1837 to 1838 Frances H. (Fanny) Eden (1801–1849) along with her sister Emily accompanied her brother, George, first Lord Auckland, Governor General of India from 1835–42, through India, where she produced four sketch albums. She wrote to her friend Eleanor Grosvenor in England, earnestly asking "do you think [I] shall get safely back again? I have my doubts because the wild beasts in this country are real wild beasts, who will not listen to reason."[3] Eden vividly conveys the feeling of living in a tent as part of a caravan on a rainy day with the "roof wet above & the floor wet below, the servants wet & miserable, the camels slipping & falling with their loads, the carts sticking in the mud with them."[4] Far from shying away from potential obstacles, Eden seems to have accepted the physical challenges of living in India as rich fodder for drawing. She describes setting off with an elephant and guide one afternoon to get to the top of a rock but "the path was so steep ... neither elephants nor bearers could get on, so I continued to walk up the rest of the road, taking a large escort with me for fear of a strong tiger & the view was beautiful (see my large sketch book)." Even her blunt assessment of a deity sculpture as "horrid" did not deter her from wanting to sit down on the stoop of the temple to draw the object, perhaps as a way of illustrating the "primitiveness" of the native art forms or religion.[5] Considered together, her animated and colorful watercolors and written descriptions present a balanced record of Eden's life in India and illuminate the strength and perseverance of women travelers.

If the physical dangers of abroad were often life threatening, it also took a toll on one's mental state. During their travels, women artists often found themselves in situations where they felt alone and bored, far from family, friends, and familiar sights. Eden, for instance, complained of her boredom with the limited social scene in Calcutta, and Charlotte Canning (1817–61)

wrote that "my personal life is absolutely uneventful. Putting dimity in a drawing-room, or a new mat, is about the principal event I can look forward to."[6] Canning had moved to Calcutta with her husband, Charles Canning, who was appointed to the post of governor-general of India in 1856. While there she produced albums full of watercolor sketches depicting her new interior and exterior surroundings. Her depiction of her sitting room at Government House in Barrackpore (Fig. 3.1) reaches beyond mere documentation. Bright green shutters barely keep out the overwhelming Indian sunlight that suffuses the room, highlighting the numerous overstuffed chairs arranged in strategic groupings. Canning's personal space seems to be confined to the far right where she has depicted a large wood desk, bookshelves, and a small easel nestled quietly between two oversized European portraits. In this small watercolor, we may see the dichotomy of the future vicereine's existence abroad as her public persona and duties overwhelmed her private life and pastimes, including sketching and writing. Anna Brownell Jameson (1794–1860), who would later gain renown as an art historian and pioneer for women's rights, described her dismal first view of Toronto after stepping off the boat in 1836 onto an empty wharf where she promptly sank ankle-deep into mud and ice. Jameson describes herself walking "half blinded by the sleet driven into my face, and the tears which filled my eyes" and feeling as "sad at heart as a woman could be." Jameson never gained much affection for her new home although her sketches of local life including winter sports, winter attire, as well as Indian culture and traditions suggest that she was fascinated by the novelty of her surroundings.[7] The challenging circumstances these women and others like them frequently faced while abroad encouraged the growth of watercolor from that of a pastime to a serious medium for documenting one's life and observations.

Sketching her surroundings quickly in watercolor allowed Jameson, and other women like her, to set in motion the cognitive process of "I was here," "I encountered this," and "this is how I can best convey this unfamiliar experience to you." Although photography since the 1850s had been used extensively on expeditions (in 1879 Isabella Lucy Bird published her photographs of the Rocky Mountains and the Countess of Aberdeen published her illustrated travel journal *Through Canada with a Kodak* in 1893), hauling around all the necessary equipment, let alone developing the photographs, was a daunting prospect for a woman. Elizabeth Thompson, Lady Butler commented that "snapshots [are] of little value, but quick sketches done unbeknown to the sketchee and a good memory serve much better," referring both to the lack of spontaneity involved in taking a photograph and the superior position of the watercolor as an ideal method for immediate documentation.[8]

Many women produced prodigious numbers of watercolors that they pasted in albums with written descriptions to ship to family and friends, thus

creating the nineteenth-century equivalent of the photo album. Because the artist herself would not be present to show these watercolors to her audience, it was of utmost importance that they were clearly rendered with lucid descriptions. Fanny Eden worried about the impact of the materials she sent to her friend Mrs. Grosvenor, writing: "I wish I knew, dear, whether my last … journal bored you very much … & whether strong qualm of bone will come over you, at the sight of another, & whether you will not wish that India had never been born [as] it is to be crammed down your throat in such a detailed way."[9] It is difficult to imagine that Mrs. Grosvenor would have responded with anything less than great enthusiasm to Eden's watercolors executed on a tiger-shooting expedition in the Rajmahal Hills or her visit to Maharaja Ranjit Singh for, like her written text, Eden's vivid watercolors of elephant caravans, tiger hunts, and rajahs in gold dress and turbans, enabled her to capture a different world unfathomable to most women in Great Britain.

Frances Anne Hopkins (1838–1919), who arrived in Lachine, Quebec, Canada in 1858 as the wife of Edward Martin Hopkins, an employee of the Hudson's Bay Company, made sketches as quickly and frequently as one might take photographs today.[10] She produced carefully dated pencil drawings of the unfamiliar landscape and the boating activity on the St. Lawrence River, which she later used as source material for painting watercolors and, still later, oils. Hopkins recorded ice floes, canoes, rafts, the town, her house, Indian encampments, tobogganing, and skating.[11] No activity was too minor for Hopkins's watercolor brush and pencil. She also took the unusual step of including herself in one drawing of a canoe outing (a practice she would repeat throughout her later canoe paintings), thus recording her own participation in her new life as a temporary resident of this harsh British outpost. As a granddaughter of painter Sir William Beechey, and daughter of Rear-Admiral Frederick William Beechey, who traveled to the Arctic and illustrated his explorations, Hopkins grew up possessing more serious art training and probably a greater knowledge of the world beyond Great Britain than most other women who traveled. In 1869 Hopkins showed her work for the first time at the Royal Academy with her oil painting *Canoes in the Fog, Lake Superior* followed by *Canoe Manned by Voyageurs Passing a Waterfall* the following year.[12] (Fig. 3.2) Describing this painting of canoeing through the backwoods of Canada, one reviewer wrote "here the scene and the incident are beautiful in themselves—things that would be welcome and delightful in fact no less than on the canvas—and Mr. Hopkins shows a sufficient skill to retain and interpret the loveliness he has found."[13] With *Canoe Manned by Voyageurs*, Hopkins tackled a theme that was exclusively the preserve of male artists (as is evidenced by the reviewer's assumption that Hopkins was a "Mr.") but gave it a twist by placing herself prominently in the center of the canvas and challenging any disbelief that women could be

physically active outdoors and that she could have participated in such an adventure.

As a landscape that is neither savage nor serene, peopled by métis (those who claim mixed Native American and non-native heritage), *Canoe Manned by Voyageurs* fits squarely within the parameters of the picturesque. According to Ann Bermingham, by the mid-nineteenth century, composing landscapes according to the rules of picturesque beauty had become clichéd and hackneyed but still many artists were deeply enmeshed in the picturesque ideal.[14] Perhaps because of the ubiquity of drawing manuals offering formulae for the depiction of picturesque elements, the watercolors of landscapes that women produced followed these principles long after they had all but disappeared from oil painting. These manuals encouraged readers to study works by seventeenth-century painters—above all Claude and Salvator Rosa—and to search for the unusual, the irregular, and the decorative in landscape and architectural elements, advice that Hopkins followed in composing her paintings. Rough and irregular rocky cliffs and walls, churning whitewater rapids, and unusual textured trees dominate the landscape, creating an inspired framework for the primary subject matter.

Women traveling abroad often exhibited a raw fascination with the subject matter, especially the customs and clothing of other cultures, which they recorded in their watercolors; however, it was always framed within the language of the picturesque. In her daily life, Charlotte Inglefield (d. 1901), for example, also sketched in detail people she encountered during her extensive travels throughout the Levant.[15] She most likely placed her vivid depictions of a Jewish girl, a Moorish woman, a fez maker, and other Tunisians in a sketchbook to be reminisced about and shown about when she returned to England. The artist seems to relish the opportunity to depict the visual richness of the clothing and North African surroundings. Sketched against a gray-wash background, a young Tunisian woman displays her finery, including a large gold necklace. Inglefield has casually written an inscription at the bottom of the watercolor, "Jewish Girl in Full Costume," no doubt to jog her memory when looking through the copious sketches she produced abroad. (Fig. 3.3) Yet Inglefield's depictions of Tunisians fit well within the requirements of the picturesque: they would have satisfied the Victorians' cravings for images of the Empire while not uncomfortably challenging their beliefs in British imperialism and its place in the world.

Inglefield's portrayals visually animate the habitudes of native peoples without hinting at any degree of personal involvement with them; her watercolors convey a sense of distance between the artist and her visually captivating subjects. Traveling women, in fact, generally did not assimilate into the cultures they described so meticulously with their pencils, brushes, and ink. Female Lawrences of Arabia donning caftans and speaking native

tongues were few and far between.[16] Instead of soaking in the culture in the midst of which these women lived, the images they produced—from landscapes to portraits—suggest an unbridgeable chasm between the viewer and the object viewed.[17] Their written observations, although also picturesque, confirm this sense of distance. Canning observed the Indian women engaged in "sewing, dibbling, weeding" who were all "very wretched looking creatures but with 3 great silver ornamented toe rings on each foot, enormous amulets as if to hold prison chains and broad silver bangles hang[ing] from the wrist almost to the elbow." Fanny Eden similarly described the "order of [her] world" in which her brother and she each had "a double set of tents" while "all the inferior servants sleep under trees and make themselves little straw huts."[18] Employing acute sensory detail, women artists conveyed to the armchair traveler the extraordinary differences between life at home and life in the outer reaches of the British Empire.

A series of articles from 1862, which appeared in the *Leisure Hour,* bring to life this cultural chasm. Describing an expedition through Burma, the female author recounts daily life in a country that the British had conquered only ten years before.[19] She records a particularly revealing encounter with some Burmese women: "On the way back to the boat," she recalled, "I was curiously examined by an old woman, for whose edification I pulled off my gloves; they were a great puzzle to her. Seven or eight women … came to look at me, and one, after asking innumerable questions … asked … whether I ate rice."[20] Even one of the most basic Western signs of gender—a dress—confounded a group of Burmese monks. The journalist seeks not to disparage nor criticize but to emphasize the cultural chasm that lay between herself and the Burmese. Emily Eden's individualized portraits provide a visual comparison to the journalist in Burma. Her portrayals of royalty that were published as a book in 1844 called *Princes and People of India* neither condescend nor do they suggest an equality. Eden's unusual opportunity to draw some of the most politically powerful Indian men through the connections of her brother, Lord Auckland, manifested itself as a series of watercolors that echo depictions of zoological specimens. Eden meticulously describes in words and pictures each sitter and his entourage as if depicting a glorious peacock in its natural habitat. Although Romita Ray suggests that Eden's sitters were portrayed in a style that was never used for British monarchy, Eden's subjects nevertheless convey a regal bearing that would not have been lost on the class-conscious English.[21] For example, Shere Singh, ruler of the Punjab, and a man whose power and reputation pervaded India, gave Eden a personal sitting for making his portrait. (Fig. 1.2) The richly bejeweled maharaja sits cross-legged on a throne surrounded by his male retinue. A large scabbard falls from his left hip while he gazes into the distance, a pose that connotes a sense of solidity and prowess. Similarly, Eden portrayed the Raja of Puttiala astride an elephant

leading a military entourage. The Raja's posture is as straight as the arrow and gun that frame the image, drawing a comparison between him and these instruments of military might. Eden's watercolors of India's royalty and people captured the fascination of a British audience by appealing to a culture with its own monarchy while appearing exotic in dress, rituals, and physical appearance.

Categorizing people, animals, and plants played a large part in the overall British imperialist scheme. With an English readership hungry for visions of their empire's riches, British publishers eagerly printed books that illustrated the fruits of colonial labors. John Gould, whose seven-volume *Birds of Australia* (1840–48) was the first endeavor to catalogue Australia's magnificent birds, depended on his wife Elizabeth's (1804–1841) meticulous ornithological illustrations, which were translated into the new technology of color lithography.[22] Although the work served a scientific purpose (John Gould had worked as a taxidermist at the Zoological Society of London), Elizabeth Gould was evidently as concerned with aesthetic presentation as she was with the scientific aspects of her subject matter. *Swift Lorikeet* springs off the page with its luminous shimmering colors. (Fig. 3.4) Perfectly balanced in a backward "S" formation, the two birds along with the surrounding foliage create a composition that may have made the multivolume study as appealing to the layman as to the professional. Elizabeth Gould formed part of a long tradition of women botanical and zoological illustrators. The traditional connection between women and flower painting—and to a lesser extent, zoological painting—gave women a field of dominance and authority that was well established by the mid-nineteenth century. By that time botanical art was especially a gendered art and well established as a feminine accomplishment.[23] Women could apply specific techniques and methods of observation that they had learned in England to catalogue plant life abroad.

The serious and intense nature of their inquiry had long-lasting repercussions for the future of women in the sciences. Although these women considered themselves amateur artists and naturalists, the recognition some of them achieved for their efforts by men in leading scientific positions and societies helped lay the groundwork for them as professional scientists themselves. Marianne North, for example, claimed Charles Darwin as her friend and became a virtual shadow member of the Linnaean Society, which did not admit women until 1905.[24] Women made an intellectual contribution to botanical sciences through their collecting, depicting, and identifying of plant specimens, requiring perseverance and physical stamina. In the farthest reaches of the Empire, women had to contend with much greater threats than glares and taunts from those unused to seeing women alone outdoors sketching and painting. In 1883 North wrote to the president of the Linnaean Society:

I am sending you the above sketch of myself in the Seychelles. I feel that you will better enter into the delight of the situation. How I got up and how I got down is still a mystery to me—but I know that if a cramp had seized me, you would have seen little more of your friend, for the boulder went sheer down some 30 feet or more on all sides![25]

North recounted her scrambling up to a valley of coco-de-mer palms cutting through roots and plants. She made her way partially by sitting down and sliding over slippery rocks, then dropping

"into foot-holes cut for me on palm-branches or anything else that came handy. In those forests there were so many thorns on the tree-stems that one had little power of holding on by one's hands, and it was not easy matter getting down an almost perpendicular bit of forest-covered hillside.[26]

North's claim successfully conveyed the crucial difference between locating and actually reaching one's subject matter abroad. Lady Canning also collected and painted the natural surroundings with equally serious intent. She wrote about walking a "hard & very steep" road while gathering specimens of ferns that the keeper of the botanical gardens in Calcutta would help her identify.[27] These she would send back to England carefully assembled in books, which she hoped did not arrive in England "mouldy & full of insects."[28] She was also partial to riding elephants to forage for specimens, reporting that "nothing can answer better than an elephant for going about to see the flowering trees; one looks well into the branches & can go close up to them & gather the flowers in the most charming way."[29] A photograph of Canning seated on elephant-back in the company of a driver and an attendant perhaps provided the proof she needed for those back in Britain that indeed she was not exaggerating her claims (Fig. 3.5). John Ruskin admired Canning's subtle use of color, but Canning herself recorded her frequent consultations with the keeper of Calcutta's botanical gardens, suggesting that her primary goal was to achieve a high level of scientific inquiry.

Canning used a muted palette appropriate for the specimens she collected and for her personal mission to depict the flora of India. Her watercolor depictions of cloves, nutmeg, tea, and coffee from a spice garden in Conoor Ghat (a hill station) accurately demonstrates the branch, leaves, and fruit of each with a cutaway of the nutmeg to reveal its interior of mace. It appears the artist went to great lengths to reach her subject matter. (A brief inscription in the work's upper left corner locates the spice garden one thousand feet above the plains). Canning employs an equally subtle palette in her watercolor *Jathropha coccinea*, a shrub she obtained in Barrackpore, about which she offers no written information but a rendering useful to any naturalist for its great detail. In contrast to Canning's restrained depictions, the watercolors produced by Olivia Fanny Tonge (1858–1949) are a riot of rich color and lively, chatty text. Tonge's father, a naturalist and painter, served in the Royal Navy

and sailed on an exploratory journey to Australia in 1837–43, where he executed many watercolors to illustrate Captain John Lort Stokes's book *Discovery in Australia*. Like Frances Anne Hopkins, it is likely that Tonge learned to paint and was drawn to travel because of her father. She worked as a writer and illustrator with the Reverend John George Wood. Wood had popularized science through the nineteenth-century equivalent of a slide lecture that he called "sketch lecturing," which entailed illustrating the subject of his lecture with color pastilles on a blackboard or in crayon on a large sheet of white paper. Tonge seems to have adopted Wood's bold palette, his anti-intellectual approach toward the teaching of natural history, and his religious conservatism. She undertook an extensive trip solo to India at age fifty, when most women would have contented themselves with depicting nature found in their own gardens and partaking of the burgeoning armchair travel culture. The preface to Tonge's sketchbooks provides a clue to her strength of conviction that she should undertake this journey to study and draw the indigenous fauna of the Southeast Asian continent:

And it came to pass, that a certain Grandmother, when that she had come to nigh on two score years and ten; and had gotten long in the tooth, spake to herself thus.—Lo, will I now paint. And she took much gold, yea much fine gold, and got her a book, and in the book, so that all men might see, painted she all the things that crawled upon the face of the earth, and all things seemly, lo, that flew in the air, and all the things that swam in the waters that are under the earth … and verily no man mote stop her.[30]

While acknowledging the humor in the idea of an aging grandmother, let alone a widow, attempting such an ambitious project, Tonge nevertheless conveys a seriousness of purpose—drawing her inspiration directly from the Bible—to make the fauna of a distant land accessible to the non-scientific community. Tonge's reference to taking gold evokes Psalm 19 in which "the heavens declare the glory of God, and the firmament proclaims his handiwork. The ordinances of the Lord are true, all of them just; they are more precious than gold, than a heap of purest gold." Tonge likely knew the popular psalm in which God's glory is revealed in nature and biblical evocation. This provided a culturally comfortable backdrop to her meticulously rendered watercolors of unfamiliar creatures. Tonge inscribed each watercolor both with objective descriptions and personal observations (such as "a small specimen of a huge toad that comes out to feed after a shower of rain. He is lively and intelligent, and very conversational"[31]), thus softening the scientific aspect of her work.

Tonge's watercolors transmitted new knowledge of animal life to a British audience eager to experience from a safe distance the exotic or unusual that the Empire now encompassed. Unlike Tonge, who felt divinely inspired to travel abroad in order to see and illustrate all living things, Canning was obliged to move as a result of her husband's new assignment. Yet after some

initial hesitation about moving to India, Canning confessed that she did not "at all object to leaving [her] monotonous London life, & [she] took great delight in all the novelty of impressions on coming to a new country."[32] By 1857 she had left behind her life of "drawing all day in a room darkened by shutters" and instead could be found scrambling up steep roads to sketch ferns or groves of nutmeg, tea, coffee, and cloves.[33] Travel abroad allowed women to pursue their own interests to a greater extent than if they remained in Great Britain and granted them autonomy to explore and interpret their surroundings. Although they had learned watercolor because it was considered an appropriately feminine pastime, women who traveled found the medium to be optimal for capturing the newness of their lives, for giving weight and body to their observations, and for sending new knowledge of the world back to the drawing rooms of the British Isles. From depictions of tiger hunts in India to fez makers in Tunisia, travel expanded the conventional recreational uses of watercolor into a medium for recording the unusual, the exciting, and the banality of quotidian life abroad. Just as women broadened the uses of watercolor, the act of producing a quick watercolor sketch served to validate and cement unprecedented experiences, as the following 1838 diary entry by Jane Ellice (1814–64) elucidates: "in the Evening we went upon Lake George ... shot a *little* rapid for the 1st time—rather frightened. Landed on an Island, made a sketch."[34]

Notes

1. Rudolph Ackermann quoted in Francina Irwin, "Amusement or instruction? Watercolour manuals and the woman amateur," *Women in the Victorian Art World*, Clarissa Campbell Orr, ed. (Manchester: Manchester University Press, 1995), 149.

2. Shirley Foster, *Across New Worlds: Nineteenth-Century Women Travelers and Their Writings* (New York: Harvester Wheatsheaf, 1990).

3. 13 February 1837, Francis H. Eden, *Four Sketching Albums*, vol. i, Eur. Mss c. 130, British Library.

4. 12 November 1837, Eden, *Four Sketching Albums*, vol. iv, Eur. Mss c. 130, British Library.

5. 2 March 1837, Eden, *Four Sketching Albums*, vol. iv, Eur. Mss c. 130, British Library.

6. Virginia Surtees, *Charlotte Canning* (John Murray, 1975), 205.

7. See Geraldine Macpherson, *Memoirs of the Life of Anna Jameson* (London: Longmans, Green, and Co., 1878), 116–117. Jameson stayed for eight months in Upper Canada and was the first European woman to make the difficult trip around Lake Huron, an adventure she recounted in her publication of 1838, *Winter Studies and Summer Rambles in Canada*. Her sketches are now at the Toronto Public Library.

8. Elizabeth Butler, *An Autobiography* (London: Constable & Co., 1923), 231. Butler accompanied her husband to Egypt where he served as Adjutant General in the British Army.

9. 21 October 1837 and 9 November 1838, Eden, *Four Sketching Albums*, vol. ii, Eur. Mss c. 130, British Library.

10. Founded in 1670, the Hudson's Bay Company was an enormous enterprise in fur-trading, exploration, and settlement. When Hopkins was there, the company controlled one -third of present-day Canadian territory.

11. Janet E. Clark and Robert Stacey, *Frances Anne Hopkins, 1838–1919* (Ontario: Thunder Bay Art Gallery, 1990), 17.

12. See N. N. Feltes, "Voy(ag)euse: Gender and Gaze in the Canoe Paintings of Frances Anne Hopkins," *ARIEL: A Review of International English Literature* 24 (October 1993): 7–19.

13. "The Royal Academy" in *Art-Journal* 13 (1874): 163.

14. Ann Bermingham, *Learning to Draw: Studies in the Cultural History of a Polite and Useful Art* (New Haven, Conn.: Yale University Press, 2000), 100, 105–106.

15. Charlotte Inglefield's sketches reflect an extensive itinerary that included Tunisia, Beirut, Istanbul, and the straits of the Bosporus. Her brother-in-law Admiral Sir Edward Augustus Inglefield, a naval artist and scientist, served in the Black Sea in 1855. Charlotte Inglefield must have accompanied him to the Black Sea, as a sketch album dating from that time comprises drawings of Turkish and Tunisian subjects. Victoria and Albert Museum, Department of Prints, Drawings and Paintings, archival notes.

16. Lady Mary Wortley Montagu (1689–1762), for example, presents an exception. Montagu, who lived in Turkey as the wife of the British ambassador, became an authority on Turkish customs and depicted herself "in the Turkish dress." Image reproduced in Bermingham, *Learning to Draw*, 208.

17. Maria Frawley, "Fair Amazons Abroad: The Social Construction of the Victorian Adventuress," *Annals of Scholarship* 7, no. 4 (1990): 504.

18. 1 January 1859, Papers and Journals of Lady Canning, Leeds District Archives; 15 February 1837, Eden, *Four Sketching Albums*, vol. i, Eur. Mss c. 130., British Library

19. 15 February 1837, Eden, *Four Sketching Albums*, vol. 1, Eur. Mss c. 130, British Library. "A Photographic Expedition in Burmah," *Leisure Hour*, no. 614 (3 October 1863). In 1824–26 the first Anglo-Burmese war ended with Burma ceding territory to the British. During the second Anglo-Burmese war in 1862 the British conquered Lower Burma and made it a province of British India.

20. "A Photographic Expedition in Burmah," 664. Although traveling with an entourage, it seems that the author in Burma may have been the sole woman in the group. Perhaps the *Leisure Hour* specifically sought a woman's viewpoint for their predominantly female readership. That may explain the author's descriptions of her encounters with Burmese women.

21. Romita Ray, "The Memsahib's Brush: Anglo-Indian Women and the Art of the Picturesque, 1830–1880," in *Orientalism Transposed: The Impact of the Colonies on British Culture*, Julie F. Codell and Dianne Sachko Macleod, eds. (London: Ashgate, 1998), 89–116.

22. Gates calls Elizabeth Gould "one of the world's finest bird illustrators." Her husband signed all of the plates "J & E Gould del et lith," which purposely muddled the authorship of the illustrations. See Barbara T. Gates, *Kindred Nature: Victorian and Edwardian Women Embrace the Living World* (Chicago: University of Chicago Press, 1998), 74.

23. Bermingham, *Learning to Draw*, 203.

24. The Linnaean Society was founded in 1788 for "the cultivation of the Science of Natural History in all its branches."

25. *A Vision of Eden: The Life and Work of Marianne North* (New York: Holt 16, Rinehart, and Winston published in collaboration with Royal Botanic Gardens, Kew, 1980), 219.

26. Ibid.

27. 27 May 1858, Papers and Journals of Lady Canning, Leeds District Archives.

28. 6 July 1858, Papers and Journals of Lady Canning, Leeds District Archives.

29. Marianne North, *Recollections of a Happy Life* (1892–94); 21 March 1852, Papers and Journals of Lady Canning, Leeds District Archives. About her traveling on the back of an elephant, Fanny Eden wrote, "I do not know why it is but the instant I am on an elephant I do not feel the least afraid for myself or anybody else. When the tall grass shakes & the elephants begin to scream, I ask whether it is a tiger or a rhinoceros in exactly the same tone I should whether it is a partridge or pheasant." 3 March 1837, *Four Sketching Albums*, vol. iv, Eur. Mss c. 130, British Library.

30. Mrs. O. F. Tonge, *Sketchbooks of Mrs. O. F. Tonge*, c.1908–1913, Library of the British Museum of Natural History.

31. Olivia Tonge Drawings Collection (1908–1913), Natural History Museum (London).

32. 8 September 1857, quoted in Surtees, *Charlotte Canning*, 239.

33. Surtees, *Charlotte Canning*, 205, 263.

34. *The Diary of Jane Ellice*, Patricia Godsell, ed. (Toronto: Oberon Press, 1975), 76.

"A Dream of Beauty": inscribing the English garden in Victorian India

Romita Ray

Suspended between the greater outdoors and the home, the garden is a secluded space protected from public paths of traffic but less rigidly bound by the social divisions demarcating the domestic interior. For nineteenth-century women, it comprised a secure place to which they could escape from the confines of the home to roam the outdoors without having actually to step out of doors into more public environments like the woods, streets, or neighboring fields. It is here that the boundaries of femininity were initially tested and shaped by childhood games, picnics, leisurely walks, sketching, and gathering flowers. Not to appreciate the garden was a sign of rejecting the codes of appropriate female behavior, exemplified by the tomboyish antics of Catherine Morland, the heroine of Jane Austen's *Northanger Abbey* (1803): "Indeed she had no taste for a garden; and if she gathered flowers at all, it was chiefly for the pleasure of mischief—at least so it was conjectured from her always preferring those which she was forbidden to take."[1] Catherine's reluctance to engage with the beauty of flowers is set forward as a refusal to cultivate good, and by extension suitable feminine taste. But Austen's characterization of mischievous behavior is also grafted onto the freedom the garden offered its female occupants.

Ultimately, the garden was a place of pleasure and rest where women had more liberty to do as they pleased—enjoy the companionship of family and friends, indulge in conversation with the opposite sex, and spend time alone reading, sketching, and gardening.[2] In a sense, the garden constituted a stage for unfettered movement without the watchful eye of a chaperone. It allowed women to harness their freedom and solitude to explore their surroundings albeit within acceptable limits, and to legitimize their artistic agency through gathering flowers, painting plants, or pursuing horticultural interests. A spate of gardening manuals like *The Gardener and Practical Florist* (1843) and Louisa Johnson's *Every Lady her Own Flower Gardener* (1845) encouraged and

validated further the feminine experience of the garden. While they may have typified engaging with flowers and plants as a female pastime, they also made acceptable the woman's desire to release herself from tedious domestic duties such that she could avail herself of the outdoors.

This essay examines how the motif of the garden positioned the Victorian woman as surrogate explorer in British India. My discussion focuses primarily on a view of the Taj Mahal and its gardens painted by Marianne North, the indefatigable Victorian artist and traveler who traveled throughout the subcontinent in the late nineteenth century. North's transformation of the famous Mughal tomb into a Victorian tragedy, through the multivalent pictorial vocabulary of the English picturesque and the Victorian garden, is a significant point of departure for analyzing the Victorian woman's role in defining aesthetic preferences and appreciation within the larger framework of British imperial culture. While English gardens in India constituted a retreat from an otherwise foreign landscape, they also signified the longing for a homeland left behind. The aestheticization of the Indian landscape—through nostalgic recreations of English environments or the application of English pictorial conventions to a view of a Mughal garden—indicates the fragile character of imperial identity as it struggled to cope with the slippages between the familiar and the unfamiliar.

On March 14, 1878, North reached Agra where she visited the Taj, noting in her journal that the famous marble mausoleum was "bigger and grander than [she] had imagined." Yet she also remarked that the "Taj itself was too solid and square a mass of dazzling white to please me (as a picture), except when half hidden in this wonderful garden."[3] Imposing though its beauty, the famous Mughal tomb confused the artist, her impressions of the building colliding with her expectations of its visual representation. Standing 180 feet high and wide, the Taj dwarfed its viewers, posing the practical challenge of transforming its epic proportions into a picture on a drastically reduced scale. Furthermore, its glistening marble edifice and soaring geometric proportions conflicted with the picturesque preference for uneven outlines and rough-hewn textures favored frequently by eighteenth- and nineteenth-century British landscape painters.[4]

North was not the only artist to be perplexed by the beauty of the Taj. Be it William Hodges, the first professional landscape painter to travel in India in the 1780s, or Edward Lear, a fellow Victorian artist and friend who had visited the subcontinent just four years earlier, North's predecessors were equally mystified by the tomb's striking appearance. As Lear exclaimed in his journal entry, "*What* can I do here? Certainly not the architecture, which I naturally shall not attempt, except perhaps in a slight sketch of one or two direct garden views."[5] The visual appeal of the Taj, therefore, oscillated between the desire to record the monument and the disconcertment experienced in its presence.

In short, the aestheticization of the building relied upon, yet conflicted with, the pleasure of looking at its marble edifice.

North dismantles such a conflict by relocating the Taj as a surprise "hidden" in a garden (Fig. 4.1). By relegating the mausoleum to the background of her composition, she suppresses any hint of its overwhelming presence, drawing attention instead to the foreground details of trees and flowering shrubs. The dense mass of reds, blues, greens, and yellows of blossoms and leaves contrasts with its polished marble surface, the riot of color rupturing the stark geometry of its massive onion-shaped dome and towering minarets. Despite the absence of standard motifs like rocks and ruins, the abundance of color infuses the composition with the picturesque love for variety. As the Reverend William Gilpin observed, color and light created ever-changing contrasts that pleased the eye in search of the picturesque: "Different lights make so great a change even in the *composition* of landscape—at least in the *apparent* composition of it, that they create a scene perfectly new."[6] Color and light were, therefore, understood to "soften" "awkward abruptness", and thereby animate formal elements.[7] Along these lines, eighteenth-century landscape designers and gardeners such as William Mason recommended red, yellow, and blue flowers to create a picturesque spectacle, the primary colors seen to underscore unexpected contrasts and harmonies.[8] Within such a visual framework, North's garden functions as a powerful counterpoint to the mausoleum, its rich intermix of surfaces and textures detracting from the tomb's precision yet heightening its geometry and startling whiteness. As a result, the Taj is transformed into an ornamental embellishment, resembling whimsical garden follies like ruined castles, Grecian temples, and grottoes that were positioned carefully in picturesque gardens to surprise and please the eye.

It can be argued that North's view is in keeping with the long tradition of recording the monument from across its garden, reflecting pools, and fountains.[9] The bulk of these images, however, emphasized the symmetry of the mausoleum and its sylvan setting, a pictorial approach first made popular by Hodges, and soon afterwards by Thomas and William Daniells. Such earlier compositions set the standard for depicting uninterrupted views across the grounds that converged on the Taj as their focal point, a perspective that still dominates contemporary representations of the mausoleum. Even the more spontaneous renderings found in Lady Charlotte Canning's watercolor (1859) and Lear's sketch (1874) are composed in this manner, their images highlighting the axial arrangement of the monument and its garden (Figs. 4.2 and 4.3).

North's painting, on the other hand, emphasizes the lush garden instead of the Taj, a visual preference undoubtedly guided by her devotion to horticulture. Her journal entry describing the experience of visiting the Taj is also distinguished by detailed descriptions of the foliage surrounding the tomb:

The garden was a dream of beauty; the bougainvillea there far finer than I ever saw it in its native Brazil. The great lilac masses of colour often ran up into the cypress-trees, and the dark shade of the latter made the flowers shine out all the more brightly. The petraea also was dazzling in its masses of blue. Sugar-palms and cocoa-nuts added their graceful feathers and fans, relieving the general roundness of the other trees.[10]

The "dazzling" impact of the garden is such that the viewer is lulled into what James Elkins describes as "a kind of dreamy reverie."[11] North's response oscillates between the precision of her gaze and the awe it induces when confronted with exotic foliage. The density of the aesthetic experience is articulated not only in her painting but also in her enthusiastic description of the profusion of color, texture, shape, and form that greeted her eye. To this end, North's commentary evokes a haphazard movement of sight such that the eye seems to dart from one plant to another, one color to another, and one form to another. The joy of appreciating visual variety, therefore, hinges upon the excitement of viewing different and unexpected types of foliage. But her verbal rhetoric also registers a sense of helpless wonder in the face of such variety, her heightened emphasis on the garden's aesthetic impact revealing an underlying dilemma of feeling overwhelmed by exotic plants and flowers. The tension between visual pleasure and confusion is diminished by North's retreat into the narrative of fantasy through which she resurrects the garden as a "dream of beauty." Such language disperses any signs of difference generated by her encounter with Indian plants, authorizing instead her supremacy as the chief spectator who mediates and structures her emotional responses to a foreign landscape setting through painting and writing.

If dreams and fantasies unfold in solitude then their protagonists are the lone individuals cocooned within the web of their private musings.[12] In North's composition, the isolation upon which her dream-like state depends is clarified further by her sequestered gaze within an enclosure of shrubs and trees. In the process, she also transforms a public space into a private precinct within which she is concealed, unchallenged by the inquiring gaze of her fellow visitors. The human figures throughout her image are reduced to colorful additions to the foliage. Defined entirely by the aesthetics of shape and color, their living presence and attendant social and cultural histories are dissolved. Instead, they resemble the ornamental plants amidst which they are interspersed, fulfilling the picturesque love for variety of textures and surfaces. Not only are they located in the garden but they are also reinforced visually as part and parcel of its abundant growth. Such an aesthetic approach is a visual parallel to North's jottings that outlines details of exotic plants but dislodges their specificity when she compares the garden to a dream. The imperial landscape is, therefore, inscribed as a shifting paradox whose contours of difference, whether signified by native peoples or exotic plants, catered to the curiosity of the foreign traveler yet could be diluted to generate

a more palatable and thereby less threatening visual experience by minimizing their individuality.

Lady Canning's watercolor evinces a similar pictorial approach to depicting native visitors to the Taj. Both artists disengage from a reciprocal act of observation on the part of their onlookers by depicting their fellow Indian viewers at a distance, an approach that literally and figuratively erases the dilemma of racial contact. Even the seated woman in the right foreground corner of North's painting appears a remote spectator, and although she faces the artist, her gaze (if any) is negated by the elimination of any and all physiognomic detail. The iconic power of sight whereby eyes meet eyes, and face encounters face, is destabilized, resurrecting the artist's line of vision as the primary mode of spectatorship. In contrast to Lady Canning's picture, North's image, however, emphasizes a more exclusive mode of observation. The borders of shrubs and trees in the foreground block a direct view of the tomb, fixing the eye within an enclosed setting and thereby privileging the artist as secret spectator. This "hidden" gaze gives the appearance of exploration while distinguishing the view as a surprise discovered while wandering through the grounds of the Taj. In comparison, Lady Canning's watercolor reiterates a touristic approach devoid of novelty, composed as it is according to the common norm of depicting frontal views of the tomb and its garden. North was no less a tourist than Lady Canning but she breaks away from pre-established patterns of representing the monument, articulating instead a view unlike any other recorded by previous artists.

Picturesque travel hinged on the fundamental act of wandering, a leisurely and discursive form of movement enlivened by the "amusement" of discovering unexpected views of nature. "Under these circumstances," as Gilpin observed, "the mind is kept constantly in an agreeable suspence [*sic*]. The love of novelty is the foundation of this pleasure. Every distant horizon promises something new; and with this pleasing expectation we follow nature through her walks."[13] North's image of the Taj is embedded in this wanderlust, the appetite for novelty gratified by her discarding conventional modes of depicting the tomb. Her "hidden" view presupposes the freedom of solitude, yet a visit to the famous mausoleum was far from a solitary experience. British India's most popular tourist landmark, the Taj was a familiar and accessible destination by the time North traveled to see it. Its touristic potential was exploited further by its transformation into a venue for entertainment organized by local British and European residents. As Harriet Tytler recalled, the "Taj gardens used to be a great resort for picnics" in the first half of the nineteenth century, noting that during one such event, "some of the officers and their wives proposed to run a race to the top of one of the beautiful white minarets."[14] In 1839, Emily and Fanny Eden, sisters of the governor general Lord Auckland, enjoyed "a pretty fête" hosted in their honor

at the Taj where close to a hundred people gathered to "[eat] ham and [drink] wine" in the red sandstone mosque flanking the mausoleum.[15] William Simpson's watercolor drawing, *The Taj Mahal, Agra* (1864) testifies to the continued use of the site as pleasure grounds in which an officer escorts two ladies during a leisurely stroll through the gardens. But the onslaught of picnics and fêtes took its toll on the historic landmark, prompting the viceroy Lord Curzon to complain to the members of the Asiatic Society of Bengal in 1900, that "picnic parties were held in the garden" of the mausoleum during which "revellers … [armed] themselves with hammer and chisel, with which they whiled away the afternoon by chipping out fragments of agate and carnelian from the cenotaphs of the Emperor and his lamented Queen."[16] In North's drawing, the tourist's assault on the Taj is suppressed by eradicating any references to fellow visitors to the monument. Instead, the artist sequesters the building and its grounds, positioning herself as surrogate explorer who appears to have stumbled on a pleasing sight. The picturesque modality of discovery built into an unrestricted movement of the eye is deployed to stage a sense of isolation in an otherwise well-traveled setting.

This is not to suggest that North was a recluse who refrained at all times from mingling with her fellow citizens in British India. Her journals note details of various hosts and hostesses who welcomed her into their homes, and provided lodging and entertainment during her travels. Contrary to her paintings that convey an impression of unfettered movement, her jottings reveal a well-organized tourist's itinerary, a far cry from wanderings inspired by the happy accident of discovering pleasing views. Instead, specific timings for reaching and departing from destinations, and modes of transportation are described at length, evoking a more controlled experience of space and movement than her images demonstrate. North's rendering of the Taj is not simply a function of a sequestered gaze removed from the presence of fellow visitors. It seems to be couched primarily in the act of private contemplation, on her focus on looking rather than being looked at. The very isolation locked into inscribing a view on paper or canvas spills over into the isolation of the monument as a "hidden" surprise. As such, her drawing not only aestheticizes the Taj and its garden, but the process of inscribing it also aestheticizes her own experience of a setting located far from the familiarity of the homeland.

By manipulating a simulated sense of wandering to record her view, North's self-positioning as an explorer embraces a more masculine mode of movement. Voyages across land and sea undertaken by famous male sea captains, navigators, soldiers, and tourists have long established exploration as a male privilege. North inserts herself into this framework by utilizing the agency of artistic pursuit, rupturing in the process the boundaries of femininity yet simultaneously veiling its disruption by aestheticizing her experience of roaming the landscape of India. If empirical truth were

understood as a male domain of observation, North's drawing of the gardens of the Taj is more allied with that form of detailed scrutiny than those of her male counterparts like the Daniellses, Lear, and Simpson. In this sense, her aestheticization of the Taj is a more sophisticated and bold attempt to capture the palpability of her surrounding beauty. It acknowledges not only the visual impact of her environment but also the experience of taking pleasure in contemplating that impact. As a result, her Edenic picture of blossoms and trees in fact unwittingly refers to the Islamic imagery of paradise that forms the basis of the original garden design of the Taj.[17] The significance of flowering plants and fruit trees planted in the mausoleum's grounds and duplicated in the intricate floral designs of *pietra dura* ornamenting the tomb's façade, is lost in images composed by the Daniellses and Lear.

North's engagement with flowers and plants began in her childhood home of Hastings Lodge where she painted in its garden and cultivated orchids and temperate plants in her father's greenhouses.[18] Such horticultural pursuits cemented an early appreciation for plants, inspiring her to venture beyond Hastings and England to explore the world in search of more exotic foliage. Starting in 1871, she embarked on a series of journeys at age 40, sketching and painting flowers and plants wherever she visited.[19] Although several of her compositions are still-life drawings, the majority of her pictures depict flowers, fruits, and trees as part and parcel of the landscape within which they flourish. The empirical character of botanical illustration is suspended in the latter category of representations, such that plants are depicted as living forms, not as specimens plucked from their habitats and transposed onto blank sheets of paper. Still, North's pictures mingle the discerning scrutiny of a botanical illustrator with the aesthetic sensibility of a landscape painter.[20] And their variety reveals in turn North's fashioning of her identity as an explorer who experiences the world as a limitless garden.

It was also in her pursuit of the floral arts that we find her seeking solace after her father's death, and exercising her freedom to travel while navigating the strictures of Victorian codes of proper behavior as an unmarried woman. The garden, it seems, had become an extension of the artist's self, a place where she could isolate herself at will and play the role of silent observer, her solitude liberating her from the tedium of social niceties. It is precisely this balance between a self-conscious isolation and freedom that distinguishes her garden view of the Taj from those of her fellow nineteenth-century artists. For the Victorian woman in India, movement was even more constrained than that of her counterparts in the homeland, complicated as it was by the fear of racial contact. In addition, the burden imposed by strict codes of deportment circumscribed by the need to maintain cultural divisions often intensified her sense of removal from the familiarity of close-knit family networks.[21] North, however, utilized her isolation to her advantage, embracing it whenever she

could to escape from what she described as "tremendous dinners and picnic parties."[22] While it allowed her to maintain a social distance, she also exploited the solitude it offered to dismantle the restrictions of her social mobility and in doing so, to exercise her artistic agency.

It can be argued that by engaging with the floral arts, North feminized her drawing. Whether or not she intended such an effect is debatable. What is clear, however, is that she rejected the sanitized modes of representation cultivated by her male predecessors in their views of the Taj. If North's picture confirmed nineteenth-century stereotypes of flower painting as feminine domains of artistic achievement, then it also asserted the multivalent Victorian discourse of love and romance exemplified by gardens and flowers.[23] Like secrets and love letters, flowers were discreet signifiers of sexual desire exchanged by couples and would-be lovers. The Victorian garden was a popular site of romantic mediation, a stage for enacting the intricacies of courtship ritual; flowers and gardens also signified the darker side of romance, the often fragile and elusive character of love exemplified by the withering away of floral beauty as changing seasons laid claim to blossoming trees and shrubs. Constructed as it is by a sequestered gaze and defined by a "hidden" view, North's garden was steeped in romantic evocations of paradise on earth and never far from Victorian cultural notions of love. It is in this context that the partial visibility of the Taj tantalizes the viewer, its remoteness in the composition compelling the spectator to contemplate the passage of time, physical and temporal distance thereby conflated in its legendary tale of love's loss.

In 1631, Mumtaz Mahal, wife of the Mughal emperor Shah Jahan and mother of their 14 children, died in childbirth at the age of 38. Built to commemorate her untimely death, the tomb made eternal the invisibility of an already mysterious empress. As was customary for royal Mughal women, Mumtaz Mahal did not pose for portraits during her lifetime, her presence veiled from public scrutiny.[24] Her absence, made all the more poignant by legends of her husband's sorrow, was romanticized first for Western audiences by European visitors including Peter Mundy and François Bernier who described the tomb as the grief-stricken emperor's gesture of love for his dead wife.[25] By the time North visited the Taj, the legend of the young Mughal empress stirred Victorian sentiments at home and abroad about queenship and mourning characterized no less by Britain's own monarch who had lost her husband the Prince Consort to typhoid fever in 1861. The fascination with Victoria as Queen and, from 1876 onwards, as Empress of India, resonated further in the preoccupation with legendary biblical, classical, and Near Eastern queens such as Helen of Troy and Cleopatra resurrected frequently in art and literature. Such motifs indicate an intense attachment to notions of female sovereignty and imperial power, an ideology that may have also

influenced the appeal of Mumtaz Mahal.[26] Victoria's national image, however, was enhanced mainly by her sorrowful devotion to the memory of her dead husband, a burden she had endured by retreating famously from the public eye for nearly a decade. While her self-imposed seclusion had invited a spate of criticism during her lifetime, her tragedy remained inseparable from her image even after her death.[27] The Taj struck a similar chord among its viewers as a monumental testimony to royal grief, reinforcing the tragedy of love while concealing its entombed protagonists. To this end, it aestheticized Shah Jahan's bereavement over the death of his young wife.

The legend embodied by the Mughal tomb was made all the more poignant by its construction through the familiar tropes of marriage, devotion, and death. As Harriet Tytler observed, "as you all know, Agra is the town in the suburbs of which stands that lovely tomb, the Taj Mahal, a striking monument of an emperor's devotion to the memory of a beloved wife."[28] Such interpretations transposed middle-class British values of domesticity onto the tomb's occupants about whose marriage, in reality, we know very little besides the probability that Mumtaz Mahal was Shah Jahan's favorite wife.[29] It was precisely this kind of domestic ideology focused on Victoria and the royal family as models of Christian virtue and family life, that had resulted in the outpouring of national grief over Prince Albert's sudden demise.[30] Shah Jahan and Mumtaz Mahal seem to have been resurrected as Victorian tragedies as well through similar Christian sensibilities, embellished as their legendary figures were by Christian ideals of love and devotion.

In reality, the ambitious architectural program of the Taj embodied the emperor's hubris more than his sadness but the proliferation of artistic views and literary accounts of the monument's beauty romanticized instead the building and its occupants.[31] The appeal of the Taj, therefore, is also couched in the power of aesthetics to gloss over facts that would have otherwise chafed against Victorian ideas of marital devotion. To this end, Mumtaz Mahal's status as empress among Shah Jahan's many wives together with the Islamic tradition of polygamy is overshadowed by the Victorian discourse of love reiterated by such observations as Tytler's "that lovely tomb." The deliberate aestheticization of the mausoleum and its occupants denied further the figure of Shah Jahan as a philanderer, characterized as such in seventeenth-century European accounts that were still in circulation in the 1800s.[32] That such controversial information failed to taint the aesthetic appeal of the Taj especially at a time when ideals of Christian morality bound together an imperial citizenry, reveals that the tomb was relocated in nineteenth-century ideals of marriage and devotion. Its beauty was thus idealized as a testimony to the sanctity of marriage such that it assured the continuity of the sacred and elevated character of marital bliss beyond the death of its participants. Such notions of sanctity may have also been reinforced by the building's white

marble, the material used extensively by eighteenth- and nineteenth-century British sculptors to create sepulchral monuments on account of its association with purity and permanence.

North's isolation of the Taj in the background of her composition echoes the very isolating force of death that separates its victims from life. Along these lines, the mausoleum's seclusion draws attention to the solitary characters of its famous story in which lovers are separated by death, hidden forever from view. Its architectural splendor, although intact in her image, is but a façade, its affiliation with love and loss dominating the sensibility of its viewers. The disorder caused by death's disruption of life is contained and controlled by the artist who secludes it in a "hidden" view of the mausoleum. To this end, the garden animated by flowers and trees represents a powerful metaphor for that balance, and its living presence forms yet another counterfoil to death entombed in the Taj. Furthermore, its location in the foreground of North's composition constitutes a visual prelude for contemplating the tomb and its legend.

The corporeality of death, however, is sublimated in the aestheticization of the tomb as a picturesque surprise. In this sense, North's image returns us to the preoccupation with nostalgia and loss, themes embedded in the picturesque fascination with crumbling castles and abbeys. Suspended as it was between the natural and artificial worlds, the ruin was a cultural signifier of the frailty of time and history. Yet its resurrection in paintings, prints, and poetry signaled the attempt to historicize the British landscape and, by extension, to take pride in the vestiges of the nation's medieval past. As a popular motif in picturesque gardens and landscape painting, it was, however, trapped between an indexical reading of history and the ahistoricity of its application as an ornamental feature.[33] Such ambivalence marks Samuel Bourne's photograph from the 1860s, of the garden at Barrackpore, the Viceroy's country residence in India. The image depicts a Victorian woman seated on a bench against the backdrop of a faux English Gothic ruin embellishing the garden.[34] As in North's composition, the photograph is dominated by trees and shrubs in the foreground, conveying a sense of solitude at hand. In North's case, however, she *is* the solitary British female presence invisible to the viewer's eye while Bourne's female subject externalizes the feminine experience of colonial space framed within the photograph. Yet again, the garden emerges as the locus of wandering, of freedom from the duties that bound a Victorian woman to the domestic interior. But her seclusion is juxtaposed with and thereby heightened by a reference to a medieval past left behind in the homeland. It is in this context that her freedom is made ambiguous, the faux ruin signifying her separation from the familiarity of places and peoples halfway across the world.

The very simulation of a medieval past on colonial soil bespeaks the ambivalence of surviving in a foreign landscape devoid of the expected signs

and signifiers of British history. Thus the ruin mediates between its use as garden ornament and as a sign of cultural displacement, its very artifice encouraging viewers to contemplate a historical era that far preceded the formation of the British Raj. Not only was it a repository of references to English medieval history, it also registered the currency of British India and its changing landscape cultivated deliberately to resemble familiar settings left behind. In this sense, both Bourne's and North's images evoke loss. The former emphasizes it vis-à-vis the fragmentary character of a ruin, an incomplete structure whose "instant declaration of a loss" is made even more poignant by cultural dislocation and dispossession.[35] The latter, on the other hand, couches a sense of loss in the poignant legend of an emperor and empress disconnected from British history. Yet both pictures inscribe India as a British imperial landscape, albeit in different ways.

In Bourne's photograph, this is played out in the positioning of British identity amidst native vegetation. The ruin may seem out of place in India but it validates the space it occupies as an English garden designed only for the pleasure of its English occupants. Undoubtedly, its location in the Viceroy's country garden forges deeper the overlap between national and colonial identity. Put another way, the ruin and its surrounding garden circumscribe an exclusive territory that contains and cultivates British taste. In this sense, they represent an imperial conceit, embedded as they are in the desire to remain staunchly British even in a radically foreign environment. Aesthetics are, therefore, exploited to maintain cultural coherence, extended further in the body of the woman attired in a Victorian walking dress. Seated beneath fig trees, her appearance is at odds with the exotic vegetation but neutralized by her alliance with the ruin beyond. Ultimately, this composite of culturally disparate signs and symbols resurrects her as a British imperial figure, not simply that of an Englishwoman located in a foreign land. Separated though she is from the heritage of her homeland, her dislocation is grafted onto her participation in the social framework of her nation's prized empire, a framework that aestheticizes itself through motifs like a faux Gothic ruin and Victorian dress to eliminate cultural dissonance.

Gardens were especially significant in such self-reflexive affirmations of Britishness in the colonial setting. Environments refashioned with the taste for specific plants, they reveal choices shaped by their participants' social and cultural backgrounds. A channel through which identity could be inscribed onto the local landscape, the practice of gardening evinced the permanent occupation of a place, for gardens necessarily rely on timely and constant attention throughout the changing seasons. With the growing population of British residents in India from the eighteenth century onwards, domestic gardens became staple features of the colonial landscape testifying to the processes through which their occupants cultivated their foreign

surroundings into more hospitable habitats. As Eliza Fay observed in a letter sent home to friends in May, 1780:

Calcutta, you know is on the Hoogly, a branch of the Ganges, and as you enter Garden-reach which extends about nine miles below the town, the most interesting views that can possibly be imagined greet the eye. The banks of the river are as one may say absolutely studded with elegant mansions, called here as at Madras, garden-houses. These houses are surrounded by groves and lawns, which descend to the waters [sic] edge, and present a constant succession of whatever can delight the eye.[36]

Fay's pleasure is defined not only by the sylvan spaces she encountered, but also by the familiarity of English gardens stretched along the river's edge. But such self-conscious reminders of the homeland left behind contrasted sharply with the official cultivation of botanical gardens to transplant economically profitable plants. Six years after Fay recorded her observation, Warren Hastings, the governor-general of Bengal, granted permission to Robert Kyd to establish a botanical garden in Calcutta for the explicit purpose of growing plants that could be sent home to Britain or distributed throughout the colonies.[37]

The laborious task of gardening, however, was often assigned to *malis*, Indian gardeners who were part of the standard retinue of servants found in Anglo-Indian households. But plants were selected by their British mistresses who frequently opted for English flowers like petunias, pansies, violets, larkspur, phlox, and snapdragons, either grown from seeds shipped from the homeland, or procured from botanical gardens set up in India from the late eighteenth century onwards.[38] By the 1860s, attempts to recreate the familiarity of the homeland through English gardens were more successful in hill-stations like Darjeeling than in the plains where climatic conditions were not as conducive to cultivating flowers, fruits, and vegetables that catered to British taste.[39] Darjeeling itself had evolved from the combined interests of botanical enterprise and judicious economic industry when it was deemed suitable for planting tea by the middle of the nineteenth century. A flourishing tea hub by the 1890s, the town was occupied by a lively community of Britons and surrounded by 174 plantations popularly known as tea-gardens.[40] The opening of the North Bengal State Railway in 1878 and the Mountain Railway in 1880 made it even more accessible for tourists who were struck continually by the Englishness of this remote corner tucked away in the eastern Himalayas.[41]

The English garden, therefore, functioned as a retreat from the intense and frequently overwhelming reality of a foreign environment, perpetuating instead the Britishness of British India. By imitating a landscape left behind, it diminished all that was strange and unpleasant about an exotic destination, relocating the thrill of navigating an unknown terrain in the pleasure of discovering familiar signs and symbols. If, as in Bourne's photograph of the

Barrackpore estate and Darjeeling's cultivated landscape, the garden signified a loss of cultural heritage, it also constituted a nostalgic means of reclaiming and securing national identity through the aesthetics of English flowers, fruits, or ruins. Such palpable motifs enabled the imperial body to define itself against the absence of the homeland. It is this return to being British that defines North's painting as well. While the garden of the Taj is a manifestation of Mughal landscape design, it is repositioned within the ideological framework of viewing English picturesque gardens. In this sense, both Bourne and North register the transferal of prescribed aesthetic values onto the Indian landscape.

Fundamentally the photograph reveals the radical cultivation and embellishment of land to recreate a distinctly English space. Yet the very application of photography to record the Victorian woman seated before an invented Gothic ruin reveals the desire to aestheticize further a body and setting arranged according to English conventions of dress and gardening. British imperial taste and sensibility are continually mirrored back to its protagonists. North's view of the Taj epitomizes such self-reflexive looking and recording by virtue of mobilizing the agency of picturesque travel and the charged imagery of a Victorian garden. It also reveals the British artist's need to return to the same site to see for themselves the legendary mausoleum. While repeated visits to the Taj and countless views of the tomb and its gardens may have decreased the monument's novelty, its aesthetic appeal always remained intact, its familiarity authorizing its status as a landmark that tourists were expected to visit in India. Such patterns of movement and visual preferences clarified the currency of British imperial rule when Mughal monuments like the Taj emerged as part and parcel of British imperial visual culture on Indian soil. Reincorporated within a different spectrum of spectatorship and appreciation, they were, however, powerful emblems of difference, rendering ever more culturally disparate the identity of the artist and the setting she or he occupied.

As Homi Bhabha has argued, "the colonial presence is always ambivalent, split between its appearance as original and authoritative and its articulation as repetition and difference."[42] It is precisely such a "split" that underscores the aesthetic framework deployed by North and other artists to record the Taj. While these artists' visual preferences confirmed the presence of British rule in India, they also paradoxically conceded to the artistic heritage of previous empires, the latter inserted into the broader visual culture of British India through the modality of touristic travel and recording. For North, the exotic character of her surroundings, no matter how culturally set apart, constituted a blessing in disguise, enabling her to justify the freedom to travel and paint. Her self-imaging as explorer in her view of the Taj makes credible the idea of traveling as liberating, exciting, and appealing, even though the novelty of

India had been diminished considerably by the well-established presence of a large British imperial community. Yet, as Maria H. Frawley has argued, "many adventuresses did indeed find in the wild zones of the wider world a way out of cramped, patriarchal England, they used it also ... as a way back in. They used their stories of adventures abroad to critique their position at home."[43] Similarly, North's view of the Taj may present her as consummate wanderer far removed from Britain but in fact, it is more revealing of the Victorian cultural attitudes its aesthetic framework encompasses. Thus the desire to inscribe British pictorial conventions on a foreign landscape may be understood as the privilege of imperial agency. But the depth and scope of imperial identity was forged by its self-reflexive gaze embedded as it was in the examination and display of its inherent belief systems through tropes as familiar as the English garden.

Notes

1. Jane Austen, *Northanger Abbey* (Ware, Hertfordshire: Wordsworth Classics, 1995), 3.

2. Tom Carter, *The Victorian Garden* (London: Bell & Hyman Limited, 1984), 8.

3. Anthony Huxley and Brenda E. Moon, *A Vision of Eden: The Life and Work of Marianne North* (London: HMSO, 1980), 127–8.

4. The Taj had long perplexed British artists including William Hodges, the first professional landscape painter to travel in India in the 1780s, and others like Thomas and William Daniells. Giles Tillotson, *The Artificial Empire: The Indian Landscapes of William Hodges* (Richmond, Surrey: Curzon Press, 2000), 82.

5. Edward Lear, *Journals in India*, vol. i, Harvard University. FMS Eng 797.4, journal entry for Monday, February 16, 1874, 57.

6. The Reverend William Gilpin quoted in Ann Bermingham, "The Picturesque and Ready-to-Wear Femininity," in Stephen Copley and Peter Garside, eds. *The Politics of the Picturesque: Literature, Landscape, and Aesthetics since 1770* (Cambridge: Cambridge University Press, 1994), 84–5.

7. Bermingham, "The Picturesque and Ready-to-Wear Femininity," 84.

8. Stephen Bending, "An Essay on the Arrangement of Flowers in Pleasure-Grounds," *Journal of Garden History* 9:4 (1989): 217–20.

9. Pratapaditya Pal, "Romance of the Taj Mahal," in Pratapaditya Pal et al., *Romance of the Taj Mahal* (Los Angeles: Los Angeles County Museum of Art, 1989), 199.

10. Huxley and Moon, *A Vision of Eden*, 128.

11. James Elkins, "On the Conceptual Analysis of Gardens," *Journal of Garden History* 13:4 (1993): 196.

12. Jerome L. Singer, *The Inner World of Daydreaming* (New York: Harper Colophon Books, 1976), 15.

13. William Gilpin, "On Picturesque Travel," in *Three Essays: On Picturesque Beauty; On Picturesque Travel; and On Sketching Landscape: To Which is Added a Poem, On Landscape Painting*, second edition (London, 1794), 47–8. See also John Whale, "Romantics, Explorers, and Picturesque Travellers," in Stephen Copley and Peter Garside, eds. *The Politics of the Picturesque*, 177.

14. Anthony Sattin, ed., *An Englishwoman in India: The Memoirs of Harriet Tytler 1828–1858* (Oxford: Oxford University Press, 1986), 12.

15. Emily Eden, *Up the Country: Letters Written to her Sister from The Upper Provinces of India* (London: Virago Press, 1983), 362.

16. George Nathaniel Curzon, *Lord Curzon in India: Being a Selection from his Speeches as Viceroy and Governor-General of India 1898–1905* (London: Macmillan and Company, 1906), 190. See also David Carroll, *The Taj Mahal* (New York: Newsweek, 1979): 132–3; David Dilks, *Curzon in India* (New York, Taplinger Publishing Company, 1969), 1: 245–6.

17. Vidya Dehejia, *Indian Art* (London: Phaidon Press, 1997), 324.

18. Laura Ponsonby, *Marianne North at Kew Gardens* (Kew: The Royal Botanic Gardens, Kew, 1996), 13.

19. Ponsonby, *Marianne North*, 15.

20. Romita Ray, "The Memsahib's Brush," in Julie F. Codell and Dianne Sachko Macleod, eds. *Orientalism Transposed: The Impact of the Colonies on British Culture* (Aldershot, England: Ashgate Publishing Limited, 1998), 89.

21. Margaret MacMillan, *Women of the Raj* (New York: Thames and Hudson, 1988), 8; Sara Suleri, *The Rhetoric of English India* (Chicago: University of Chicago Press, 1992), 90–91.

22. Huxley and Moon, *A Vision of Eden*, 237.

23. Ann Bermingham, *Learning to Draw: Studies in the Cultural History of a Polite and Useful Art* (New Haven, Conn.: Yale University Press, 2000), 203, 209; Susan Casteras, *Images of Victorian Womanhood in English Art* (London: Associated University Press, 1987), 87–96; Nancy Rose Marshall, *James Tissot: Victorian Life/Modern Love* (New Haven and London: Yale University Press, 1999), 110.

24. Pal, "Ruler of the World," 40, 41, 44. Two pictures identified as her portraits are questionable at best: one, a seventeenth-century watercolor and the other, a nineteenth-century miniature probably invented as a result of the appeal of the Taj.

25. W. E. Begley and Z. A. Desai, *Taj Mahal: The Illumined Tomb: An Anthology of Seventeenth-Century Mughal and European Documentary Sources* (Cambridge: The Aga Khan Program for Islamic Architecture, Harvard University and Massachusetts Institute of Technology, 1989), 291–300.

26. Angus Trumble, "Love and Death: Art in the Age of Queen Victoria," in Angus Trumble, *Love and Death: Art in the Age of Queen Victoria* (Adelaide: Art Gallery of South Australia, 2002), 34; David Cannadine, *Ornamentalism: How the British Saw Their Empire* (New York: Oxford University Press, 2001), 101.

27. John Wolffe, *Great Deaths: Grieving, Religion, and Nationhood in Victorian and Edwardian Britain* (New York: Oxford University Press, 2000), 206.

28. Sattin, *An Englishwoman in India*, 12.

29. Pal, "Ruler of the World," 28–9, 41.

30. Wolffe, *Great Deaths*, 198–9.

31. Begley and Desai, *Taj Mahal*, xx.

32. Ibid, 302–306; Pal, "Ruler of the World," 41.

33. Stephen Copley and Peter Garside, 'Introduction,' in Copley and Garside, eds. *The Politics of the Picturesque*, 6.

34. Ray Desmond, *Victorian India in Focus: A Selection of Early Photographs from the Collection in the India Office Library and Records* (London: Her Majesty's Stationery Office, 1982), 98–9. For more about the faux Gothic ruin and other similar "Gothic" structures and follies in the Viceroy's estate at Barrackpore, see Charles Allen, *A Glimpse of the Burning Plain: Leaves from the Indian Journals of Charlotte Canning* (London: Michael Joseph, 1986), 41.

35. John Dixon Hunt, *Gardens and the Picturesque* (Cambridge, Massachusetts: MIT Press, 1997), 179.

36. Eliza Fay, *Original Letters from India (1779–1815)* (New York: Harcourt, Brace and Company, 1925), 180–82.

37. Sir George King, *A Guide to the Royal Botanic Garden, Calcutta* (Calcutta: Thacker, Spink, and Co., 1895), 19–21; Ray Desmond, *The European Discovery of the Indian Flora* (New York: Oxford University Press, 1992), 57; Ray Desmond, *Kew: The History of the Royal Botanic Gardens* (Kew: The Harvill Press with the Royal Botanic Gardens, 1995), 95, 98.

38. MacMillan, *Women of the Raj*, 152. See also Janet Dunbar, *Golden Interlude: The Edens in India 1836–1842* (London: John Murray, 1955), 43.

39. Dale Kennedy, *The Magic Mountains: Hill Stations and the British Raj* (Berkeley and Los Angeles: The University of California Press, 1996), 47.

40. Graeme D. Westlake, *An Introduction to the Hill Stations of India* (New Delhi: HarperCollins, 1993), 136; Edmund Mitchell, *Thacker's Guide Book to Darjeeling. With Two Maps* (Calcutta: Thacker, Spink and Company, 1891), 7.

41. Mary H. Avery, *"Up in the Clouds" or Darjeeling and its Surroundings, Historical and Descriptive. With a Map* (Calcutta: W. Newman and Company, 1878), 17.

42. Homi K. Bhabha, *The Location of Culture* (London: Routledge, 1994), 107.

43. Maria H. Frawley, *A Wider Range: Travel Writing by Women in Victorian England* (London: Associated University Presses, 1994), 126–7.

Women and the natural world: expanding horizons at home

Ann B. Shteir

In *A Family Tour of the British Empire*, a popular travel book published in 1804, the widowed Mrs. Middleton sets off on a journey with her teenage children, "not for the amusement of the moment, but for the sake of collecting useful knowledge."[1] Under her watchful eye, her sons and daughters learn about geography, encounter the natural world, visit factories, meet people from various walks of life, and have opportunities to discuss topics of contemporary social interest such as child labor, slavery, and religious toleration. Their travels are within the "British Empire" close to home, and they find as much food for thought in England, Scotland, Ireland, and Wales as they would if they were journeying to more distant and exotic domains. Priscilla Wakefield, the author of *A Family Tour*, wrote for middle-class families who wanted books of informal education to supplement their children's more formal schoolroom learning. Over the course of her career, she shaped moral tales, popular science manuals, and colorful accounts of adventures in Britain, Europe, Africa, and North America that aimed to open the minds, eyes, and hearts of armchair travelers to the wonders of the world. In all her books, Wakefield habitually showed young people gathering plants, collecting insects, and learning about the habits of animals. She understood the public hunger for knowledge, including knowledge about the natural world, its flora and fauna, laws and processes, its utility, beauties, and mysteries.

Many of Priscilla Wakefield's books feature young women who study natural history as part of what she termed their "mental improvement." Their real-life counterparts also had access to a wide array of resources for learning about nature, as natural history was very popular in the nineteenth century. People across all levels of society were caught up in the enthusiasm for ferns, shells, seaweed, aquaria, butterflies, and animals of many kinds.[2] Natural history was a topic in education for children, and a focus for religious and

moral instruction. Women participated fully in the development of natural history, which, during that time, afforded them opportunities for intellectual pursuits. For during Victoria's reign, women were excluded from almost all formal institutions of learning and science and had little standing in professional circles. Many scientists, physicians, and others believed firmly in "natural" differences between women and men, and identified women with nature. They promoted separate spheres of activities, criticized intellectual women, and made "bluestocking" a pejorative term. Yet those same beliefs about women could ease the way for women to turn their attention to the study of nature. Emphasis on women's "duties" in the private and domestic spheres of life included natural history and science as part of family life. Mothers taught their children at home, and daughters needed knowledge of nature as part of their education. Natural history became, therefore, an area of accomplishment for women, a topic for conversation in polite society, and a welcome artistic skill as well.

At home in Britain, women were extensively involved in a variety of informal activities in natural history and could develop and pursue their curiosity about nature in many ways. Reading gave women wide fields for travel in the imagination and in the mind's eye. Women also traveled themselves, to gardens and fields, to the seaside, and out into the hills and forests, cultivating their own curiosity about the natural world. As a resource for women, natural history provided pathways to intellectual satisfaction, spiritual connection, the pleasures of sociability, and, for some, the prospect of an economic livelihood.

Botany—the scientific study of plants and flowers—was the most popular and fashionable area of natural history. Partly because of new systems for classifying and naming plants, botany became a hobby for ladies and gentlemen, who walked out into gardens and fields and collected wildflowers, ferns, mushrooms, grasses, and other examples of the wonders of the Vegetable Kingdom. Botanizing was considered good recreation because it represented healthy activity and was seen as a useful kind of leisure. People practiced botany with their families or with groups of friends and organized informal outings to neighborhood sites, or, sometimes, farther afield. They carried pocket guides from which they could identify plants and flowers. Once home, a young woman could press and dry her specimens, and compile a herbarium. She might exchange plants with friends or correspond with botanists who could assist her in naming a plant or who would welcome some of her plants for their own collections. She might make watercolor drawings of plants out in her garden or sitting in her breakfast room.

But there was more to the world of flowers than technical matters about names and classification of species. Interest in their beauty, uses, folklore, and historical associations was part of Romantic and Victorian literature, art, and

culture. Poets, novelists, and painters created visual fields that celebrated the sublimities of large vistas as well as delicate details, from the massive seascape to the tender individual daffodil. Flowers were revered as symbols of a divine plan and significance. Country gardens cultivated a taste for "natural" and "picturesque" landscapes, and city dwellers brought the green world into town with "portable flower-gardens" in window boxes and as houseplants.[3] A fashion for what became known as the "language of flowers" taught that a well-chosen bouquet could convey many kinds of meanings by its selection of individual blossoms. More generally, floral motifs were used in home and fashion design. The floral arts were one of the conventional accomplishments of genteel women, who learned to draw and paint flowers, shape them out of wax, shells, feathers, and beads, and ornament leather with designs of flowers and ferns. In books such as the mid-century *Elegant Arts for Ladies*, knowledge of botany complemented the artistic techniques being taught (Fig. 5.1). Botany was, in other words, science, art, and sociability for a well-brought-up young woman. It represented new horizons of knowledge and was also a part of recreation and polite culture.

Because of botany's wide appeal for women, it became a popular topic in many publications directed at female readers. Women's magazines—an important part of the cultural scene for women of the middle and upper classes—provided a wealth of material about natural history. Resembling twenty-first-century magazines in their mix of fashion, fiction, and general information, they offered readers more instruction in the sciences than we are accustomed to seeing today. Botany, natural history, and other sciences were still part of general culture at that time, and writing on such topics was therefore not consigned only to specialist publications. Because moral lessons could be derived from details about flora and fauna, natural history was featured in essays, editorial columns, and stories in many magazines. During the opening decades, the editorial policy of one such publication, the *Lady's Magazine*, was "to provide for the more amiable sex a fund of innocent amusement and useful knowledge ... equally avoiding what might be too abstruse or formal on the one hand, or too trivial and frivolous on the other."[4] Lessons in elementary botany were a fairly constant feature, often accompanied by drawings that readers could color themselves. A series of "floral biographies" during the 1830s described common garden flowers and featured folklore associated with much-loved plants such as primulas and cowslips.

Women were a niche market for introductory popular science in books as well, and these books often were quite precise about the ages and circumstances of their intended readers. For example, *Elements of Botany* (1837) is an introductory text for young women that promoted the benefits of botany for the mind, body, and religious spirit. The author, Mrs. E. E. Perkins, wrote

that "[n]o department of Natural History more strongly evinces the existence of a Supreme Cause than the study of the vegetable world, the simplicity and harmony of which are well calculated to elevate, while they delight the mind."[5] This book teaches about the Linnaean system of plant classification, a simple way of organizing and naming plants that had done much to make botanical study popular in England since the late eighteenth century. Mrs. Perkins was identified on the title page as a "Professor of Botanical Flower Painting," and illustrations probably were part of the attraction of *Elements of Botany*. Perkins dedicated the book to the newly crowned Princess Victoria, expressing her hope that botany "may supersede some of the less important, not to say superficial, studies in the education of many of our sex in the present day."[6] Among other books meant to teach women about plants, John Lindley's *Ladies' Botany* (1834–37) promoted what was called the "natural system" of plant classification, bringing in considerable technical information. Jane Loudon, a popular writer herself on many aspects of botany and horticulture, found his explanations too complicated for the readers she had in mind. Accordingly, she shaped her *Botany for Ladies* (1842), retitled *Modern Botany* in its second edition (1851), to be deliberately more accessible in its vocabulary and descriptions. "It is so difficult," she wrote in the preface, "for men whose knowledge has grown with their growth, and strengthened with their strength, to imagine the state of profound ignorance in which a beginner is."[7]

As print culture offered women in England many resources for learning about the Vegetable Kingdom, many women in turn made the world of plants a resource for themselves. Individual women played active roles in the culture of nineteenth-century natural history as writers, artists, collectors, patrons, and teachers. There are several examples of English women working at home who, building upon natural history enthusiasms of the time, produced writing and art that reflected their own absorption in nature.

During the early years of the century, Agnes Ibbetson (1757–1823) studied botany "for the love of the Science." A keen plant physiologist, she worked in relative isolation at her home in the Devon countryside, observing and analyzing the internal structures of stems, leaves, and roots. She conducted long-term research and recorded minute changes as her botanical specimens grew. Like Barbara McClintock, winner of the Nobel Prize in 1983 for her work in plant genetics, Ibbetson wrote about having "a feeling for the organism," as she traced what she called "the line of life." Ibbetson dissected plants (she called it "cutting vegetables"), and used microscopes extensively in her work. She compiled her findings in more than 50 essays submitted to two general science magazines during the opening decades of the nineteenth century. These set out her theories about how a flower bud develops, for example, and how seeds form. In one of her many essays in the *Philosophical Magazine* for example, she wrote about how parasite plants take in food and moisture not

only through their roots but also through their leaves. To accompany her essays, Ibbetson prepared many detailed drawings as a record of her observations, and these were published too.[8]

By contrast to Ibbetson's absorption in a dedicated intellectual quest, Sarah Bowdich (1791–1856), known in later life as Sarah Bowdich Lee, had a career in natural history that was shaped by economic necessity. As a married woman in the 1820s, she developed broad knowledge of both botany and zoology and enjoyed close professional links to the French naturalist Georges Cuvier (1769–1832). Widowed in 1825, she employed her natural history pencil and pen in order to support her three children. With encouragement from the entrepreneurial pictorial publisher Rudolph Ackermann, Bowdich drew fish and hand-painted 3000 plates for what became her sumptuous *Fresh Water Fishes of Great Britain* (1828–38) (Fig. 5.2). Fifty subscribers, including notable men of science of her day, paid 50 guineas each for beautifully detailed portraits of fish, painted from the living specimens, along with her notes and observations.[9] Bowdich (known after her second marriage as Sarah Lee) also wrote juvenile fiction and non-fiction for children and adults about animals and trees. Her book *Elements of Natural History* (1844) was widely distributed within school systems. She worked equally well within the orbits of popular science and more technical and specialized areas of knowledge and was adept at negotiating the marketplace.

Across the history of women and natural history there is a striking pattern of women coming into the field of natural history through family circles and social networks. In tandem with fathers or husbands or mothers and sisters, they collected specimens, made observations, and shared the pleasures of exploration and discovery. Often they were the unacknowledged assistants on projects. Family, botany, and art overlapped, for example, in the story of Sarah Anne Drake (1803–55). She worked at the heart of British botanical culture during the 1830s and 1840s in the home of the teacher and author John Lindley. Drake worked initially as a companion to the Lindley children and then was taught how to prepare botanical drawings for Lindley's books and magazine projects. She was Lindley's botanical artist for 16 years and produced the technical artwork for publications such as his *Ladies' Botany*. Lindley was a keen orchidologist, and Drake's drawings for his other publications about exotic orchids probably did much to build interest in them. Drake also prepared watercolor paintings of orchids for what became the largest book published during the early Victorian age, John Bateman's *Orchidaceae of Mexico and Guatemala* (1837–43), a very expensive folio, issued in a limited edition of 125 copies (Fig. 5.3). Drake did not travel to Mexico or Guatemala to paint flowers on site; indeed, she seems to have gone no farther than the Botanical Gardens at Kew, the work table at the Lindley home, or to Loddiges, a London nursery well known for its orchids, where specimens

were put on display expressly for her. She painted from life as much as possible, but at times had only descriptions or dried flowers to guide her pen and brush. It is interesting and poignant to realize that a family nexus gave her access to botanical knowledge and art production, yet that same family connection probably also kept her from being singled out for status and attention. Floral art was such a commonplace of women's work that botanical drawing and painting by a young and female quasi-member of the family carried low status, even when she was the resident artist for an influential botanist. Sarah Drake drew or painted about 1400 new plants, more than 300 of them orchids, during an artistic career that lasted nearly 20 years. Her work brought knowledge of exotic plants home to England, and opened botanical horizons beyond British borders. Yet she was treated during her lifetime as a technical assistant rather than celebrated as a botanical artist. Recent scholarship has cast welcome light on Drake and her significant body of botanical art.[10]

Associations between women and flowers may have made Drake invisible within learned and professionalizing circles of botany, but those same associations eased the way for some women writers and artists to work within popular culture and to be acclaimed for their achievements. During the 1840s and 1850s Anne Pratt (1806–93) was a favorite author of many who, as she put it in one book, were "fond of flowers" but had not studied botany scientifically. A versatile writer, she penned descriptive elementary books about native species, including ferns, grasses, and seaside plants. Pratt wanted to interest her readers in the study of nature by helping them identify common plants that they would see in the meadows, hills, and tidal pools of England. Her books are filled with folklore about herbal remedies and are used now to revive older understandings about the medicinal uses of plants. Many of Pratt's books are illustrated with line drawings that are meant to serve as guides to plant identification. *Wild Flowers* (1852–53), one of her books for young readers, for example, contains nearly 100 colored figures of sentimental favorites such as bluebells; her publisher issued the plates in single sheets too, so that they could be hung in schoolrooms. Pratt's best-known work was *Flowering Plants and Ferns of Great Britain* (1850). This is an extensively illustrated work in five volumes, with simple botanical descriptions of British examples from each of the natural orders of plant classification, along with comments of interest to general readers. At that time, in addition to flowers, ferns became an object of fervor, and a "fern craze" resulted. The "pteridomania" of the 1840s and 1850s was so intense that it threatened native specimens, as plant hunters set out across the British countryside, their journeys now facilitated by swiftly spreading train lines. Avid novices could have in hand illustrated books such as Pratt's *Ferns of Great Britain* (1855), her second book on the subject. With Pratt's encouragement, accessible instruction, and detailed descriptions, they could search out native species

and transport a sampling of ferns into their own home conservatory to display them under glass in their parlor or dry and press them for a fern scrapbook.

Across the Victorian era, amateur collectors—including women, clergymen, teachers, and artisans—often corresponded with one another about plants, seeking out people who could supply specimens for their local and regional collections. An enthusiastic workforce of individuals was ready to exchange plants, drawings, and advice. Anna Maria Hussey (1805–77?) is a good example of how such enthusiasms unfolded into creativity. She loved mushrooms and fungi, and the circumstances of her life in the English countryside gave her opportunity to pursue this interest seriously. She was a busy wife and mother with many responsibilities. Nevertheless, throughout the 1840s and 1850s, she learned about mushrooms firsthand by collecting specimens near her home with help from her children and others. Hussey studied elementary books and drew and painted fungi, sometimes for eight hours a day.[11] During the 1840s she exchanged letters and specimens with the fungi expert Miles Berkeley, and their unpublished correspondence is a window onto a Victorian woman's keen involvement in nature study. At one point she wrote to him,

I was asked today to state how much I know of mycology and could only say very little—but I hope to fulfill any promise I make—I am not the sort of person to venture beyond my depth, I hope—at any rate I can hold out a hand to guide in shallow waters if I cannot venture into the swell of the Atlantic. I *can* paint—that I am sure of.[12]

Hussey put together a series of what she called "portraits" of fungi. These were issued in monthly parts, each with three colored lithographs, and later published in two volumes as *Illustrations of British Mycology* (1847–55), containing 140 plates. Her book was quarto sized and expensive, and was geared more toward the British drawing room than a botanist's study or the library of a scientific institution. But amateurs and professionals alike could find much of interest in Hussey's attention to relatively unstudied cryptogamic plants such as fungi, mosses, and lichens. Hussey's publication was a welcome contribution to public taste because it combined technical information about a specific grouping of fungi with lively descriptions and informal, almost chatty, anecdotes. Her practice was to blend botanical commentary with information about the habitats of her specimens, and then to make remarks that would bring this world to life. Thus, along with long descriptions of particular species, she discussed legends about fairies connected with fungi and inserted a recipe for making a giant-puffball omelet. *Illustrations of British Mycology* showed a voluble and energetic woman on a mission to promote her favorite area of natural history. Hussey spoke from her heart when she wrote in the text that accompanied her portrait of a boletus mushroom, "Some may worship Flora, others revere Ceres and rejoice in

Pomona, but to what goddess of woods and fields shall we dedicate Mycology? What umbrage-screened dryad or dewy-buskined nymph will protect and bring into fashion the useful and beautiful among the fungus tribes?"[13] (Fig. 5.4)

The Victorian eye and the Victorian collecting spirit found much to linger over in their native land, and tastes were eclectic. The abundance and variety of the plant kingdom captured the imagination. Just as Pratt promoted the charms of popular local favorites, and Hussey rhapsodized over mushrooms, so others reveled in native grasses or the enticing and mysterious world of seaweeds. But the world of exotics also beckoned. Botanists traveled abroad to compile information about plants in British dominions, and collectors and colonists sent plants from Canada, India, and elsewhere, to be stockpiled at Kew, the botanical heart of the Empire. New technologies made it possible to bring more specimens home alive to display them in botanical gardens or in window and balcony gardens. In 1837, a plant explorer came upon a gigantic water lily in the Amazon in British Guiana, and sent plants back to England. Reports circulated widely about the size and magnificence of the leaves and its flowers. Named *Victoria regia* (now known as *Victoria amazonica*), the plant became a Victorian sensation, the object of publications for specialists and for a general public that was curious about rarities (Fig. 5.5). The structure of the water lily's capacious and deeply veined leaf became the model for Joseph Paxton when he proposed the architectural design of the Crystal Palace at the Great Exhibition of 1851. Botany and empire cross-fertilized at the Great Exhibition, for the actual structure of the Crystal Palace was a greenhouse. A visitor walking down the main avenue, passing gigantic ferns and dramatic trees, saw England's native treasures, but her eye also was drawn outward to worlds of wonder in Britain's far-flung dominions. Displaying plants and flowers from many lands, the Crystal Palace opened the eyes of visitors to the industrial and natural productions of colonies abroad.

By the 1850s and 1860s, natural history interests had begun to stratify into modern scientific disciplines with their own learned societies and specialist publications. Because the study of nature was becoming more technical, a growing number of popularizers stepped forward at this time who could mediate new information for different groups of readers. The example of the author Elizabeth Twining shows that women played an important role in this part of the culture of natural history, too. Twining had a deep interest in expanding her readers' understanding of foreign flora. Her interests and publications mirror natural history enthusiasms at home as well as those that were extending out to new horizons elsewhere. A writer of instructional books about plants for young people, adults, and teachers, she also assiduously promoted knowledge of natural history for working-class enthusiasts.[14] Twining is celebrated now for her *Illustrations of the Natural Orders of Plants*

(1849–55) in which 160 plates depict examples of plants that belong to the system of plant classification that had by then replaced the earlier popular Linnaean system. But she had larger agendas than taxonomy and botanical art. An educator and philanthropist with a religious sensibility and a powerful social conscience, she wanted readers to apply knowledge of natural history for their own health and well-being. Twining promoted window-box gardening, for example, as one way for city dwellers to learn that clean air and water were beneficial to plants and also to people.

Twining particularly wanted readers to expand their mental, geographical, and scientific horizons well beyond Britain. A member of the family whose estates played such an important part in the tea trade across the British Empire, she endeavored to connect Britain to the wider world through her botanical work. In *Illustrations of the Natural Orders of Plants* she deliberately drew both native plants and foreign examples of species, and focused attention on the geographical distribution of plants across many parts of the world. That same cross-border spirit shaped *The Plant World* (1866), an introductory book for young readers. There Twining used non-technical language to explain the structure of plants and to discuss plants of particular use to humankind. She chose examples that ranged across the world, from rice in the Carolinas to mangoes in the East Indies and from parsnips in Guernsey to cotton in the West Indies.

Writing in the years after the Great Exhibition of 1851, Twining made the larger world her terrain, and promoted natural history as an essential part of education for all ages and social classes. Her popularizing botany books and illustrations show how much people's horizons expanded in the 1800s. At the beginning of the century Priscilla Wakefield's family had toured around the British Empire at home, but 60 years later readers of Twining's botany book journeyed out to many foreign shores. Victorians were discovering new worlds through flora and fauna, and women reaped many benefits from the excitement about natural history. Botanical culture also whetted their appetites for knowledge about the world at home and beyond British coastlines. Natural history culture also opened doors for women to other artistic and scientific arenas. Whether they worked on their own or in the company of families, women found intellectual and social pleasures in natural history activities. Despite restricted social roles, natural history gave women areas for growth and strategies for observing, learning, teaching, and writing about nature.

Notes

1. Priscilla Wakefield, *A Family Tour of the British Empire* (London: Darton & Harvey, 1804), 2.
2. N. Jardine et al., *Cultures of Natural History* (Cambridge: Cambridge University Press, 1996); David Elliston Allen, ed., *The Naturalist in Britain* (Princeton: Princeton University Press, 1994).

3. Elizabeth Kent, *Flora Domestica, or the Portable Flower-Garden* (London: Taylor & Hessey, 1823).

4. *Lady's Magazine* 36 (1805): iii.

5. Mrs. E. E. Perkins, *Elements of Botany* (London: Hurst, 1837), xvii–xviii.

6. Perkins, *Elements of Botany*, xxiii.

7. Mrs. Loudon, *Modern Botany: or, A Popular Introduction to the Natural System of Plants*, edn. 2 (London: John Murray, 1851), vi.

8. Ann B. Shteir, *Cultivating Women, Cultivating Science: Flora's Daughters and Botany in England, 1760 to 1860* (Baltimore: Johns Hopkins University Press, 1996), 120–35.

9. Donald deB. Beaver, "Writing natural history for survival – 1820–1856: The Case of Sarah Bowdich, later Sarah Lee," *Archives of Natural History* 26 (1999).

10. See R.M. Hamilton, "Miss Drake" – *Sarah Anne Drake (1803–1855) The Botanical Artist: Biographical Details and Finding-lists of her Works*, Richmond, B.C.: Orchid History Reference Paper No. 28, 2000, esp. pp. 7–29.

11. Shteir, *Cultivating Women*, 208–16.

12. Anna Maria Hussey, undated letter to Miles Berkeley, Berkeley Correspondence, Natural History Museum, London.

13. Mrs. T. J. Hussey, *Illustrations of British Mycology*, ser. 2 (London: Lovell Reeve, 1825), plate 25.

14. Ann B. Shteir, "Elegant Recreations? Configuring Science Writing for Women," *Victorian Science in Context*, Bernard Lightman, ed (Chicago: University of Chicago Press, 1997), 246–7; Barbara T. Gates, *Kindred Nature: Victorian and Edwardian Women Embrace the Living World* (Chicago: University of Chicago Press, 1998), 46–8.

Shifting continents, shifting species: Louisa Anne Meredith at "home" in Tasmania

Barbara T. Gates

Intrepid women like Louisa Anne Meredith (1812–95), a British writer and painter living in Tasmania were invaluable in cataloging the outposts of the British Empire with their collecting, their illustrations, and their books. Sara Mills believes that such women "produced a vision of the colonized country as a storehouse of random flora and fauna waiting for the civilizing order of the narrator with her Western science."[1] Western taxonomic science was not, however, "their" science: gatherers, observers, and recorders they were, namers they were not. When they reached a general public hungry for news of scientific discovery, most functioned more as interpreters of what they saw with their own eyes than as originators of scientific knowledge or theory.[2] If, as cultural critic Gillian Beer suggests, natural history writing served as a "sub-genre"[3] in the imperialist enterprise, particularly when it came to exploration, then they belonged to an underclass of writers. But if we look at their roles in natural history illustration and education, these women appear invaluable to their cultures. Serving a function quite different from "high" science, their writings, drawings, and paintings of natural history purposefully made arcane or inaccessible knowledge public and accessible.

In an 1845 review of books by women travelers, Lady Eastlake (Elizabeth Rigby) captured something of their cultural importance. She singled out Meredith's *Notes and Sketches of New South Wales during a Residence in that Colony from 1839–1844* (1844) as having "a separate attraction of its own in the valuable store of natural history it communicates."[4] Her review is especially informative in terms of the audience it reveals:

Birds and beasts, fishes and insects, and creeping things innumerable equally engage her intelligent attention, and are described with a simplicity and precision which will give much valuable information to the professed naturalist, no additional jargon to the dabbling amateur, and involuntary interest to the most uninitiated. Not a trace of pedantry appears, nor of what is quite as bad, and too frequent when women treat such matters—not the slightest affectation of a popular tone. Not a microscope nor a

herbarium is seen; but keen eyes and taper [*sic*] fingers, and a most active mind it is evident have been at work.[5]

These comments in the *Quarterly Review* shadow the intelligent audience for which a colonial writer of natural history might aim: the general reader interested in natural science in the far-flung corners of the Empire who might resent condescension. They also suggest one important reason why we today have been slow to write colonial women naturalists and illustrators into either the history of colonization or the history of science: we have marginalized their media because we have underestimated their audience. Sara Mills again gives only a part of the story when she writes that the experience of women travelers remained "eccentric" because it "could not be generalized to refer to other women."[6] Other women, and men and children too, were hungry for new information about the world's flora and fauna and ready to read or view information from anyone who could describe this exotic world outside Britain.

Meredith is an interesting figure in the history of natural history study. She began her career as a British artist and writer but eventually became an Australian colonist with special insights into antipodean species—insights unavailable to all but long-term, firsthand observers. In England, and under her maiden name of Twamley, Meredith began her formal literary career as a poet and her artistic career as a portrait painter and illustrator. Both careers engaged her in the 1820s and 1830s when, as a young woman, she lived in Birmingham and traveled in artistic circles. She was quickly recognized as a woman of talent and advised as an artist by Sir Thomas Lawrence, President of the Royal Academy. As a poet, she found her early work praised by the famous author and editor Leigh Hunt, who wrote that her pen and pencil gave "promise like Spring."[7] In addition, from an early age Louisa Twamley spent many hours out of doors, studying and painting flowers from nature. In the later 1830s she published *The Romance of Nature; or The Flower Seasons Illustrated* (1836) and *Our Wildflowers Familiarly Described and Illustrated* (1839). Thus from the beginning, writing, painting, and botanical study captured Meredith's imagination.

Throughout this time period, Twamley's family was in frequent touch with the Merediths, relatives who had emigrated to Tasmania. George Meredith, Louisa's uncle, asked her to come out to Australia to act as governess for his children. Mindful of her accomplishments and her place in Birmingham circles, Louisa soundly refused. Despite her prized collection of natural history objects from Tasmania and her curiosity about the colony, her interest in emigration was nil. "Can you imagine," she wrote to her uncle, "that anyone of my habits and pursuits could bear the estrangement from all the many delights afforded them by living in a civilized (pardon the word) country among friends whom, did I choose or could I afford it, I might speedily extend to a much larger circle" (18 May 1833).[8] Nevertheless, when

Charles Meredith, George's son and Louisa's contemporary, came to England for a visit a few years later, Louisa became enamored of her handsome cousin and rethought her decision to travel to Australia. Despite Louisa's disdain for a puny blue gum tree the two saw together at the Birmingham Botanical Garden and her fears that trees like its own larger relatives in Australia might little delight the natural historian in her, Louisa overcame her resistance to the "uncivilized" outback and consented to marry Charles. The two sailed together in 1839, intending to stay in Australia for only about five years.

In the early years in Australia, Louisa Anne Meredith continued to write for a "home audience," by which she meant people in Britain who might be fascinated by the exotics of the world "Down Under." Only slowly Tasmania came to represent Meredith's new "home," a word she would use in several of the titles of her books on Tasmania. The preface to her first Australian work, *Notes and Sketches of New South Wales*, the book that Lady Eastlake reviewed, offers its subject knowing that many British were still quite unaware of those parts of the world to which their country had laid claim. In Meredith's words: "Many persons at 'Home' are deeply interested in these distant colonies, as being the residence of dear friends and relatives … As in the case of my own home-connections, they really understand very little of the general aspect of things here." She goes on: "I believed that a few simple sketches from nature, however devoid of scientific lore, would be a welcome addition to the present small fund of information on common every-day topics relating to these antipodean climes."[9] Some 40 years later in the preface to one of her last works, *Tasmanian Friends and Foes: Feathered, Furred, and Finned* (1880), Meredith still hoped to engage the interest of British audiences.

Throughout her career, Meredith's publishers were in London, not Australia, and Meredith consistently found a large part of her readership in England, although she also enjoyed popularity in America and Australia. With the exception of her final book, Meredith sent off all her manuscripts— the written text and the pictures—to England in a package, and these were returned only after printing. The bulk of Meredith's work was thus not corrected by the author/illustrator herself, something that often tormented Meredith, especially when she got back printed text with misspellings or lithography that did not exactly reproduce what she wanted represented. She insisted on sending some of her early sketches to one of the Dalziel brothers, the famous engravers of the Pre-Raphaelites, in order to get something closer to what she had in mind. As she said, "a clever and judicious engraver can make a charming picture out of next to nothing—and … a dolt can render such a clumsy version of excellence, as to make it seem below mediocrity."[10]

The Merediths lived in Australia for all of their lives after marriage, although as an elderly woman, Louisa did return to England for her one and only visit to that first island home. All in all, Meredith would write five books

about Tasmania: *My Home in Tasmania; or, Nine Years in Australia* (1852), *Some of My Bush Friends in Tasmania* (1860), *Our Island Home: A Tasmanian Sketch Book* (1879), *Tasmanian Friends and Foes, Feathered, Furred, and Finned* (1880), and when she was 79, *Last Series: Bush Friends in Tasmania* (1891). The books are of several sorts: *My Home in Tasmania* is a travel account, with descriptions of the settlement, the settlers, and their ways—but also the ways of Tasmanian plants and animals. It contains reproductions of black-and-white pen-and-ink drawings. By way of contrast, the *Bush Friends* books are both brilliantly illustrated folios with elaborate prose and poetic descriptions of the plates. *Our Island Home* is also amply illustrated, printed in autotype from the author's pencil illustrations. And *Tasmanian Friends and Foes* is a popular science book for children, modeled on earlier books like Jane Loudon's, which tell the stories of a family learning together about the wonders of the natural world. It too is amply illustrated, often with brilliantly tinted plates. Meredith's travel books, including *My Home in Tasmania*, established her popularity; her other works represent Meredith's deepening interest in the natural world around her.

Meredith was always fascinated by the native flora as well as the fauna that lived nearest to hand. In her *Romance of Nature*, the early book written and illustrated in England, she acknowledged to her readers: "Need I say that the Wild Flowers of my own fair land are dearer to me than any others?"[11] *Romance* slightly anticipated the fashion for books featuring illustrations complemented by poems and was therefore considered by Meredith to "be essentially different from that of any contemporary work on Flowers."[12] Nevertheless, Meredith was better known for the books she produced later on, in her second homeland. Books combining flower painting and poetry became commonplace in Great Britain, and many were as beautiful as hers. In the Tasmanian books, on the other hand, Meredith presented a new "fair land" with a growing sense of scientific authority. The exoticism inherent in imperial outposts gave women like Meredith not just a subject but also a momentary scientific status they were not granted in Britain. Out in the colonies, with opportunities to witness what others could not, they gained authority largely in proportion to their remove from English society.

As Meredith's knowledge of native species grew, her writing changed. Take for example her discussion of the waratah, an Australian wildflower described both in the earlier *Notes and Sketches of New South Wales* (1844) and in the later *Some of My Bush Friends in Tasmania* (1860). In *Notes and Sketches* Meredith characterizes the flower like the novice in Australiana that she is:

I had often been told of the Awaratah (*Telopea speciocissima*), and its grand appearance when growing; and as we drove along, instantly recognised from the description of the first of these magnificent flowers we saw, and soon after came more into their especial region, which is about half-way up the height of the mountains, few being seen either

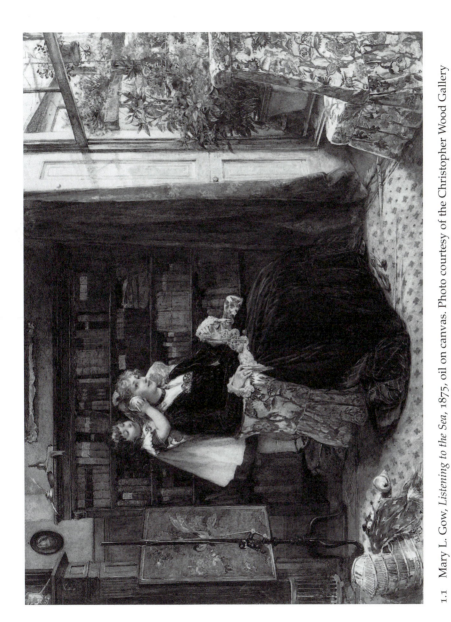

1.1 Mary L. Gow, *Listening to the Sea*, 1875, oil on canvas. Photo courtesy of the Christopher Wood Gallery

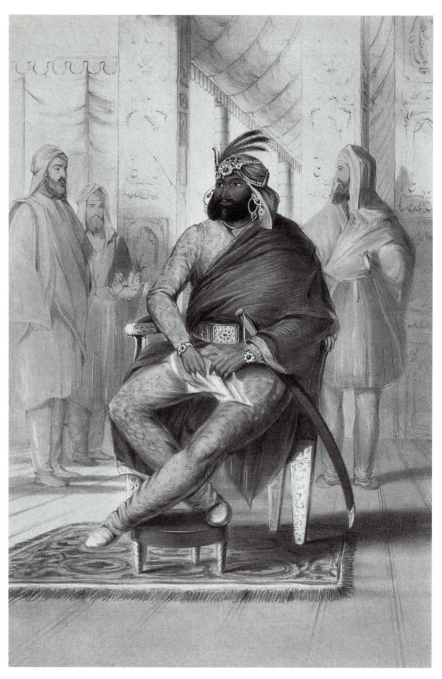

1.2 Emily Eden, *Maharaja Shere Singh*, 1844, chromolithograph. Gift of the Kapany Collection, 1998.63.2 © Asian Art Museum of San Francisco. Used by permission

2.1　Dining Saloon, from Annie Brassey's *Sunshine and Storm*, 1880, engraving

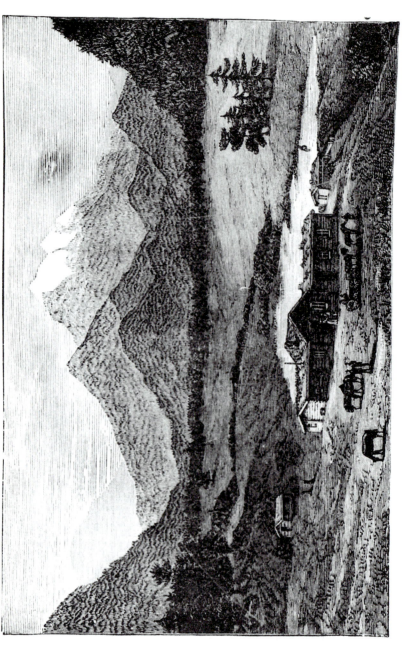

2.2 *My Home in the Rocky Mountains*, from Isabella L. Bird's *A Lady's Life in the Rocky Mountains*, 1879, engraving

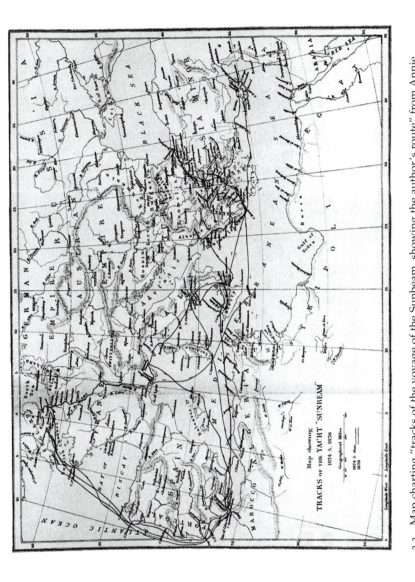

2.3 Map charting "tracks of the voyage of the Sunbeam, showing the author's route" from Annie Brassey's *Sunshine and Storm*, 1880, engraving

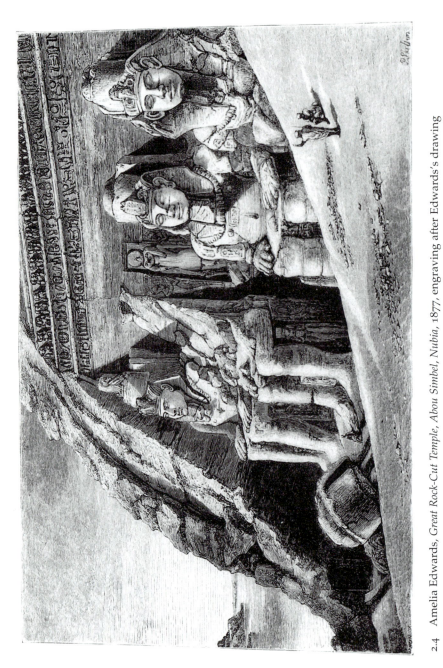

2.4 Amelia Edwards, *Great Rock-Cut Temple, Abou Simbel, Nubia*, 1877, engraving after Edwards's drawing

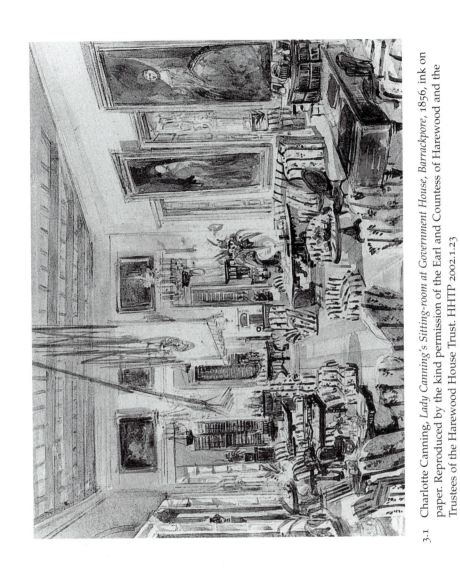

3.1 Charlotte Canning, *Lady Canning's Sitting-room at Government House, Barrackpore*, 1856, ink on paper. Reproduced by the kind permission of the Earl and Countess of Harewood and the Trustees of the Harewood House Trust. HHTP 2002.1.23

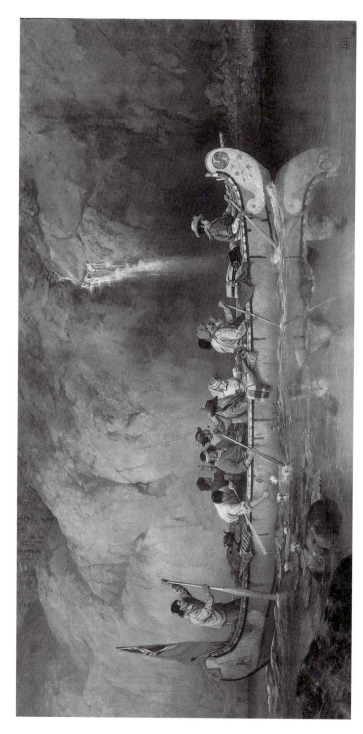

3.2 Frances Anne Hopkins, *Canoe Manned by Voyageurs Passing a Waterfall*, 1869, oil on canvas, National Archives of Canada, Ottawa (C-002771)

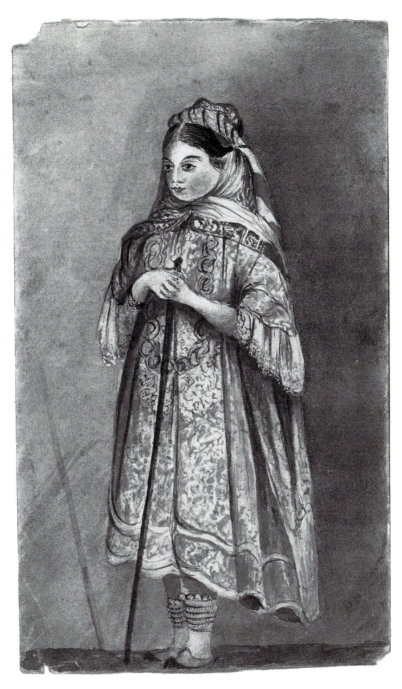

3.3 Charlotte Inglefield, *Jewish Girl in Full Costume*, n.d., watercolor on paper, V&A Images/Victoria and Albert Museum, Searight Collection

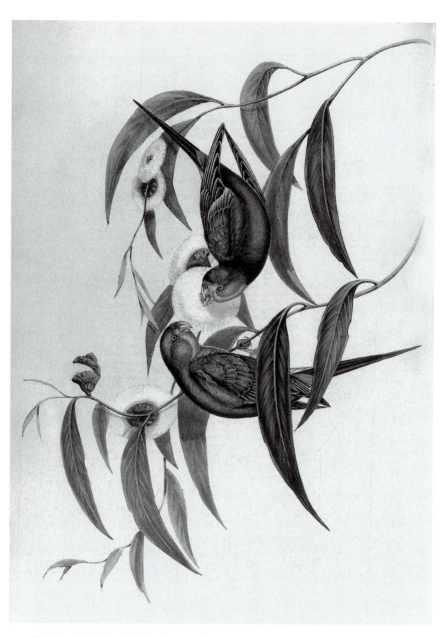

3.4 Elizabeth Gould, *Swift Lorikeet*, *c.* 1840–41, watercolor on paper, from John Gould's *Birds of Australia*, London: printed by R. and J. E. Taylor, published by the author, 1848. Courtesy of the Division of Rare and Manuscript Collections, Cornell University Library

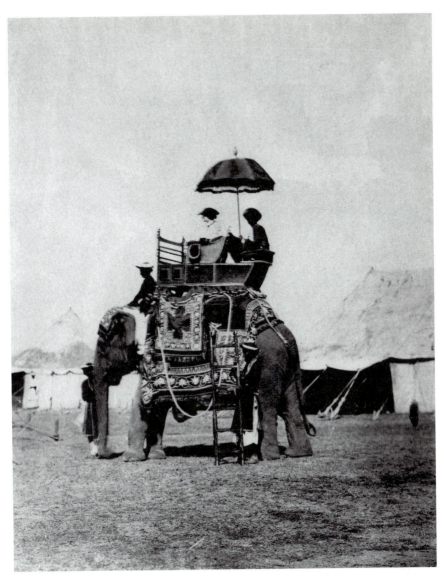

3.5 Photograph of Lady Charlotte Canning seated on an elephant, *c*. late 1850s. By permission of The British Library

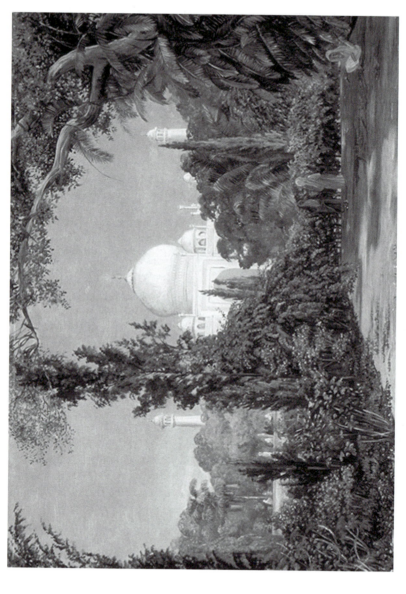

4.1 Marianne North, *Taj Mahal at Agra*, 1878, oil on newsprint mounted on board. Reproduced with the kind permission of the Director and the Board of Trustees, Royal Botanic Gardens, Kew

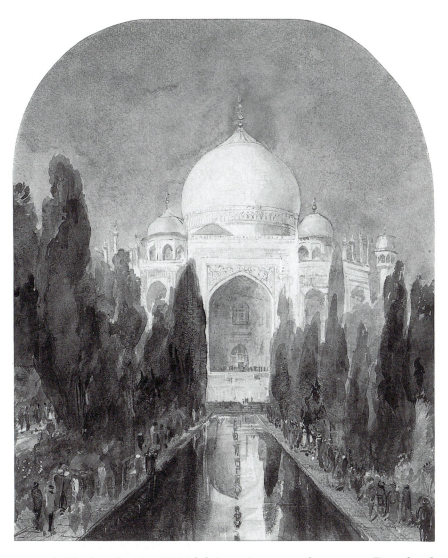

4.2 Lady Charlotte Canning, *Taj Mahal, Agra*, 1859, watercolor on paper. Reproduced by the kind permission of the Earl and Countess of Harewood and the Trustees of the Harewood House Trust. HHTP 2002.1.48

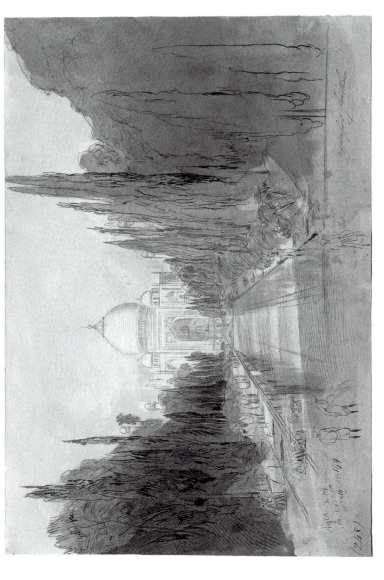

4.3 Edward Lear, *Agra: The Taj, 15/16 February 1874*, 1874, watercolor and sepia ink over graphite on paper, Edward Lear Drawings and Manuscripts, Agra (248), Oversize Box 5 [1728], Department of Printing and Graphic Arts, Houghton Library, Harvard College Library

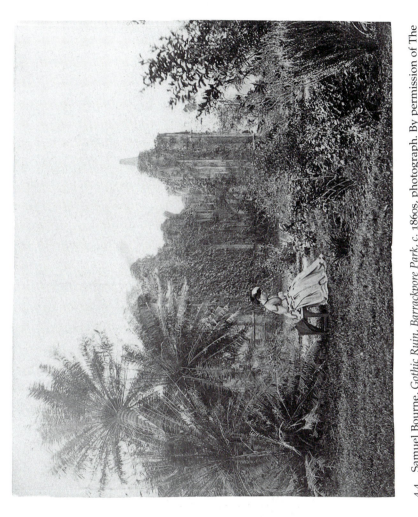

4.4 Samuel Bourne, *Gothic Ruin, Barrackpore Park*, c. 1860s, photograph. By permission of The British Library, photo 29/53

ORNAMENTAL LEATHER WORK.

No. 2.—5. THE HOP PATTERN.—The stem is rough and square, and with the leaves, is formed as usual. The capsules are formed by uniting from 30 to 35 pieces of the sizes A and B (Fig. 16), round, irregular, and signed strips of leather, so as to represent the strobiles, and fastening them as usual.

No. 2.—6. FUCHSIA PATTERN.—The stem is round and smooth externally.

No. 3.—FLOWERS, FOLIAGE, &c.

Let those who would become proficient in the art of constructing flowers or foliage in leather, study Nature in all her varied forms, in the school of the broad fields, the wild hedges, or the cultivated pastures. Amid the surrounding grasses, let the student copy, by the aid of drawings or processes we shall name hereafter, the varied and graceful curves of outline, the structure, and peculiarities of each species. Furnished with a number of patterns and designs, the operator is in a proper condition to commence manipulating.

The materials required are the same as for the other work we have described, and the mode of operating almost similar; but there are some peculiarities which require notice; viz, The

No. 3. FLOWERS, FOLIAGE, &c.

the three largest placed at the base of the corolla, while the other two are placed superiorly.

The style and eight stamens—for the flower belongs to the class *octandria*, order *monogynia*—must now be formed in the manner pointed out in our last paper, and the base of the whole being smeared with the liquid glue, they must be pressed into the centre, and the complete flower varnished when dry.

The palmate leaves are made as usual; the stem,

Fig. 20.

however, is inserted into the under part at A (Fig. 20), by piercing in an oblique direction, as in the shaded part above A.

The seed-vessel is made by meaning a strip of leather, rolling it into the proper shape, and then indenting it with a porcupine's quill, so as to give the furrowed appearance.

The *Ground-Ivy* (*Glechoma hederacea*), has a

Fig. 21.

square, rough stem, which may be made of roll leather, or two strips of basil glued together; it

Nasturtium (as it is generally called) or *Tropaeolum*, has a one-leaved calyx, having five cloths,

Fig. 17.

and spurred. This part is made by cutting out a piece of leather of the size and form given in Fig. 17, bevelling off the edges, and bringing the parts a, b, c, d, together, so that the whole shall represent the calyx of the flower, with its characteristic spur.

The next part to be formed is the stem, which is made as usual of a strip of leather, and affixed by liquid glue to the parts a, c, when brought together. It is better to have a small wire (.) through the centre of the stem, in order to give it firmness.

The next parts to be formed are the petals, which are five, and unequal, consisting of two

Fig. 18. Fig. 19.

of the same shape and form as Fig. 18, and three of the same as Fig. 19. These are made by placing the pattern upon the leather, and proceeding as if forming a leaf; the edges are then bevelled off, the surface moistened by dipping the leather petal into cold water, or wiping it with a wet sponge, and the veining executed as usual, in the direction of the dark lines.

Fig. 19 requires the parts a and b to be carefully cut out with a sharp penknife.

The calyx are then to be smeared with liquid glue, and the petals arranged as in the usual flower, each petal alternating with a cleft of the calyx; the edges of each petal being somewhat everted, and

5.1 Illustration from *Elegant Arts for Ladies*, c. 1850s

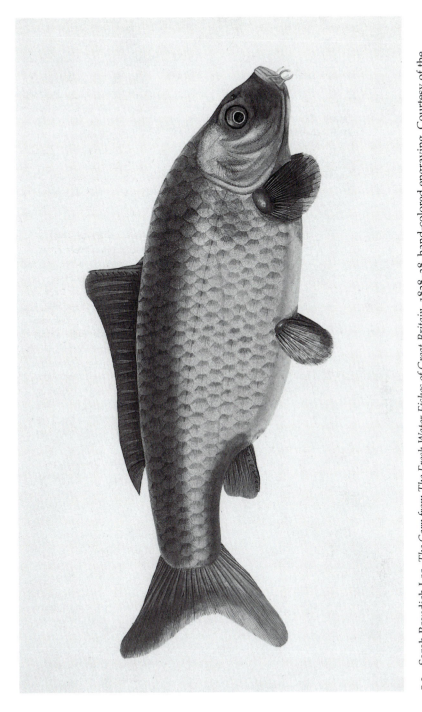

5.2　Sarah Bowdich Lee, *The Carp from The Fresh Water Fishes of Great Britain*, 1828–38, hand-colored engraving. Courtesy of the Chapin Library of Rare Books, Williams College

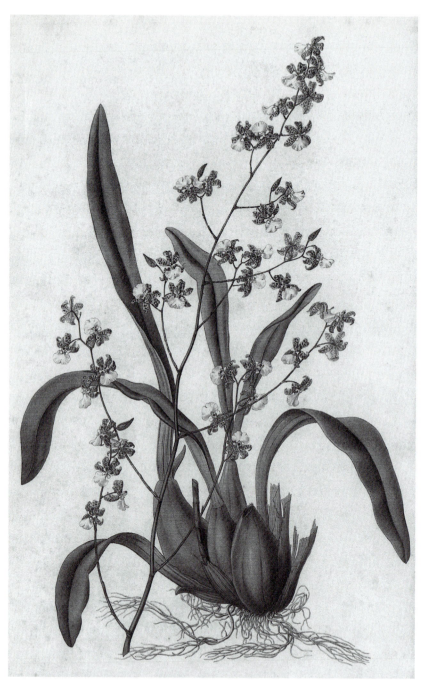

5.3 Sarah Anne Drake, *Oncidium leucocorbilum* from John Bateman's *Orchidaceae of Mexico and Guatemala*, 1837–43

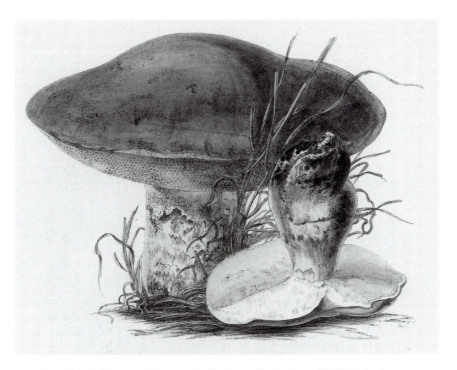

5.4 Anna Maria Hussey, *Boletus aestivalis*, from *Illustrations of British Mycology*, 1847–55

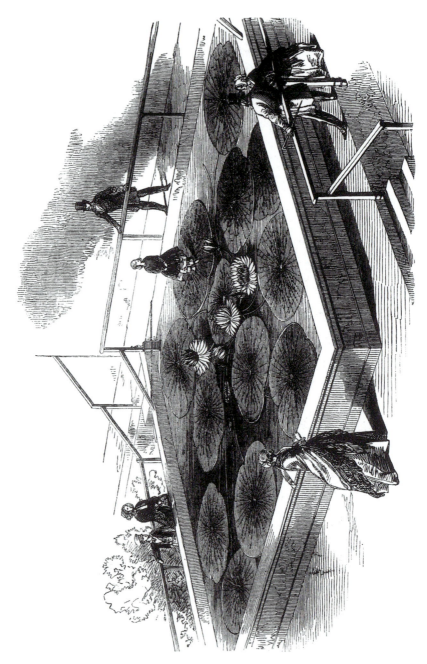

5.5 Illustration from the *Illustrated London News*, The Gigantic Water-Lily (*Victoria regia*), in Flower at Chatsworth, 1840

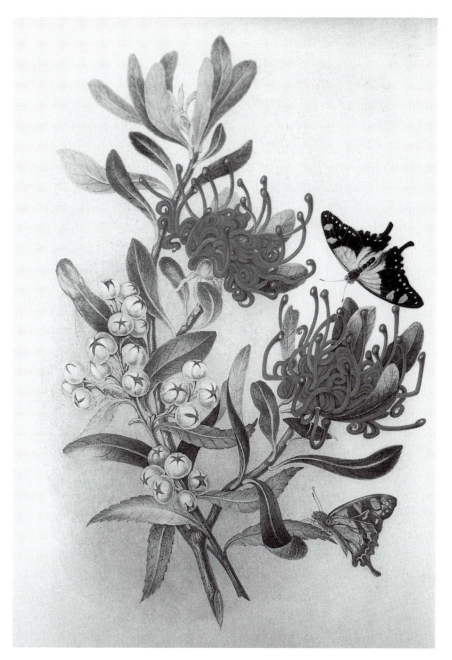

6.1 Louisa Anne Meredith, *Waratah and Native Arbutus*, from *Some of My Bush Friends in Tasmania: Native Flowers, Berries and Insects Drawn from Life, Illustrated in Verse and Briefy Described*, 1860, engraving, Tasmania Library, State Library of Tasmania

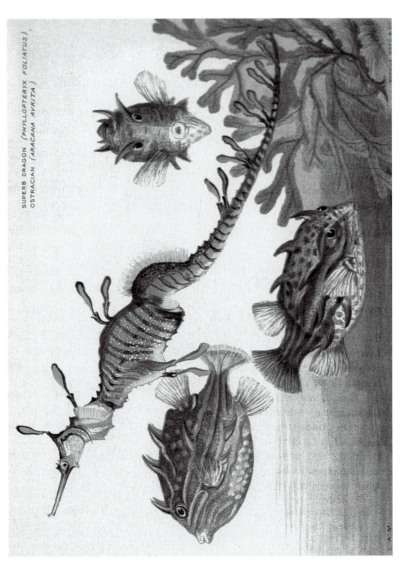

SUPERB DRAGON (PHYLLOPTERYX FOLIATUS).
OSTRACIAN (ARACANA AVRITA).

6.2 Louisa Anne Meredith, *Superb Dragon and Ostracian*, from *Tasmanian Friends and Foes: Feathered, Furred, and Finned*, 1880, engraving, Tasmania Library, State Library of Tasmania

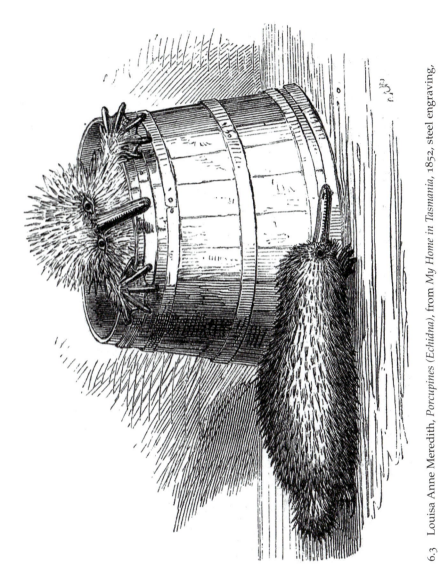

6.3 Louisa Anne Meredith, *Porcupines (Echidna)*, from *My Home in Tasmania*, 1852, steel engraving, Tasmania Library, State Library of Tasmania

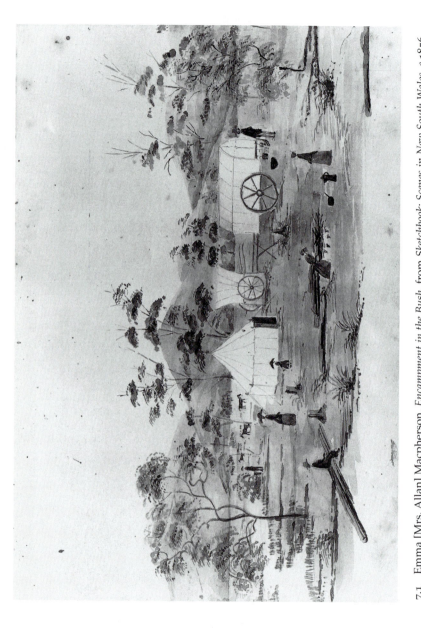

7.1 Emma [Mrs. Allan] Macpherson, *Encampment in the Bush*, from *Sketchbook: Scenes in New South Wales*, c.1856, watercolor, Mitchell Library, State Library of New South Wales

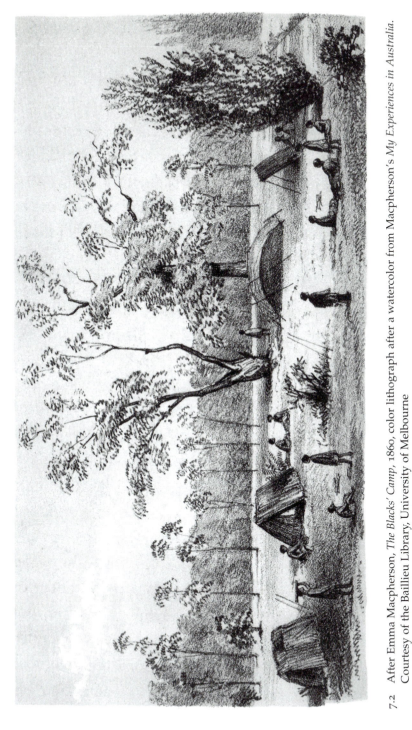

7.2 After Emma Macpherson, *The Blacks' Camp*, 1860, color lithograph after a watercolor from Macpherson's *My Experiences in Australia.* Courtesy of the Baillieu Library, University of Melbourne

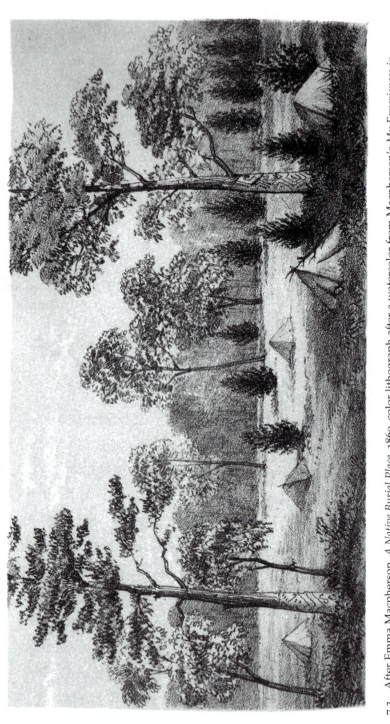

7.3 After Emma Macpherson, *A Native Burial Place*, 1860, color lithograph after a watercolor from Macpherson's *My Experiences in Australia*. Courtesy of the Baillieu Library, University of Melbourne

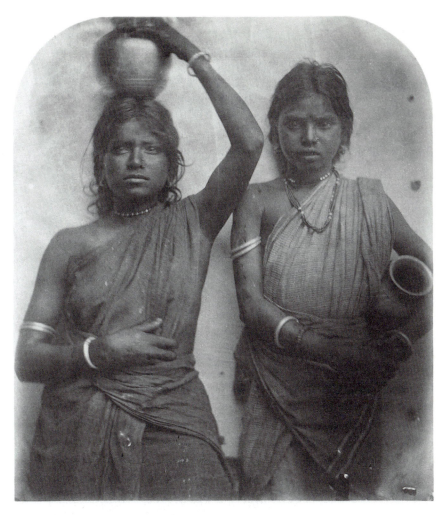

8.1 Julia Margaret Cameron, *Two Young Women, Ceylon, c.* 1875–79, silver-gelatin
 photograph, Art Institute of Chicago, 1970.839

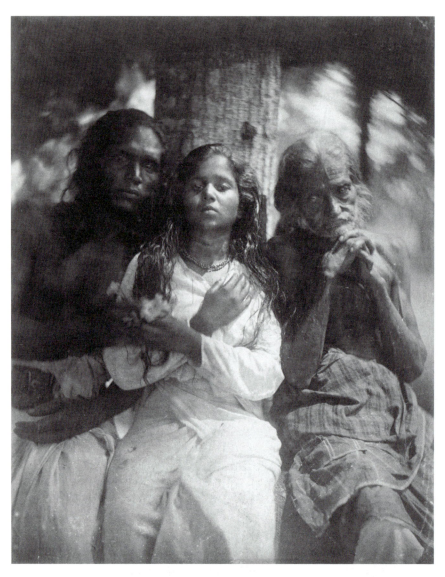

8.2 Julia Margaret Cameron, *A Group of Kalutara Peasants*, *c.* 1875-79, silver-gelatin
photograph, Royal Photographic Society Collection at The National Museum of
Photography, Film & Television, 2076.

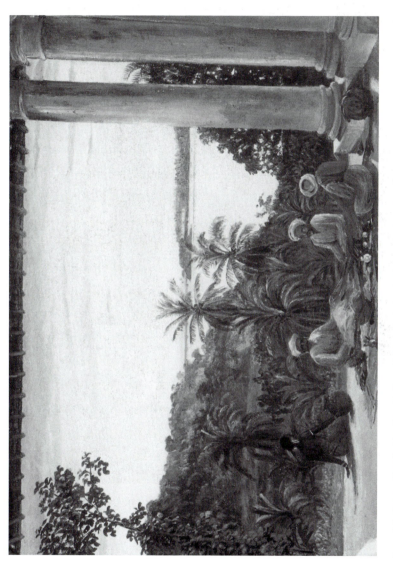

8.3 Marianne North, *Bombay Pedlars in Mrs. Cameron's Verandah, Kalutara, Ceylon*, 1876, oil on newsprint mounted on board, Marianne North Gallery, reproduced with the kind permission of the Director and the Board of Trustees, Royal Botanic Gardens, Kew

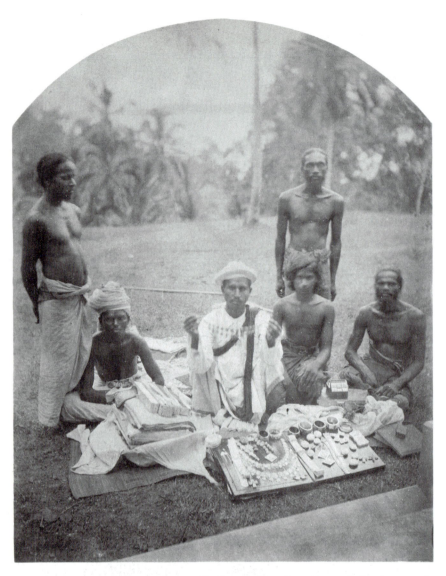

8.4 Julia Margaret Cameron, *Group of Pedlars, Ceylon*, 1877, silver-gelatin photograph, Royal Photographic Society Collection at The National Museum of Photography, Film & Television, Bradford, 2081.

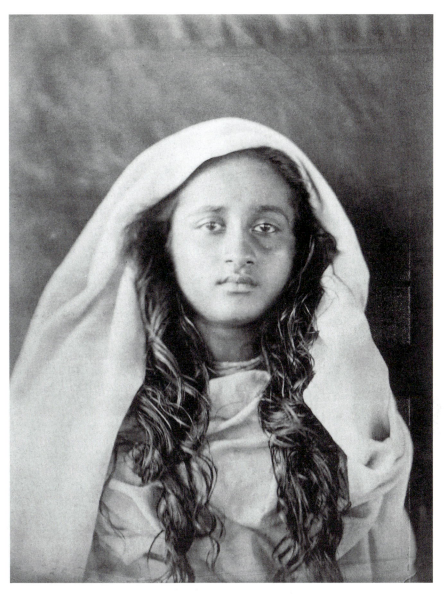

8.5 Julia Margaret Cameron, *Young Woman, Ceylon, c.* 1875–79, silver-gelatin
photograph, Art Institute of Chicago, 1970.841

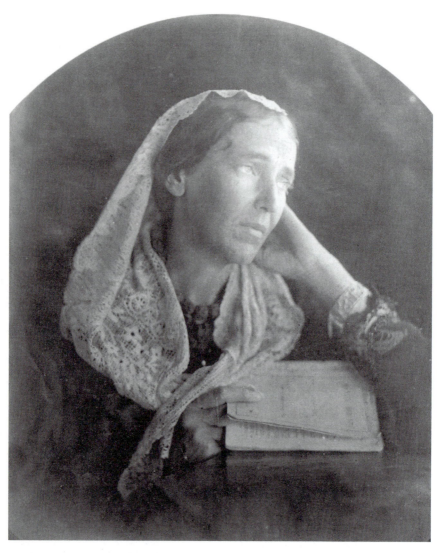

8.6 Julia Margaret Cameron, *Marianne North*, 1877, silver-gelatin photograph,
Victoria and Albert Museum

far above or below this range. From the temperature, I should think their cultivation at home would be easy, and it would well repay some pains to have such noble flowers added to the treasured wealth of English gardens … [Here follows a detailed, physical description of the flower.] Unfortunately I had no opportunity of making a drawing of one, having no materials at hand on our journey, and failed to procure a flower during our stay in Sydney. The few plates I have seen give but a very faint idea of this most stately and regal flower.[13]

The flower is still a stranger to Meredith here, thought of in the guise of something that could be transplanted to England, as were so many exotic species in Meredith's day. Note the differences in this description from *Bush Friends*, published 16 years later. The latter is more pointed, assured, and authoritative, and its verbal notes are accompanied by a vivid illustration:

Much as I admire our Tasmanian Waratah, I must at once explain that it is not *the* Waratah which astonished and dazzled me years ago, on the Blue Mountains of New South Wales; nor is it nearly equal in splendour to that gorgeous flower, which is not indigenous here. Ours, which I have drawn, is a very handsome shrub or low tree, growing in some parts of Mount Wellington, and near the Meander river. The flowers are in perfection about Christmas, and, judging from the merciless quantities which are brought down from the mountain into Hobarton, the trees are in danger of extermination. Many an evening bouquet and wreath for the hair is enriched by the glowing Waratah blossoms, which have a peculiarly *coralesque* character, enhanced by their encompassing polished rich green leaves, which usually close round the flower in a cup-like form; but those of the branch I copied, being more open than usual, were better suited for my purpose, as disclosing more of the flower. A large drop of clear bright honey lies at the base of each great stigma, whence the spreading divisions of the calyx turn over in curls, the stamens being placed in their ends; and thus are scarcely noticeable.[14] (Fig. 6.1)

In this second description Meredith has achieved an easy and appreciative familiarity with native species—to the point that she can tell a typical from an atypical branch or flower and can relate local customs surrounding the flower, even making a veiled plea for its preservation. The flower has become "ours," the Tasmanians', and is not thought of as an export.

Living far afield could thus afford colonial women specialized knowledge of natural history. When the *Tasmanian Journal of Natural Science* appeared in 1842, it suggested that "as colonization enlarges the territory of any civilized people, so also, as a necessary consequence, will the empire of science be widened and cultivated."[15] Meredith seized this opportunity for her own writing and illustration. As one of her characters in *Tasmanian Friends and Foes* says to a child: "Careful scientific descriptions of all these creatures have been written by learned naturalists for learned people; the only ground on which there is room for our pens is the familiar every-day knowledge of little habits and peculiarities, which the greatest professors at home cannot always observe for themselves."[16] In Australia Louisa Meredith could collect and witness at first hand things that scientists in South Kensington could see only

as dead specimens. Her science might be popular, but it had the distinct virtue of being based on living evidence.

Of this she was duly proud. In the preface to *Tasmanian Friends and Foes* she noted that

since writing the chapters on our native animals, I have, for the first time, read the following observations upon them in the article "Marsupialia" in *Chambers's Encyclopaedia*, vol. vi., p. 342:— "In accordance with this condition of the brain, these animals are all characterised by a low degree of intelligence, and are said (when in captivity) not to manifest any sign of recognition of their feeders."[17]

To this Meredith retorts, "whilst regretting that so unjustifiable an opinion should be held by men of science, I am fain to rejoice over those pages of my unpretending book, which I think will supply evidence that the engaging and affectionate animals whose brief memoirs they contain were far from deficient in intelligence."[18] She goes on: "I do not presume to offer scientific information on any subject, but have given the proper names of most objects alluded to, so that works of authority on Natural History may readily be consulted by the inquiring or studious reader."[19] Accordingly, she utilizes some of ornithologist John Gould's bird illustrations and the work of an Australian taxonomer to lend accuracy to her own observations, always paramount in her books.[20] All this rather complex arguing with its citing of experts is represented in a book designed especially for children, one meant to aid in their education to the wonders of the natural world. Even here, Meredith wanted it known that she herself took great pains to be both accurate and authoritative.

Nevertheless, Meredith's desire for scientific respectability did not detract from her lively and entertaining style of writing. In *Friends and Foes* she vividly introduced her audience to the distinctive and the odd in the Tasmanian natural world. Take the book's thirty-eighth chapter as an example. Here, a Mrs. Leslie introduces the beauties of the southern ocean to a group of youngsters. She first brings in a globe full of "fishy characters" like splendid Scarlet Dragon, exclaimed over by an excited young girl named Lina: "Wonderful creatures! … How splendid is that Scarlet Dragon shape, with blue, yellow, and purple markings! and dark red fins all down its tail, exactly like leaves of seaweed! Its head is something like a hippocampus, but so vivid in colour. And what a bright eye!"[21] (Fig. 6.2) So as not to interrupt the raptures of her young viewer, Meredith moves to the bottom of the page to footnote the dragon's scientific name, *Phillopteryx foliatus*. Nothing must contain Lina's enthusiasm as she unfolds multiple wrappings of kelp to expose yet other wonders of the sea, all depicted in Meredith's eighth plate. More raptures ensue as Lina continues "that must be the jewel-fish that old Donald said I should find. He said it glittered and shone 'all manner o' colours,' as he pulled it up, 'like the Queen's crown in the Tower of London.' "[22] With reference here both to the new home and the old, to working classes

and to middle-class children and adults, Meredith—by means of her fictional characters and her footnotes—covers a multiplicity of possible audiences for her writing.

At the same time she glosses her written text with her picture and her picture with her written text, dressing up the one with the other. Meredith calls special attention to her rendering of the outrageous and stunning sea creatures when her narrator says: "Mrs. Leslie used all diligence in making accurate portraits of the fish, often complaining that no tints her palette could furnish were able to realise half their beauty ... The 'Superb Dragon' is very rare."[23] Here Mrs. Leslie bears the role of the illustrator of natural history writing, giving Meredith the chance to comment on the art complementing the written text. The natural history artist, she suggests, is beholden alike to viewers and to a brilliant natural world beyond the human mind and the paintbrush, and this is not always a comfortable situation. Being an artist in two media did indeed cause Meredith some unease, perhaps because she wanted most of all to be considered a writer, aware, as she must have been, of the stigma attached to women illustrators, who were considered second-class artists. After reviews of *Some of My Bush Friends in Tasmania* appeared, she wrote to Sir Henry Parkes, a personal friend, "I feel very keenly the mischief I have done myself by being an artist. Because my books are illustrated by my own pencil they are reviewed as picture-books chiefly."[24]

Despite the authoritative ring and the brilliance of images so evident in *Tasmanian Friends and Foes*, Meredith's 1852 *My Home in Tasmania* remained her most popular book. It was also her most important in several ways. It was, for example, the first description of Tasmania produced by a female colonist. And it was so well received that it was issued in America a year after its publication in Britain. As the preface to the American edition (Bunce and Brother, 1852) said, the book represents more than "mere 'Extracts from a Diary' got up for the occasion, but the results of a long sojourn in the land ... to disabuse the public mind of many erroneous notions long associated with the name of Australia."[25] The popularity of *My Home* also stems in part from its fascinating digressions into anecdotes about pet animals, intended to give Meredith's readers a closer look at the behavior of native species via vignettes (Fig. 6.3). For example, a longish anecdote about Willy, the "spirit of fidget,"[26] features a tame possum's nocturnal antics around the author's home. These included keeping people awake most nights until it stormed, when the animal tucked itself into a hat for protection—much as it would have into a tree hole, had it been free to do so. In *My Home* Meredith did not set out to write a book about tamed animals but simply utilized anecdotes to help enhance interest in natural history. She carefully apologizes to the reader who might have expected purer science, and not a possum story: "If any of my readers find this memoir of a pet 'Phalanger,' somewhat prolix, they must attribute my

tediousness to my zeal for science, and my desire to make known whatever knowledge I may possess on this interesting subject … these creatures are not very well known."[27]

In *My Home in Tasmania* Meredith favored a number of strategies that lent status to her popular science writing. These strategies show Meredith in the process of transforming from a somewhat sentimental, English Louisa Twamley, flower painter and writer, to Louisa Anne Meredith, accurate recorder of Australian biodiversity. As Meredith began to feel a familiarity with the once odd creatures and plants she discussed and curiosities became things commonplace for her, she realized that she needed to alter the nature of her books to reveal her growing expertise. Despite her desire to be a popularizer of science, Meredith also knew there was a chance that she might uncover something scientifically new. As one of Meredith's characters reflected in the fictional *Tasmanian Friends and Foes*:

I remember an old friend in England, a good naturalist, who asked me to write descriptions of anything and everything I saw out here. He said, 'observe everything and describe everything. Ninety-nine things have probably been better done before, but the hundredth may be a welcome addition to general information.'[28]

It was, of course, always possible that Meredith herself might happen upon the so-far undiscovered.

In the meantime, Meredith authorized herself by contesting existing authorities and sources of knowledge when she could correct misinformation with her own firsthand observations. The common reader, she believed, should not be hoodwinked by so-called experts with insufficient hands-on knowledge of Tasmanian natural history. In *My Home*, Meredith set records straight in several ways. Here, as she would later do in *Tasmanian Friends and Foes*, she directly confronted wrong-headed contentions of presumed scientific writers, as in this passage on the importance of bushfires to the Australian landscape and animals:

A recent scientific writer (the Count Strzelecki), in treating of this colony, condemns the practice of burning, as seriously injurious to the pasturage, and seems to suppose that the custom originated with the colonists; whereas the aborigines practiced it constantly, knowing the advantages of destroying the dense growth of shrubs and coarse plants which cover the country in many parts, and spring up again after the fire with young and fresh shoots, which many of the wild animals then gladly feed on. The grass also grows again immediately after the fires and is greatly preferred by all animals to the old growth; whilst, for the destruction of tall ferns and scrub, it is rendered more accessible to them.[29]

Experts in all fields who might be inaccurate come in for Meredith's corrections. Even John Gould, whose bird pictures she used and greatly admired, is criticized. In discussing Australian oystercatchers, whose common Australian name was "red-bills," Meredith noted:

The figures of my favourite red-bills, under the name of "oyster-catchers" in Gould's "Birds of Australia," are less faithful than most of his admirable plates; they are too heavy-looking, and represent the bills and feet as orange-coloured, instead of their real hue of pure brilliant coral-red.[30]

If Meredith's Tasmanian painter's eye captured living things, Gould and his team of illustrators, she implies, often worked from dead skins and took no heed of native names of species that might be known to the non-experts for whom she wrote.

Another literary strategy Meredith used in her books of natural history was the invention of fictional characters that were interested in natural history but were misinformed. Such characters enabled her to correct commonly held misbeliefs and false information. For example, in describing the Australian magpie by indicating their warbling of "full, rich, deep tones," Meredith offers what she calls an "ample refutation of the assertion made by some unobservant person, and echoed by many thoughtless ones, that 'the Australian Birds have no song,' than which nothing can be more untrue."[31] In other books Meredith corrects confusions of Australian emus with African ostriches. Her reproofs via dummy characters, however, always come gently and are made in the name of learning. They are akin to Meredith's re-definitions of language for the non-Australian audience, as here:

Perhaps my use of the common colonial term 'marsh' may be misunderstood at home, as I remember that I myself associated it at first with the idea of a swamp; but a 'marsh' here is what would in England be called a meadow, with this difference, that in our marshes, until partially drained, a growth of tea-trees (*Leptospermus*) and rushes in some measure encumbers them.[32]

From this example, one readily sees the usefulness of Meredith's own double identity. "Marsh," as in the Tasmanian word, is in quotation marks, whereas meadow, as in the English word, is not. Yet in the end Meredith identifies with the Tasmanians, as in "our marshes." This double identity served her well; it maintained her authority as a colonial while it reinforced her ties to her original homeland.

Meredith's most powerful strategy for correcting ignorance of Tasmanian biology remains her own fine rendering, both in words and in pictures, of Australian natural history. From one of her word-pictures, the reader can easily visualize cockatoos digging for grubs near Meredith's home, the busy cockatoos with their "bowings and curtseyings, as they gravely moved about with their elegant golden crests alternately raised or depressed," the grubs "perfectly white, smooth, and rather glossy: more like models of grubs in white wax, than living things."[33] Or one can view her color plates and marvel with the children in *Tasmanian Friends and Foes* at the contrast between vibrant, living creatures with "droll little pursed-up mouths" and "eyes so clear and bright", so different from the "dry little mummy in my [natural history] cabinet."[34]

Offering a new sense of colonial natural history, Meredith thus traced for her readers a world they did not know. It seems appropriate that she should also preface *Tasmanian Friends and Foes* with this quote from Longfellow, found on the title page:

Oh! thou sculptor, painter, poet,
 Lay this lesson to thy heart;
That is best which liest nearest,
 Shape from that thy work of art

It seems appropriate, too, that Louisa Meredith was granted a pension not from the English but from the Tasmanian government for having "by her writings and paintings rendered considerable services to the cause of Science, Literature, and Art in Tasmania."[35] By this time, both her art and her heart had come to be at home in Tasmania, Van Diemen's land. Although she sent some objects and paintings to the Crystal Palace exhibition, Meredith herself traveled back to England only the one time. By then she was an elderly widow, accompanied by her granddaughter and namesake, who was herself a budding natural history painter. On this trip, she, like Mary Kingsley, carried exotic fish to Dr. Günther at the British Museum of Natural History in South Kensington. But, unlike Kingsley's, Meredith's were not decomposed specimens but accurate painted representations. Nevertheless the renowned Günther could not use them because he deemed them not accurate enough; Meredith had not numbered each fin and scale. Like the painstaking work of so many women naturalists in the nineteenth century, Meredith's does not therefore descend to us through the annals of science. Her painstakingly written and illustrated books are themselves our legacy, enabling us to feel vividly at home in another place and another time.

Notes

1. Sara Mills, "Knowledge, Gender, and Empire," *Writing Women and Space: Colonial and Postcolonial Geographies*. Alison Blunt and Gillian Rose, eds. (London: Guilford, 1994), 41.

2. Barbara T. Gates, *Kindred Nature: Victorian and Edwardian Women Embrace the Living World* (Chicago: University of Chicago Press, 1998), Chapter 3.

3. Gillian Beer, *Open Fields: Science in Cultural Encounter* (Oxford: Oxford University Press, 1996), 59.

4. Elizabeth Rigby, "Lady Travelers," *Quarterly Review* 76 (1845): 106.

5. Ibid.

6. Sara Mills, *Discourses of Difference: An Analysis of Women's Writing and Colonialism* (New York: Routledge, 1991), 119.

7. Leigh Hunt, *Blue Stocking Revels; or the Feast of the Violets*, canto 2, line 222. *The Poetical Works of Leigh Hunt* (London: George Routledge and Sons, 1860), 212.

8. Quoted in Vivienne Rae Ellis, *Louisa Anne Meredith: A Tigress in Exile* (Sandy Bay: Blubber Head Press, 1979), 37.

9. Louisa Anne Twamley Meredith, *Notes and Sketches of New South Wales during a Residence in that Colony from 1839 to 1844* (London: John Murray, 1844), vii.

10. Ellis, *Louisa Anne Meredith*, 191.

11. Louisa Anne Twamley Meredith, *The Romance of Nature; or, The Flower-Seasons Illustrated* (London: Charles Tilt, 1836), ix.

12. Meredith, *Romance of Nature*, xi.

13. Meredith, *Notes and Sketches of New South Wales*, 65.

14. Louisa Anne Twamley Meredith, *Some of My Bush Friends in Tasmania: Native Flowers, Berries and Insects Drawn from Life, Illustrated in Verse andBriefly Described* (London: Day and Son, 1860), description opposite plate iv.

15. Quoted in Judith Johnston, "The Very Poetry of Frogs: Louisa Anne Meredith in Australia," *Natural Eloquence: Women Reinscribe Science* (Madison: University of Wisconsin Press, 1997), 101.

16. Louisa Anne Twamley Meredith, *Tasmanian Friends and Foes: Feathered, Furred, and Finned* (London: Marcus Ward, 1880), 69.

17. Ibid., 3.

18. Ibid., 5.

19. Ibid.

20. John Gould's signing of all the plates "J & E Gould del et lith,",which only partially reveals his wife Elizabeth as the true illustrator, purposely muddled the authorship of the illustrations. See gates, *Kindred Nature*, 74.

21. Meredith, *Tasmanian Friends and Foes*, 247.

22. Ibid., 248.

23. Ibid., 249.

24. Quoted in Ellis, *Louisa Anne Meredith*, 191.

25. Ellis, *Louisa Anne Meredith*, 193.

26. Louisa Anne Twamley Meredith, *My Home in Tasmania during a Residence of Nine Years* (London: John Murray, 1852), 9.

27. Ibid., *My Home*, 13.

28. Meredith, *Tasmanian Friends and Foes*, 69.

29. Meredith, *My Home*, 108–109.

30. Ibid., 116.

31. Ibid., 235.

32. Ibid., 163.

33. Ibid., 232–3.

34. Ibid., 248.

35. Quoted in Ann Moyal, *"A Bright and Savage Land": Scientists in Colonial Australia* (Sydney: Collins, 1986), 115.

Emma Macpherson in the "blacks' camp" and other Australian interludes: a Scottish lady artist's tour in New South Wales in 1856–57

Caroline Jordan

In 1860 Emma Macpherson published a book called *My Experiences in Australia: Being Recollections of a Visit to the Australian Colonies in 1856–7* in London, under the pseudonym of "A Lady".[1] The book is illustrated with lithographic plates after her own drawings, most of which are contained in her original Australian sketchbook in Sydney's Mitchell Library. While Macpherson's literary reputation is small (her book has never been republished like those of her direct contemporaries, Louisa Anne Meredith and Ellen Clacy), and her artistic reputation is possibly even more modest, she does have a particular claim to fame as an artist of colonialism based on her lively written and pictorial descriptions of Aborigines.[2] Other colonial women artists occasionally drew or sculpted the indigenous Australians, but their images were not necessarily the product of sustained personal interactions as were Macpherson's.[3] Macpherson's images also have the advantage of an accompanying text, which gives valuable insights into her knowledge, opinions, prejudices, and negotiations with her "native informants," that at least in one instance, radically changes our reading of her drawing. Evidence of this degree of intimate cross-cultural exchange is therefore unusual to find at any time among colonial women artists in Australia and especially as late as the 1850s, and Macpherson knew its value. Her adventurous pictorializing in the "blacks' camp" was the highlight of her travels in Australia.

Like a contemporary tourist, Macpherson's journey owed much to visual sources. It was at least partially purposefully built around what we would call today "photo opportunities," and what were for her opportunities to sketch, either in word-picture or image. But Macpherson was more than just a tourist in Australia; she was also a squatter's wife whose travels were due to her husband's economic interests in the colonies.[4] When she visualized the country it was from the additional perspectives of a colonialist, a middle-class white woman, and a Scot. The ability to appreciate and represent the visual in

the colonies was a source of power and distinction for Macpherson. She used it to indicate her social superiority over servants and colonial women and, also, to establish her difference as a Scot from the English. This visual-based authority took on an imperialist form in Macpherson's collection and representation of flora and fauna in Australia. However, Macpherson's claims to power implied by her imperial gaze were unstable, and she often came away from her colonial encounters with rather less than she had hoped.

As with other Victorian women writers, the first test of Macpherson's authority was to justify going into print, in her case in the already saturated market for gold-rush travelers' narratives. David Goodman, who has made an extensive study of the genre, observes that this was perhaps *the* defining form of literature about Australia in the 1850s.[5] Macpherson herself remarks, "so much has been written of late years about the Australian colonies, that it may seem at first sight that there is nothing left to write about." Still, she perceives "something untold" in all those weighty informational tomes catering to the "statesman, the man of science, the merchant, and the emigrant", that is, they give "but little notion of everyday life in the colonies, as it would appear from a lady's point of view."[6]

Macpherson was either unaware or unwilling to acknowledge that other women had paved the way before her. Three similar accounts by ladies in Australia had already appeared in London, two dating from the early 1850s—only a few years before her visit. These were Louisa Anne Meredith's *Notes and Sketches in New South Wales* (1844) and *My Home in Tasmania* (1852), and Ellen Clacy's racy and anecdotal *A Lady's Visit to the Gold Diggings of Australia in 1852–53* (1853). Although Meredith is justifiably far better known than Macpherson as a prolific artist and travel writer on Australia, she did not illustrate her own earliest works in the genre.[7] Clacy's book is also unillustrated. Macpherson was the first woman to have illustrated her own book of Australian travels in the nineteenth century and apparently the only one to do so other than Meredith. However, unlike Meredith, whose books record a struggle to come to terms with an emigrant identity in Australia, Macpherson was a genuine transient. Although Macpherson's account is explicitly directed to the female emigrant, she was only resident in Australia for less than a year and a half. Despite her deeply felt trials as a lady in the bush, her equanimity could always be preserved in the knowledge of an assured passage home with her husband.

If Macpherson's book is something less than a true emigrant account, it is not quite a tourist narrative either. Australia was simply too far away for the casual tourist. Before steam was introduced to halve the time of the passage, the sea voyage of 16000 miles occupied on average just under four months.[8] This tended to promote lengthy stays once in the colonies. Female travel in mid-century Australia was also not yet the domain of what Sara Mills calls the

"exceptional spinster" or the Victorian exploratress.[9] The perceived destabilizing social effects of the rush for gold had tended to exacerbate existing fears for white women traveling unaccompanied by a male companion. Female travel was therefore often a contingent business and a family affair.

Macpherson's travel was typical in that it was dependent on a male relation. While Meredith was accompanied by her husband and Clacy by her brother and a party of his friends, Macpherson came out with a mini-entourage of servants and family, including her husband, her young daughter, and her nurse. She gave birth to her second child before she left Australia. The course of her travels was not primarily dictated by her but by her husband, Allan, who had lived in Australia in the 1840s before his marriage. The purpose of the couple's journey was to visit his sheep station, Keera, on the Gwydir River in New England, 300 or 400 miles from Sydney, and to arrange the sale of their property in Australia. Their round-trip voyage took 15 months.[10] Macpherson's intent to produce notes and sketches for a book on her travels was a secondary purpose, to be squeezed in around her husband's commitments. It was Mr. Macpherson who generally dictated where they went and how long they stayed, although his wife was granted more flexibility to choose their itinerary on the way back from Keera.

Macpherson found her travels constrained and curtailed by her husband's frequent stops, starts, and absences, which caused her to stall for long periods in Sydney and in country towns while he attended to business en route. The supervision of servants, care of her toddler (and later on, new baby), and the limitations of what could be encountered on the road between Keera and Sydney, caused further fissures between Macpherson's expectations of Australia and the actual experiences her journey offered her.

Macpherson's consciousness of these gaps indicates the extent to which her expectations were shaped before she arrived, most likely by external visual influences, such as prints. Published pictorial sources on Australia included engravings from the illustrated press and collections of ethnographic and picturesque views sold as picture books or print folios. Practically every colonial male artist of note either resident or visiting in Australia produced at least one of these, including George French Angas, Nicholas Chevalier, S. T. Gill, J. S. Prout, and Conrad Martens. Undoubtedly, it was not only the flood of guidebooks but also the great mass of visual information circulating in Britain about Australia for the aspiring emigrant that influenced Macpherson's decision to produce an illustrated narrative for her own emigrant audience.

Visual information also came packaged in the form of urban commercial entertainment, such as magic-lantern shows and panoramas. These typically combined spectacular visual special effects with lectures and music. Recently emerging scholarship is beginning to yield a comprehensive picture of the

content and popular reach of these early visual mass-media, and their role in representing the Antipodean colonies to Britain and Europe and vice versa.[11] J. S. Prout and J. H. Stocqueler were two who mounted visual travelogues on Australian themes in the 1850s. In the previous decade Prout had left his wife in charge of their ten children *for eight years* while he drummed up business in the Antipodes, a rather different sort of travel constraint than that experienced by Macpherson. On his return to London, Prout turned some of his Australian pictures into a magic-lantern show called *Dioramic Views of Australia*, which closed in 1850 after a brief season. One year later, following news in Britain of the gold discoveries, Prout saw the opportunity to revive his failed show and reworked his glass slides and dissolving views into a "moving panorama."[12] Although based on his Australian sketches from the 1840s the new panorama was supplemented by amateur work, presumably for the new sections describing the gold fields. The panorama opened in Regent Street in 1852 and was shown in London over 600 times before it was taken on a three-month tour of the Plymouth–Torquay area in April–June 1854, ending up again in Leicester Square in 1855.[13] The showings in Plymouth, the usual departure point from England to Australia, were targeted directly at those about to emigrate. Stocqueler's "moving diorama," the *Ocean Mail to India and Australia*, opened in London in June 1853. Like Prout's lantern show it began with the departure from Plymouth and ended on the gold fields, interspersed with various excursions of interest.[14]

Although it is not known whether Macpherson actually viewed either spectacle prior to her voyage in March 1856, or read the books that accompanied them, there are direct parallels to be found between the best-documented of the two, Prout's, and her own illustrated narrative. Macpherson's tale follows a conventional arc, beginning with a detailed account of the voyage from Britain (Clacy, by contrast, cuts out the usual discussion of shipboard etiquette and fast-forwards to the gold fields). On arrival Macpherson is subjected to a lengthy sojourn in Sydney. "I know of few more uninteresting places," she complains, "there is not the charm of novelty, which renders a short residence in a foreign town agreeable … yet … all old associations are also wanting." While she diligently describes Sydney's suburbs, political economy, and so on, she is bored there and impatient to commence the trek into the interior of New South Wales (NSW) to Keera. The novelty of this prospect "was of itself exciting and amusing."[15]

As seen in Macpherson's sketch *Encampment in the Bush* this overland travel was an elaborate affair, involving a covered wagon, a dog-cart with a canvas shelter that converted into a bedroom at night, and a tent. (Fig. 7.1) Echoes of the Empire are found in camping accessories such as the "Crimean bedsteads" or small iron stretchers with cork mattresses, and the waterproof gutta-percha rugs, made from latex extracted from Malayan trees. A table, stools, crockery,

and washing-up apparatus also went into the luggage. There was a man to drive the cart, his wife to cook, and the girl servant from Scotland to look after the Macphersons' toddler. Completing the party was a youth, a relation of the Macphersons. The long journey, proceeding slowly over poor roads, culminates in the achievement of Macpherson's bush home in the mountains. The next substantial section of the book describes domestic life there, followed by the journey out of the interior (marked by tourist interludes), and the voyage home.

To compare properly with Prout, we have to take into account not only what Macpherson actually saw in Australia, but also what she wanted to see and did not. Macpherson's frustrations with the limitations placed on her journey are expressed by her becoming "anxious" at various points in the narrative. This anxiety coincides with a desire to take advantage of particular opportunities she previously knew of in the Australian colonies. The first and most successful of these opportunities was the "blacks' camp," which was conveniently located near her husband's property. "Naturally," she writes, "[I was] very anxious to learn all I could about this strange race, and their encampment was a source of great interest to me." Further anxieties were triggered by the start of her return journey. Because she "was anxious not to leave the colony without having visited a goldfield" her obliging husband made a day-long detour so she could visit the Rocky River Diggings. By this time, however, her extended time in the bush was taking its toll and she had contracted ophthalmia in one eye. The affliction prompts a rare direct reference to her on-the-spot drawing; by stopping to sketch an unfamiliar gum tree and then taking a sketch of the diggings the following day she made the ophthalmia worse. With one eye bandaged there was no further reason to linger, despite the tourist appeal of the gold fields. Once back in Sydney, waiting for her husband to conclude his business there, however, she is sufficiently recovered to become anxious again, this time to visit the famous Illawarra district around Kiama and Wollongong on the spectacular NSW central coast. This was a district known to her as the "garden of Australia." Like the detour to the diggings, however, this trip was plagued from the start. She and her husband made no progress on horseback and they "had neither writing nor drawing materials, neither were they procurable." They gave up and returned part of the way by means of the prosaic, unnewsworthy, but wonderfully comfortable train to Sydney.[16]

Macpherson's ideal (and only partially successful) tourist journey in Australia was therefore one that included encounters with Aborigines, a visit to the gold fields, and a trip to the Illawarra. This emphasis is reflected in the choice of illustrations for her book: *Vignette*; *A Bush Encampment*; *A Native Burial Place*; *A Native Encampment*; *The Rocky River Diggings*; *Albany – King George's Sound*; *Night View of Aden*, which variously describe the author, her camp and traveling party, the "blacks' camp", and the gold fields. The last two

depict moments on the voyage homeward: a view of a port of call in Western Australia where she stopped to collect flowers and specimens, and a night view of the Egyptian port of Aden.

When compared to the assured draughtsmanship and storytelling dash of Prout's illustrations, Macpherson's simple figures appear wooden and her landscapes stiff. Her drawing is careful and accurate but lacks flexibility or inventiveness in composition, line or narrative imagining. In fact, her views are all rather alike—figures in a landscape, uniformly frozen in a middle-distance view. Despite the obvious discrepancies in style, however, there are strong parallels between the content of Macpherson's published illustrations and Prout's more embellished pictorial journey, particularly if we take into account Macpherson's aborted missions. Like Macpherson, Prout emphasizes the voyage itself and its sights. Prout progresses outward from Plymouth through the Bay of Biscay, Madeira, Tenerife, Rio de Janeiro, and the Cape of Good Hope, to his final port in Melbourne, Australia (briefly described by Macpherson on her outward journey). Within Australia, Prout's panorama crisscrosses back and forth between Victoria and NSW. Grouped thematically, rather than in the order of the panorama, these consist of scenes of picturesque spots around Melbourne; a camp scene and a corroboree scene of Aborigines; sheep stations in the Goulburn Valley and the Snowy Mountains; the Illawarra district and its famous cabbage tree palms and ferns; the towns of Geelong, Wollongong, and Sydney; and scenes from the diggings at Mount Alexander, Summerhill and Ophir Creeks. Like Macpherson's final image, this last image of Prout's is a night view.[17]

While no doubt the popular ingredients of Prout's panorama feature in many literary texts of emigrant travel, the similarity of his choice of colonial scenes to Macpherson's suggests that emigrant visual material of this kind merits more attention than it has been given hitherto. It seems a likely avenue for Macpherson to have formed ideas of what there was to see in Australia before she arrived. Subsequently she did her best to influence her own travel, travel in which she was a secondary agent to her husband, in order to bear witness to certain quintessential tourist experiences in Australia in word and picture for her readers.

In doing this, Macpherson was not simply aiming to reproduce male tourist narratives emanating from the metropolis. Rather, a consciousness of her own difference is elaborately built into her narrative. This consciousness is often expressed in her exercise of visual appreciation (taste) and her desire to sketch in the colonies. Once on the road and thrust into a close daily association with a party consisting of servants as well as family, Macpherson uses this exercise of taste to let her readers know that she has not sacrificed her position as a lady, above common labor. Hence her detailed descriptions of the social hierarchy within the traveling party, down to the sleeping arrangements and

the division of daily tasks. Predictably, her own duties were not arduous. She dressed her daughter and set the table for breakfast, which was cooked by one of the servant women. While the men rounded up the horses and packed up camp, she washed and put away the breakfast dishes. Her main challenge was to learn to take the reins. With Mr. Macpherson rising early to go into town on business, she remarks "had I not been well provided with books and drawing materials, I should have found the days a little wearisome." The possibility of ennui was the prerogative of her class position. Macpherson, who had a liking for birds, notes that she was the only one in the party who had the "leisure to indulge myself in listening to them" because her husband made the others rise between 4.00 and 5.00 a.m. to start work.[18]

One of the stories contained in Macpherson's book is the erosion of this ladylike identity in the bush. Once installed at Keera she is affected by a general shortage of labor induced by the gold rush, the serious illness of one of her girls, and her recent childbirth. As a result she is forced to work hard for the first time, cooking, sewing, and carrying out "such nursing as only falls to the lot of the poorest labourer's wife at home." She offers her experience to other women emigrants as a warning. Without leisure, the lady in the bush became absorbed in housewifery "to the complete exclusion of more intellectual pursuits; so that when they have children to train up it is out of their power to form their minds properly, or fit them for moving in anything like refined society."[19]

While the exercise of taste through sketching, reading, writing, and the appreciation of nature was essential to Macpherson's identity as a middle-class British lady abroad, there were also numerous fine distinctions to be made within this general category. She insists, for example, on her identity as a Scot rather than as an Englishwoman in the colonies, and one of the ways she chooses to mark this difference is in her visual response to the much-maligned Australian eucalyptus. To her contemporary Ellen Clacy, gum trees "never have the exquisite young tint which makes an English spring in the country so delicious. Their faded look always reminded me of those unfortunate trees imprisoned for so many months beneath the Crystal Palace." Clearly conscious of this conventional view, Macpherson writes that

English eyes may miss the bright green foliage of the trees of their own land; but to mine, which had been so long accustomed to the darker hues of the Scottish fir woods, the sombre tints of trees, which are mostly of the Eucalyptus tribe, wore a home-like aspect.[20]

Macpherson's open-mindedness toward the eucalyptus is borne out in her drawings, where she is at pains to draw the slender river gums accurately. She depicts the exposed limbs that reveal the structure of the branches, the sparsely spaced clumps of foliage, and the bare branches that stick out from the tops of the trees. Unfortunately, when the lithographers came along they

tidied up her carefully observed trees, making the canopies more regular and dense, and removing the protruding branches.

Macpherson's inclination to privilege the visual sensation and the visual record in her travels in Australia was a function not only of her class and nationality, but more generally of the period in which she lived. John Urry observes that after 1800 British treatises on travel "shifted from a scholastic emphasis on touring as an opportunity for discourse, to travel as eyewitness observation. There was a visualization of the travel experience, or the development of the 'gaze.'"[21] This shift explains why visual language and visual description often feature prominently in nineteenth-century travel texts written by non-sketchers as well as by artists such as Macpherson.

The ability to visualize scenes in terms of a sketch was valued as an aid to one's memory. Macpherson notes that "one of the pleasures of traveling [is that] these lovely pictures do not pass away from recollection, and that as much delight is often experienced in dwelling on the remembrance of those scenes as is felt at the time when actually witnessing them." In a long passage near the beginning of her book, Macpherson transforms her memory of an Australian landscape into a picture that is cinematic in its intensity. Macpherson situates herself

on a dull February morning in Scotland, the snow beating against the window panes, and myself ensconced in a large arm-chair with my table drawn close to the fire [when] a picture of one of these views comes vividly before my mind's eye: I am once more seated in a handsome stone verandah … near Sydney.

From this vantage point she establishes the foreground, middle ground, and distance of a picturesque view:

a flight of stone steps leads down to a small, neatly kept garden, with some really green turf to refresh the eye and remind one of home; a field beyond, and the slanting roof of a cottage seen through some low growing trees; one or two Norfolk pines, rearing their tall heads far above the others; these form the foreground of my landscape; and beyond are the bright blue waves breaking on the yellow sand, and picturesque headlands, crowned at first with a dark glossy green and becoming more and more indistinct[22]

Suddenly, like a magic-lantern slide, she changes the scene to night: "Or I view the same scene by the soft light of the moon; far in the distance are heard faint sounds of music, and steaming up the harbour is one of the fine mail steamers hung with lamps from stern to stern." But the pleasurable lapse into picturesque nostalgia is quickly brought up; she then confesses to the reader that, "I must own that the principal pleasure I derived from the time from contemplating it, was in the thought … that in the good ship's next voyage we should probably be among the homeward bound passengers."[23]

In addition to lengthy picturesque descriptions like the above, one finds visual spaces regularly inserted in travelers' narratives. These pauses

interrupt the motion of the journey while the traveler takes visual stock of the scene. Clacy, for example, uses the metaphors of the sketcher when she halts for a moment on the Victorian gold fields: "Before proceeding with an account of our doings at the Eagle Hawk, I will give a *slight sketch* of the character and peculiarities of the diggings themselves ... I will leave myself, therefore, safely ensconced beneath a tent at the Eagle Hawk and take a *slight and rapid survey* of the principal diggings in the neighbourhood" she writes (my italics).[24] As Macpherson does, Clacy physically situates herself within the scene she is about to describe, orienting the reader with an embodied viewpoint from which she may take up the invitation to settle down and take in the prospect.

As Mary-Louise Pratt, Deborah Cherry, and others have argued, this process of reclamation of foreign terrain into familiar sketch, survey, or picturesque view may be interpreted within the colonial context as a statement of power, even of violence. Equally, it has often been recognized that female colonizers have a typically ambivalent relationship to this imperial gaze; as Pratt remarks, it is "hard to think of a trope more decisively gendered than the monarch-of-all-I-survey scene."[25] An Australian example of the masculine magisterial view is George French Angas, author of a lavish, large-scale volume of hand-colored lithographs, *South Australia Illustrated* (1846). In a description accompanying his sublime view of the Crater of Mount Schanck, Angas writes, "I was the first to climb the mountain, stand alone on the edge of that vast crater, and to feel that thrill of pleasure which the grand and sudden panorama awakened.—This is one of the rewards of the traveller's toil." (As Pratt points out, the male explorer's conceit of being the *first to climb the mountain* requires the deliberate omission of the native guide who presumably brought him there in the first place).[26]

In contrast, there is little in Macpherson's account that conforms to a masterful discourse of discovery of this nature. This was something she experienced vicariously, if at all, through her husband's experiences in his pioneering days. In describing their preparations for the journey inland to the station, for example, she comments that it was not really necessary to rough it out camping, as there was plenty of accommodation, albeit of a low standard, along the route. It was just that her husband preferred to do it that way. Nor, she remarks somewhat regretfully, was there any fear of encountering thieves, bushrangers, and Aborigines in the tamed interior of the day. What Clacy and Macpherson describe as women travelers in Australia in the 1850s is already a landscape populated by settlers, not a real or imagined wilderness populated by savages. As if to underline this, they adopt viewpoints for their pictorial pauses that belong to the domestic space: for Macpherson the quintessentially gendered feminine space of the verandah, and for Clacy the improvised shelter of the tent. The closest Macpherson comes to reproducing Angas's sublime moment is when she settles to witness a sunset over the mountainous

country approaching Keera, which her wagon party has just traversed with great difficulty. For her, however, the contrast of the "toil of travel" to the breathtaking mountain view provides relief rather than a sense of triumph. It means she has reached the end of her exhausting journey and is about to take possession of her new home in the bush.[27]

If women's imperial gaze on the landscape was not one obviously distinguished by a sense of mastery and discovery, their unassuming business of making pictures (an ostensibly purely descriptive act) nevertheless shows them as intimately engaged in the construction of imperial knowledge. Mary Stodart, a mid-century author of a prescriptive text on the "correct" genres of women's writing, makes the rather chilling generalization of women authors that their "sphere is confined and the view is microscopic." Women's special talents, she writes, are for "all the minutiae of common life, which man looks at and passes by."[28] For the woman artist–traveler, this translates as an instruction to keep her eyes on the ground to study the minutiae of nature rather than on the grandeur of the distant prospect. Macpherson was as enthusiastic as any about entering into this discourse about the "discovery" of nature in Australia, although she laments she is no botanist and possesses limited skills in drawing flowers.[29] She quickly abandons her attempts to use drawing as an aid to memory (none of these drawings survive in her sketchbook) and instead focuses on collecting as a means of fixing her discoveries, with the intention of literally carting them back to the center of Empire. As Nicholas Thomas has argued, however, just because colonialists were willing to enter into imperialist discourses does not mean they were automatically capable of achieving them with any semblance of dominance or success.[30] For Macpherson, the collection of flora and fauna, a manifestly feminized area of authority and knowledge within the Empire, turned out to be a site of recurrent frustration and failure.

Macpherson began optimistically, even assertively, by representing her interests in botanizing, collecting, and sketching as empowering evidence of her superiority to colonial women. The latter she found "very American" (not a term of praise in her book), and conspicuously lacking in literary tastes and "mental culture."[31] With her husband away on an exploring excursion with native guides in the north-west of the state, Macpherson was left to amuse herself in a suburb of Sydney. She took pleasure in astonishing her hosts with her intrepidity in going on long rambles to collect wildflowers. These rambles were "not a little detrimental to ladies' dresses," she writes, "indeed, I very much doubt whether any of the colonial ladies ever venture on such expeditions."[32] This is a surprising statement, given the ubiquity of flower drawing and the popularity of nature rambles among amateur women artists in Australia, as elsewhere in the Empire. Her ignorance on this point seems to have stemmed partly from her own insularity, and partly from her relative

social and geographical isolation at this time. She is stationed about ten miles out of town and writes, for example, that she "could get no work on the plants of Australia, and very little information ... so that of many of the most beautiful specimens I do not even know the name."[33]

To her chagrin, Macpherson found the armfuls of unidentified wildflowers she gathered in such abundance were fickle and short-lived. She collected approximately 20 varieties of acacia from the Sydney area and tried at first to propagate the flowers at home, warming the seeds by the stove. When these attempts failed, she tried to press and dry them, but they completely lost their color. Only as a last resort did she turn to sketching them "although ... never having previously attempted flower drawing, I did not succeed as well as I could have wished, still my sketches gave a better idea of their form and colour than was suggested by their own poor withered remains."[34] As time passed, Macpherson became increasingly desperate to secure her collection. Following the disappointment of her aborted trip to the Illawarra, where she had hoped to put together a case of exotic plants, she was forced to be content with the "commoner" flora from around Sydney to take back to Scotland with her. Although few of these survived the homeward journey, she was fortunate in being able to obtain plenty of seeds from the Superintendents of the Botanic Gardens in Melbourne and Sydney. Her collection of native birds was similarly ill fated. Although she had been anxious to take home the collection of 30 or 40 parrots and parakeets she had amassed along the journey, their cages jostling against the sides of the wagons, she did not recommend others imitate her. The colorful birds turned out to be a "great trouble" on board ship and to suffer miserably in the cold of a northern winter.[35] Overall, then, Macpherson's attempt to collect the Australian flora and fauna and turn them into a personal compendium of imperial knowledge was a conspicuous failure; instead of reinforcing her sense of power and control over nature they led her up against the restrictions of her own amateurism and ignorance. Oddly, she was more successful, at least in her own terms, in her attempts to pictorialize what appears to us to be a far less potentially knowable and conquerable subject than birds and flowers—the indigenous Australians.

The "blacks' camp" from the beginning fascinated Macpherson. Situated about a quarter of a mile from the Macphersons' cottage it was "one of the most interesting features of the landscape in the vicinity of our station." It was not just boredom at being in such a remote location that drew her back repeatedly to the camp with her husband in the evenings; she obviously relished what she learned there and valued the friendly relationships she formed with the Aborigines. For their part, they seemed to have valued the flow of food and goods that came from having the Macphersons in residence at the station, and the camp expanded into a more or less permanent encampment of about 30 or 40 people during their stay.[36]

Pratt calls this kind of dedicated space for cross-cultural exchange the "contact zone." Her conception of the term emphasizes the mutuality of agency of colonizer and colonized and the often unpredictable nature of their encounters, in which the rules of engagement were often made up on the spot.[37] Negotiation and improvisation are indeed the hallmark of Macpherson's visits to the "blacks' camp" and many of her cross-cultural mediations focus on acts of visual representation. She is greedy for information and pictures, but to get them she must negotiate directly with her native informants.

Her book includes two images relating to the two chapters on the Aborigines: *A Blacks' Camp*, which can be read as a counterpart to the previous scene of her own camping party, and *Native Burial Place*.[38] (Figs 7.2, 7.3) Although she may have sketched these from memory once back at the homestead rather than directly in front of the motif, we can assume from the following anecdote that she sometimes took her color box down with her, presumably with the intention of sketching.

On one occasion I had my colour box with me when at their camp; their delight in examining the different paints was very great, and one old man (known among them as "King Sandy" from being acknowledged head of their tribe) was made especially happy by my husband executing some remarkable hieroglyphics in bright tints on his face and forehead. I soon made him desist, however, for there was something melancholy in seeing the childish eagerness with which this really fine looking old savage submitted or rather petitioned to be thus bedaubed.[39]

Macpherson's description of the color box incident follows on from lengthy critical comments about indigenous appropriations of European dress and some notes regarding "native adornments monopolised by men" that included being "bedaubed with ochre."[40] While Macpherson is aware of the ritual practice of face and body painting within indigenous culture, particularly as it was practiced by men of status, she seems unable to make the link between the practice of face painting and the delight with which the indigenous elder King Sandy accepts having his face painted with her watercolors. Instead of an adaptation of indigenous practices, elsewhere a sign of manly display, she sees his gaudily decorated face and "mistaken" pleasure in it as infantilizing and degrading. She therefore puts a stop to the jape, ostensibly out of pity for this "really fine looking old savage."

Beyond these transparently racist professions of sympathy with the "childlike savage" one wonders what else about the incident may have prompted her to put so quick a stop to it. Was she unsettled by the way her paintbox, which was both a precious symbol of her status as a lady and of her power to represent the natives in the contact zone, was taken from her, handled by brown fingers and passed around? Could it be that she felt excluded and annoyed by the merriment between her husband and King

Sandy, some bonding between men that she could not share? Did it perhaps trouble her that painting directly on the skin is an intimate act, requiring touch and face-to-face contact? Gender protocols made it unthinkable for her to have taken on her husband's role as face-painter in this instance, either in her own and probably in the indigenous culture as well.

A distaste for the body, particularly the naked, painted body of the native is certainly apparent in her account of a corroboree that follows on from this anecdote. The corroboree, or traditional Aboriginal ceremonial gathering, is a celebratory ritual involving song, dance, and storytelling. This one took place near Macpherson's house at night, where she witnessed it discreetly "at a respectful distance." Although corroborees were commonly depicted by colonial artists and amateurs (one features, for example, in Prout's panorama), Macpherson did not choose to sketch it. Drawing a picture of the scene in words instead, she likens the spectacle to her experience of the theater in its eerie lighting and sense of unreality. She describes the men's hair covered in feathers and down, and their bodies bedaubed with red and white. The dance taking place by firelight seemed to her grotesque and devilish: "It really hardly occurred to me that they were human beings, the whole picture in the lurid glare of their torches seemed so unreal, I could only compare it to a scene of diablerie from *Der Freischütz* or *Faust*."[41]

When Macpherson did draw the Aborigines, she depicted far less dramatic and spectacular daytime images of the camp and the burial ground. This represents a consistent choice in her repertoire of images. In Australia, she never drew any people or faces close up and there are no portraits, only tranquil views seen from a "respectful" middle distance. In contrast to the wild night of the corroboree, one senses she may have felt on safer ground in the indigenous cemetery, where naked bodies were safely interred and hieroglyphics appeared on trees rather than on faces. However, when one reads the image alongside the narrative of how she came to obtain it, this illusion of peacefulness and respect is dispelled. *Native Burial Place* is a violently transgressive image.

Evasion of their incessant questions is a recurrent theme of the Macphersons' encounters with indigenous Australians. Macpherson acknowledges this resistance and provides an unusually detailed account of the interactions that occurred between herself and the Aborigines. She makes no secret of her dependence on her informants and stresses the expedient friendships that formed between settler and Aborigine. She knows perfectly well that she is unable to locate the site of the graves without their owners' help, and shows herself and her husband in rather unflatteringly dogged pursuit of their defensive custodians. This differs from Angas's more scientific, dispassionate account of Aboriginal gravesites, which presents the facts as if they were there for all to see, without any hint of the obstacles in obtaining them. Macpherson's

disclosure of her negotiations does not mean that she is any less imperialist in her assumptions or any more sensitive to indigenous culture than Angas (whose stated aim was to document the "benighted and sunken creatures" before they were completely eradicated by "progress"[42]). It is more a function of her adoption of a "female voice," with its previously noted lack of mastery. This voice is not the authoritative one of the male expert. Her information is either clearly derived from other authoritative sources, including her husband, or else it develops out of her personal relationships and eyewitness gathering of knowledge. By having no choice but to privilege the latter she therefore registers indigenous opposition in her story, even if she misunderstands it.

To Macpherson, indigenous rites and beliefs could only be explained as one of so many native superstitions. The meaning of the corroboree, for example, was a mystery to her, but she supposed it was probably no more than a "superstitious observance," possibly relating to the seasons or the phases of the moon. In her prefatory remarks to the burial-ground incident she doubts the Aborigines had any religion or "regular creed beyond the belief in the existence of evil spirits."[43] It did not help with enlightenment that they were "very chary in communicating anything touching on their ways and customs."[44] Hence Macpherson was often only dimly aware of cultural hierarchies and taboos. Of these she mentions laws regulating rights of individuals to eat certain dishes and kinds of game, depending on their age and gender, and notes "they were particularly jealous of the presence of Europeans at ceremonies for initiation."[45] She was not surprised, then, to encounter very strong objections to her desire to look at the burial place, which she knew was not far from the station. Given her inclination to interpret these objections as irrational superstitions rather than religious protocols, however, she was quite undeterred by the initial horrified reaction.

"They [the Aborigines] have a great dislike to hear death spoken of, or the names of their deceased friends mentioned," she writes calmly. The Macphersons' favorite informant, the ordinarily amiable and cooperative King Sandy, "shuddered and literally turned *pale* when we broached the subject," protesting "no, no, too much dibil, dibil, sit down there." King Sandy would only name those buried there in a fearful whisper after insistent questioning from Mr. Macpherson. Finally persuaded that they were not going to get any further with King Sandy, the Macphersons went back to the tribe and after much difficulty eventually found someone else to act as their guide. They followed him for half a mile, when he stopped abruptly, pointed in the direction, and ran off.[46]

One imagines Macpherson moving among the graves, her long skirts swishing against their edges, refusing to be spooked in that deserted spot. She was not there to conjure up ghosts and tremble with fear like the natives. To

the contrary, her aim was to cast an ethnographic eye over the site she had achieved in the face of such concerted opposition from its owners, and proceed to turn it into a sight for European consumption through a double description in word and image. This was the prerogative of the European, to cast light on darkness and to reveal what superstitious natives wished to remain hidden.

The graves, large mounds of gravel, were surrounded and supported by tree branches. The trunks of the surrounding trees were carved with "rude representations of weapons, such as the boomerang, waddy, &c. and others supposed to delineate opossums and other kinds of game." These carved trunks can be seen carefully translated by the lithographers from Macpherson's drawing. She reports on hearsay, perhaps deriving from her husband, that other northern tribes observe different mortuary practices: some exposing the deceased on trees or on wooden stages, others cremating the corpse, while cannibalism is "known and well authenticated." Whereas Angas depicts these various presentations of the dead in a page of comparative drawings, Macpherson is limited by her experience of only one particular locality and tribe. She attempts to find out how their spiritual ideas might tally with Christian beliefs in the afterlife, but finds responses to her questions either vague and unsatisfactory ("How me know?") or extraordinary: "Me jump up white fellow." A more reliable source of information for her is the evidence of her own eyes, and she observes sympathetically that the graveyard is carefully tended, "so that it would appear that, however much they may dislike to name the dead or visit their last abodes, they do not allow the tombs of their friends to suffer from their neglect."[47]

Protected by a cloak of half-knowledge and incomprehension, Macpherson appears to have been genuinely impervious to any suggestion of trespass or violence caused by her visit to the burial ground. However, she shows herself as highly sensitive to the issue of settler violence toward indigenous Australians in other contexts. While justifying the European land grab that underpinned the conflict to unnamed critics, she finds herself struggling to reconcile the immediate interests of her own family and squatter class with her affection and grudging respect for the Aborigines she has come to know personally. Macpherson freely admits her husband took part in guerrilla warfare against Aborigines in opening up the northwest to white settlement some years before, but adds, "is there a foot of ground in the colony to which we have any right but that of the strong arm?" This question seems to be directed at the newly elected colonial government in Sydney, because she goes on to say that only when those in Government House are prepared to hand over the keys to the "last of the tribe" should the squatter be required to give up his hard-won homestead. In fact, the increasing pressure from government

quarters in the 1850s on squatters to give up some of their use of vast tracts of Crown land was coming from democratic land-reformers who wanted the land more equitably distributed. Macpherson, however, presents the debate as between squatters' versus Aboriginal land claims, rather than between squatters and selectors.[48] In truth, the rights of the Aborigines were only a secondary concern in the bitterly contested campaign to claw back squatters' land in the 1850s.[49]

Why, then, did Macpherson frame the debate solely in these terms? It may be an indication of a troubled conscience, or a sensitivity to criticism (she says she has often been provoked by others' ill-informed pronouncements). Although she doesn't specify the identity of the critics or the nature of the criticism, the suggestion is that it referred to a history of squatter violence. Meredith, whose husband was from a squatter family in Tasmania, had also retaliated in print at the belief prevalent in England in the 1840s that the white man had been the aggressor in indigenous conflicts. Macpherson, too, may have been vulnerable to criticism from humanitarian quarters, since apart from her husband's previous involvement in frontier violence, their current property was close to the site of the notorious Myall Creek massacre of 1838, for which white men were tried and hanged for the murder of Aborigines. Like Meredith before her, Macpherson had a vested interest in defending the integrity of the squatter against such charges, which was antithetical to mounting an ethical argument in favor of indigenous claims to the land. She argues that while these claims should not be entirely disregarded, the Aborigines would find ways to survive without ownership of the land: they could still hunt, and if not, labor for Europeans would always support them. Macpherson ultimately insists that although her sentiments might appear cruel to some, her heart is in the right place regarding the Aborigines, whom she considers her friends: "there are very few who ever felt more kindly towards the natives than I did ... I felt more regret in bidding adieu to our dark friends at the black encampment, than in parting with the greater number of persons and things whom we left behind in New South Wales."[50]

Macpherson's travels in Australia were framed from the double perspective of a tourist and a colonialist. Her journey was first and foremost dictated by her membership of a class of foreign-based colonial property owners, which granted her firsthand experience of the European dispossession of Aborigines. Meanwhile, mass-culture literary and visual representations of the colonies at home influenced her choices of what there was to see and sketch when in Australia. Her own book of illustrated travels, published in London, subsequently became part of this tourist representation of the Empire. Macpherson's descriptions formed an important part of her cultural identity in Australia and provided public authority at home. She valued her ability to represent her travel experiences visually as an aid to memory, a vehicle for

scientific knowledge and as a signifier of class, gender, and national distinctions. By illustrating her text with scenes she had witnessed at first hand she also compensated for a comparative lack of authoritativeness deriving from her relatively short stay in Australia and her female voice. However, while Macpherson's travels in Australia frequently enhanced her identity and authority, the opposite was also true. Macpherson records a tension between her desire to know, catalogue, and thereby own the country, and the often less-than-skillful ways she went about her tasks of sketching and collecting. Her persona as a confident imperialist and squatter's wife, always mindful of her power and social position, is shaken when we see her grand plans routinely collapse, her side trips abort, her collections of flowers wither and die, her birds languish, and her native informants refuse to cooperate. For all her determined attempts to master Australia's indigenous inhabitants through empirical visual and verbal description, by her own account, Macpherson was left staring, confounded, at the catalogue of her own failures.

Author's acknowledgments

I would like to thank Alan Atkinson, Stephen Foster, and Mary Roberts for their kind assistance in preparing this chapter.

Notes

1. "A Lady" [Mrs. Allan Macpherson], *My Experiences in Australia: Being Recollections of a Visit to the Australian Colonies in 1856–7* (London: J. F. Hope, 1860).

2. At the time of writing, Stephen Foster (Australian National University) is preparing new research on the Macphersons and seeking to republish their Australian accounts.

3. For Louisa Anne Meredith's and Mary Morton Allport's representations of Aborigines, see my "Progress versus the Picturesque: White Women and the Aesthetics of Environmentalism in Colonial Australia 1820–1860," *Art History* 25, no. 3 (June 2002): 341–57.

4. A squatter was a large landholder who ran sheep or cattle on Crown land, leased or licensed from the government for a low fee.

5. David Goodman, "Reading Gold-rush Travellers' Narratives," *Australian Cultural History: Travellers, Journeys, Tourists* 10 (1991): 99–112, 99.

6. Macpherson, *My Experiences in Australia*, Preface.

7. Patricia Thompson, ed., *A Lady's Visit to the Gold Diggings of Australia in 1852–53. Written on the Spot by Mrs. Charles Clacy* (Melbourne: Lansdowne Press, 1963); Mrs. Charles Meredith, *Notes and Sketches of New South Wales during a Residence in that Colony from 1839 to 1844* (Melbourne: Penguin facsimile ed., 1973) and *My Home in Tasmania, during a Residence of Nine Years*, 2 vols. (London: John Murray, 1852). *Notes and Sketches* is unillustrated, while *My Home in Tasmania* is illustrated by a friend, Bishop Nixon of Hobart. Meredith illustrated some of her later publications, including *Some of My Bush Friends* (1860) and *Over the Straits: A Visit to Victoria* (1861).

8. J. S. Prout, *An Illustrated Handbook of the Voyage to Australia; and a Visit to the Gold Fields Descriptive of the New Moving Panorama, Exhibiting Daily at 309, Regent Street* (London: Peter Duff & Co., [1852]), Preface.

9. Sara Mills, *Discourses of Difference: An Analysis of Women's Travel Writing and Colonialism* (London: Routledge, 1991), 3–6.

10. Macpherson, *My Experiences in Australia*, Preface, 88; see also Joan Kerr, ed. "Emma Macpherson," *Dictionary of Australian Artists ... to 1870* (Melbourne: Oxford University Press, 1992). In *Mount Abundance, or the Experiences of a Pioneer Squatter in Australia Thirty Years Ago (c.1871)* Allan Macpherson wrote of his experiences in Australia.

11. See Anita Callaway, *Visual Ephemera: Theatrical Art in Nineteenth-Century Australia*, (Sydney: UNSW Press, 2000) and "A Broad Brush Dipped in Gold" in I. McCalman, A. Cook and A. Reeves eds, *Gold: Forgotten Histories and Lost Objects of Australia* (Melbourne: Cambridge University Press, 2001); Mimi Colligan, *Canvas Documentaries: Panoramic Entertainments in Nineteenth-Century Australia and New Zealand* (Melbourne: Melbourne University Press, 2002); Elizabeth Hartrick, "Consuming Illusions: The Magic Lantern in Australia and Aotearoa/New Zealand 1850–1910" (Ph.D. thesis, University of Melbourne, 2003).

12. Colligan, *Canvas Documentaries*, 35–9.

13. Tony Brown, "J. S. Prout" in Kerr, *Dictionary of Australian Artists*.

14. Colligan, *Canvas Documentaries*, 39–40.

15. Macpherson, *My Experiences in Australia*, quotes successively, 37, 90–91.

16. Macpherson, Blacks' Camp, 203; Goldfield, 268–70; Illawarra, 306, 310–11.

17. Prout, *An Illustrated Handbook*.

18. Macpherson, *My Experiences in Australia*, 108–120, 108–109.

19. Macpherson, *My Experiences in Australia*, 199; Goodman identifies this storyline, of the topsy-turvy inversion of labor in the colonies whereby "Jack becomes as good as his master," as a universal trope of goldrush travelers' tales.

20. Clacy, *A Lady's Visit*, 132; Macpherson, *My Experiences in Australia*, 18.

21. John Urry, *The Tourist Gaze: Leisure and Travel in Contemporary Societies* (London: SAGE, 1990), 4.

22. Macpherson, *My Experiences in Australia*, 39–40.

23. Macpherson, *My Experiences in Australia*, 40–41.

24. Clacy, *A Lady's Visit*, 49.

25. Mary Louise Pratt, *Imperial Eyes: Travel Writing and Transculturation* (London: Routledge, 1992), 213; Deborah Cherry, *Beyond the Frame: Feminism and Visual Culture, Britain 1850–1900* (London: Routledge, 2000), Chapter 2.

26. G. F. Angas, *South Australia Illustrated* (London: Thos. Maclean, 1846), Plate iv and accompanying text; Pratt, *Imperial Eyes*, 201–202.

27. Macpherson, *My Experiences in Australia*, 92, 124–5, Chapter 9.

28. M. A. Stodart, *Female Writers: Thoughts on their Proper Sphere, and on their Powers of Usefulness* (London: Seely & Burnside, 1842), 21, 105.

29. Macpherson, *My Experiences in Australia*, 42–3, 51–2.

30. Nicholas Thomas, *Colonialism's Culture: Anthropology, Travel and Government* (London: Polity Press, 1994), Chapter 5, esp. 160–169.

31. Her first reaction on seeing the Australians was "what a set of Yankees!", Macpherson, *My Experiences in Australia*, 17. See also 29, 59–60 where she speculates on the development of "American" characteristics in the population as an outcome of a liberal political economy.

32. Macpherson, *My Experiences in Australia*, 50–51.

33. Ibid., 42–3.

34. Ibid., 51–2.

35. Ibid., 310–12.

36. Ibid., 202–203.

37. Pratt's definition of the contact zone is "a space in which peoples geographically and historically separated come into contact with each other and establish ongoing relations, usually involving conditions of coercion, radical inequality, and intractable conflict." *Imperial Eyes*, 6–7. For discussion of indigenous agency specifically in cross-cultural artistic exchanges see Jill Beaulieu and Mary Roberts, *Orientalism's Interlocutors: Painting, Architecture, Photography* (Chicago: University of Chicago Press, 1992).

38. The two "Aboriginal" images have been removed from the sketchbook; along with others they are held in a private collection. See Macpherson entry in Kerr, *Dictionary of Australian Artists*.

39. Macpherson, *My Experiences in Australia*, 219. "King Sandy's" indigenous name is not recorded. Such nicknames, often engraved on a plate worn around the neck, were commonly bestowed on prominent Aboriginal men and women with whom colonizers had contact. It is debatable whether this was a strategy to co-opt Aborigines to the squatters' cause, or a quasi-respectful acknowledgment of their indigenous social standing. Heather Goodall, *Invasion to Embassy: Land in Aboriginal Politics in New South Wales, 1770–1972* (Sydney: Allen & Unwin, 1996), 63.

40. Macpherson, *My Experiences in Australia*, 218.

41. Ibid., 221–2.

42. Angas, Preface & General Remarks on the Aboriginal Inhabitants of South Australia, *South Australia Illustrated*, unpaginated.

43. Macpherson, *My Experiences in Australia*, 222–3.

44. Ibid., 204.

45. Ibid., 215, 222.

46. Ibid., 224–5.

47. Ibid., 225–6. Angas, who was privy to more information than Macpherson, informs his reader that the bodies entombed within a similar type of mound in South Australia were posed semi-upright in a seated position and "at stated times, the mourners, who are women, come to the tombs and with their *Kattas* dig up the ground about them, and put the place in order; this they accompany with the most violent howling and lamentation," *South Australia Illustrated*, Plate XL and accompanying text.

48. Selectors were small farmers who settled on Crown lands originally claimed by squatters. The earliest Selection acts in Victoria (1860) and NSW (1861) came after sustained popular agitation defending the "little man" against the "aristocracy" of the squatters. See John Hirst, "Selection" in G. Davidson, J. Hirst, and S. MacIntyre, *The Oxford Companion to Australian History*, rev. edn. (Melbourne: Oxford University Press, 2001), 584.

49. Macpherson, *My Experiences in Australia*, 231–6. For debates on land use in NSW *c.*1838–60 see Goodall, *Invasion to Embassy*, 44–72.

50. Macpherson, *My Experiences in Australia*, 236–40. On Meredith, see Jordan, "Progress versus the Picturesque", 354; on the history of humanitarian opposition to Aboriginal dispossession see Henry Reynolds, *This Whispering in our Hearts* (Sydney: Allen & Unwin, 1998). Macpherson's relative sympathy for the indigenous Australians contrasts with her xenophobic fear of the Chinese in Australia, *My Experiences in Australia*, 181–3.

Cameron's colonized eden: picturesque politics at the edge of the Empire

Jeff Rosen

In late 1876, the botanical painter Marianne North paid a visit to the well-known portrait photographer Julia Margaret Cameron in Kalutara, a coastal city on the island colony of Ceylon. The year before, the photographer, together with her husband, Charles Hay Cameron, had emigrated to the island from England to join their four grown sons, one stationed in governmental service at Kalutara, the others plantation owners of coffee and tea estates that had been purchased decades earlier by the Camerons. In traveling to Ceylon, North was completing the final leg of a Far Eastern tour, which had included, just prior to Ceylon, the colonies of Singapore, Borneo, and Java. North's primary destination in Ceylon was the Royal Botanic Gardens at Peradeniya, as she was there to capture in her works some of the unusual flora of the island. The Camerons were on the island, by contrast, as permanent residents; Ceylon was to be their final home and ultimate resting place.

Although today Marianne North is not as well known as Cameron, whose portraits of Tennyson and Carlyle, and imagery of Madonnas and children seemed to capture something essential about Victorian Britain, North achieved renown during her day as an accomplished botanical illustrator.[1] A self-sufficient woman of independent means, North devoted her early life to caring for her widowed father, learning to paint while traveling with him, and was encouraged in her botanical representations by Joseph Hooker, a family friend who was also the chief botanist and director at the Royal Botanic Gardens at Kew. When her father died, she found that she enjoyed traveling alone more so than in the company of others, and in 1876, embarked upon on a round-the-world trip, creating hundreds of paintings. In general, her paintings are relatively small, designed for portability with most no larger than one by two feet, and are brilliantly colored. Upon her return to England in 1877, she exhibited some 500 of her paintings at the South Kensington Museum, garnering generally favorable reviews. In 1879, she exhibited her

work in a one-woman exhibition on Conduit Street in London, and again later that same year, she herself donated the funds to erect a building to house her paintings on the grounds of the Royal Botanic Gardens at Kew. Three years later, 832 of these paintings were installed in the new Marianne North Gallery, where they remain today.

The meeting between North and Cameron produced several works by each artist, and some notable cross-fertilization in their styles, particularly when they represented a scene in each other's company. Before examining that influence, it will be necessary to interrogate the narrative spaces occupied by North and Cameron, as each artist recorded her impressions both verbally, in letters (and in North's case, a diary), and in visual representations, producing paintings and photographs that conformed to their own brand of visual convention and ideology. In their written travel narratives, both women revealed their attitudes of superiority toward the native populations they encountered. Their sentiments are entitled and penetrating, denying a stereotype commonly attributed to British women travelers of this time, sometimes called "the guilt of the sight" to refer to a retiring or withdrawn attitude.[2] By contrast, both North and Cameron adopted a surveyor's active and possessive approach. Theirs is a telescopic penetration that swallows up both the landscape and its inhabitants. These women, after all, were used to naming, framing, rearranging, and representing their world; they were not content to portray it passively.[3] As the chief protagonists of their travels and of their artistic lives, they freely drew upon another entitlement that characterizes their visual representations: both artists joined together the picturesque and the primitive in a self-assured and confident manner that did not question their right to portray the subjects they chose. In their imagery, Cameron and North adopted a discursive strategy of framing their subjects so that the narrative structures of the picturesque and the primitive emerge as central motifs. These are evident, in part, in the ways in which Cameron and North manipulated well-worn artistic conventions that portrayed foreign lands and their inhabitants as pure and unblemished by traces of industry or modern life, exotic relics that escaped both time and progress. But as we shall see, the ways in which Cameron and North merged the picturesque and the primitive as strategies of representation also disclose an insidious political agenda in their work that is particular to British colonialism.

As they constructed their letters and diary entries as well as their works of art, Cameron and North both employed and confronted their own narratives of home and displacement. The native subjects depicted by both women have been frozen by an artist's objectifying gaze; as subjects of that gaze, they record both the journey itself and the artist's own physical displacement from home. At the same time, their subjects provide representational doubles or stand-ins for a "primitive," pre-industrial age, no longer depicting individuals

but points of reference marking visual and cultural difference from Western norms.[4] Moreover, the representations of Cameron's and North's native subjects are also dislodged as portraits of known individuals, having become inflected through the act of representation by the artist's internal conflict demanding that she simultaneously uphold the colonial agenda while at the same time repressing uncomfortable political uncertainties and social confrontations. Moreover, North's encounters with Cameron make it possible to tell a redemptive story, as both artists dealt with their uncertainties by first articulating, and then undermining, an ideology of national salvation and deliverance, in which the present is redeemed by returning to a more authentic past, and one revealed through "the return to origins." North's meeting with Cameron at the edge of the Empire afforded them both the opportunity to create imagery affirming "national greatness," especially as expressed in a collaborative moment, where nation building and the reclamation of past greatness is redeemed through colonial activities which were transforming Ceylon from a land of "primitive simplicity" to an economic and political asset in "British Asia."

Julia Margaret Cameron was born in 1815 in Calcutta and lived there during her early married years. When in 1848 her husband turned 53 and was forced to retire from governmental service in India and Ceylon, she accompanied him to London; the two settled on the Isle of Wight several years later. Prior to 1848, the Camerons had enjoyed high society in Calcutta. While Charles helped to write the penal and educational codes for the two colonies, Julia Margaret organized social events on behalf of Lord Hardinge, India's governor-general.[5] By 1850, the Camerons had purchased two large plantations in Ceylon, one called Dimbula, the other Rathoongodde, their aggregate holdings making them the largest private landowners of the island.[6] While he made frequent trips to Ceylon to conduct his private affairs on the island while waiting for the East India Company to assign him to a post in Malta or the Ionian Islands (an appointment that never materialized), she remained on the Isle of Wight in their Freshwater home.

While often worried for her husband about the hazards of these long trips, Julia Margaret had no doubt that he was visiting something approaching an island paradise, having been assured that Ceylon was lush with a picturesque tropical growth that was punctuated by rushing mountain streams. The unmistakable psychological connection between home and "home-away-from-home" was made manifest by Julia Margaret in calling her Freshwater home Dimbula after the Ceylonese plantation, and her picturesque sensibility of the land influenced markedly by her husband's effusive communications. In numerous letters, such as this fragment from Rathoongodde, dated 16 December 1850, Charles described Ceylon in glowing romantic terms:

O Juley! Juley! How I wish you could see all that I have been seeing for the last few days

… About 200 yards [from the building] is a deep ravine down which flows a lovely mountain stream which I have christened the Julia Oya (I believe it is the very same stream that I used to call by that name when looking at the plan of the estate [when we first purchased the land when we were] at Calcutta. When it crosses the path it forms a beautiful cascade falling in two white and foaming sheets of water.[7]

Between the lines of text in his letter, Charles even illustrated this picturesque narrative with a pen-and-ink drawing depicting the waterfall. As he wrote, the waterfall was there to nourish and sustain *"the Soul,"* and an abundance of inexpensive produce, thriving livestock, and plentiful fowl were present there as well, he assured her, to satisfy their daily needs and sense of thrift and prudence (*"to sustain the Pocketbook"*).

Despite these fervent enticements, Julia Margaret never chose to accompany her husband or their sons to the island until their decision to leave England in October 1875. When the time finally came, Julia Margaret Cameron likened her journey east to a kind of spiritual rebirth. Writing to her friend Lady Ritchie during her passage through the Suez Canal, Cameron asserted:

O what good it does to one's soul to go forth! How it heals all the little frets and insect-stings of life, to feel the pulse of the large world and to count all men as one's brethren and to merge one's individual self in the thoughts of the mighty whole![8]

Feeling the "pulse of the large world," counting "all men as one's brethren": in 1875, Julia Margaret Cameron felt she was "going home." As Marianna Torgovnick reminds us in her book *Gone Primitive*, "the metaphor of finding a home or being at home, recurs over and over as a structuring pattern within [the discourses of] Western primitivism. Going primitive is trying to 'go home' to a place that feels comfortable and balanced," for "'going home,' like 'going primitive,' is inescapably a metaphor for the return to origins."[9] In the act of the physical journey itself lies a search for deep psychological connections, even a universalizing impulse: "'Going home' involves only an individual journey – actual or imaginative – to join with a 'universal' mankind in the primitive. There can be no homelessness then."[10] The words "primitive" and "primitivism" are essential critical terms for this analysis, because they historically encapsulate the strategy that joins the myth of timeless origins and evolutionary beliefs of the nineteenth century. When the concept of "going home" is located in representations of "the primitive," the return to origins takes on an unforeseen magical ability to dissolve historical differences. Primitivism is eternally present only if one has access to the spaces of primitive peoples. An anxious fear emerges as a result, requiring that any evidence of origins be preserved, else they disappear for all eternity, whether owing to indifference or to active destruction.

In this respect, Cameron's photographs of the native inhabitants of the island and North's paintings of the fragile and disappearing flora help us situate their need to preserve the pure spaces of newly found primitivism in

the midst of the encroaching colonial appropriation of the land and the new social laws established to govern its people. During her voyage to the island, Cameron anticipated her own well-being there using such terms, expecting to find in Ceylon a spiritual connection to the "universal primitive," especially when she expressed her sense of merging into the "thoughts of the mighty whole." When she finally arrived and established her new home, she found her anticipation confirmed. After one year in Ceylon, she wrote:

My first impressions have been modified—confirmed or effaced—My wonder for instance has been tamed but not my worship—The glorious beauty of the scenery—the primitive simplicity of the Inhabitants & the charms of the climate all make me love and admire Ceylon more and more. I do not think our severe Island of England at all recognizes the charms of her Tropical sister[.] They have only to be studied; for all the weak and fragile Inhabitants of our Northern Climes to flock here with the Instinct of the swallow and to find a sure redemption from every disease [...] combined with exquisite enjoyment: for dead indeed must be the soul who is not satisfied with Nature as here presented to the eye.[11]

Many of her photographs taken in Ceylon are therefore inflected by her sense of native primitive simplicity and pure uncontaminated nature, but the "sure redemption" of the return to origins operates on more than one level.

For Cameron, the natives were not only simple, as in childlike or uneducated, but also were inherently incomplete. She framed many of her female subjects in such a way to represent them stereotypically as "outside" of history: pressed to the front of the picture plane, robed in flowing saris and jeweled armbands, decontextualized and objectified in front of an abstract backdrop, they depict clichés of exotic and eternal beauty, idealized feminine symbolism (fecundity), and passive colonial subjects.[12] (Fig. 8.1) The "outsider status," or exteriority of Orientalism[13] is a paradox of the world-view expressed here, as the "primitive Other" is judged culturally wanting from the outside but is also seen to be connected directly to the "more advanced society" in evolutionary terms. In Homi Bhabha's words, the two are "tethered" to each other.[14] The discursive space which equates the primitive and "the return to origins" is therefore founded upon notions of universality and transcendence, as "origins [must] transcend family, class, religion, or homeland," and all journeys which attempt to "go home," to experience the primitive origins of mankind, are dependent upon a kind of reconciliation, even atonement, invoking a harmonious joining of the Westerner "[to] a 'universal' mankind in the primitive."[15]

At the same time, another kind of double articulation is present in such imagery, as one element of the colonizing mission was to bring "civilized" order to such primitivism in the form of modern governmental codes and civil processes, sound forms of economic practice, and rational political structures. Charles Cameron was intimately aware of such a civilizing mission. Years earlier, as a member of Thomas Macaulay's Commission overseeing the

establishment of the judicial code in India, Cameron had recommended to the British Government that it was Britain's role and moral duty as a superior nation to venture into primitive lands to transform the feudal social apparatus and organization of such societies into modern, advanced institutions. With respect to Ceylon, Cameron stated these ideas explicitly in a brief written in 1832 recommending judicial and governmental reforms to the colonial administration of the island:

[T]he peculiar circumstances of Ceylon, both physical and moral, seem to point it out to the British Government as the fittest spot in our Eastern dominions in which to plant the germ of European civilization, whence we may not unreasonably hope that it will hereafter spread over the whole of those vast territories.[16]

In colonial Britain, Ceylon was seen as emerging out of its infancy, developing toward Western norms, and for Julia Margaret Cameron, the "primitivism of the island" was an unquestioned maxim that was defined by such prevailing Orientalist attitudes.[17]

According to the theories informing this view, the "origins of primitive man" could be found in "primitive" cultures as remnants, relics, or cultural artifacts. In a telling photograph, Cameron depicted the common presence of one such relic coexisting among those in the present. (Fig. 8.2) Beneath this image she wrote: "A group of Kalutara peasants, the girl being 12 years of age, the old man saying he is her father and stating himself to be 100 years of age." The image invites speculation into the subjects' line of progeny while simultaneously branding this group as emblematic of the persistence of primitive origins in the present day. At the same time, the image merges the picturesque and the primitive, containing markers of virility (fatherhood at age 88), fecundity (the girl aged 12), ancestry and unbroken lineage, and documented longevity. In each quality, the image puts forth a primitive legacy that is presented as if it were uncomplicated, uninterrupted, and by extension, ubiquitous. Because Cameron's subjects have been turned into symbols for the native population as a whole, moreover, they also present a complicated double narrative that cannot be decoded by the artist's inscription alone. Cameron's native subjects have been contextualized with specific historical references, "giving the discourse an authority that is based on the pre-given or constituted historical origin *in the past*." Yet they have also been extracted from particular historical contingencies as symbolic referents, becoming instead "subjects of a process of signification that must erase any prior or originary presence" of their individuality or particular social realities. As a result, they emerge as a "sign of the *present* through which national life is redeemed and iterated as a reproductive process."[18]

Redeemed and naturalized by such double articulations, such imagery helps to mask how native peoples have been displaced and disinherited from their land and social autonomy by virtue of the continually shifting key

references within the representation. Charles Hay Cameron's work in 1832 establishing the judicial codes of Ceylon was instrumental in framing the new social structures that would become responsible for creating "appropriate civil behavior" in the colony. As Ashis Nandy has described, the ramifications of this so-called civilizing mission had a profound psychological impact, in which, for example, the marked passivity, weakness, and immaturity of the subjects in Cameron's image of the 12-year-old girl with her 100-year-old father could be taken as tacit evidence of such containment and inferiority; indeed, these qualities are inscribed by Julia Margaret Cameron's own hand. For Nandy, British law and civil codes helped to foster an uncomfortable cultural consensus among the colonized, in which the political and psychological roles of dominance and submission were accepted mutually by colonizers and colonized alike:

In such a culture, colonialism was not seen as an absolute evil. For the subjects, it was a product of one's own emasculation and defeat in legitimate power politics. For the rulers, colonial exploitation was an incidental and regrettable by-product of a philosophy of life that was in harmony with superior forms of political and economic organization.[19]

For Charles Cameron, it was Britain's role and moral duty as a superior nation to venture into primitive lands, like Ceylon, to transform the social apparatus and institutions of such societies into advanced civic and political structures.

North's first impressions of the island colony were also informed by sensibilities that joined together the primitive and the picturesque, attitudes which affected her paintings and inflected her diary entries. For example, reflecting upon her travel up the island's coast between her first stop, the port of Galle, to the island's colonial heart and its largest city, Colombo, North wrote the following diary entry. In this account, she compared in her mind's eye a picture of Java that she had made there only a short time before, to the mental sketch she was then forming in preparation for another image she would soon paint once she found herself settled in Colombo:

The road was most interesting all the way, near the beautiful shore or through swamps full of pandanus and other strange plants, with perpetual villages. I much missed the neat mat and bamboo houses of Java. In Ceylon they were mud-hovels, and everything was less neat, the people lazier, but the little bullock-carts were very pretty. There were plenty of flowers, many of those I remembered having seen in Jamaica.

Colombo is most unattractive, but cooler than Galle. All its houses seemed in process of being either blown up or pulled down. My hotel had 'temporary' actually printed on the bills.[20]

For North, Ceylon was simply another stop on her world tour, and it seems natural that she compared one new land to another. In invoking Java, North was specifically recalling Buitenzorg, the Dutch Royal Botanic Gardens there, where she made several works immediately preceding her trip to Ceylon. In

Ceylon, North's ultimate destination was Peradeniya, the Royal Botanic Garden of Ceylon, located near the mountain-top city of Kandy, where she was to stay for several weeks.[21] Therefore, in connecting together Java, Ceylon, and Jamaica in her diary, North was not randomly associating the qualities of different cultures or impoverished island colonies, but instead was comparing the specific colonial outposts where Britain's important botanical gardens were located. These experiences enabled North to reflect upon an apparent disjunction in which her immediate experience of the poverty and decline of native life did not accord with her far more refined experience in the comfort of the gardens, where she represented the systematic, ordered, and planned cultivation of plants, undisturbed by the poverty existing outside the gardens' walls. For North, this formal connection operated as both the literal and ideological common thread that linked together Java, Ceylon, and Jamaica. In her writing, North regularly contrasts the ephemeral and the permanent, shuddering at the thought of "temporary" housing and rickety means of transportation that characterized everyday life, calmed by the apparent enduring permanence and eternal qualities of the walled gardens that she was privileged to record.

Central to North's expeditions were the description, cataloging, and recording of primitive plants. To contemporary botanists, these plants were considered "primitive" not only because of their location on the globe, but also owing to their "unusual" (called "primitive") reproductive systems, their flamboyant and strange colors, and their apparent singularity or rarity in nature. One such example painted by North was the "taliput" palm (no. 284 in the Marianne North Gallery), which was said to flower only once, at full maturity and in a blaze of color, and then die.[22] Other studies from Ceylon include paintings of cocoa nut palms on the coast near Galle (no. 229), Ceylonese pitcher plants (no. 242), and an avenue of India rubber trees at Peradeniya. In choosing such diverse subjects, North marked their botanical importance not only by their attractive coloring, unusual flowers, or interesting growth patterns; these plants also were intriguing subjects of scientific investigation and possible economic use. "In colonial gardens we may discern a complex agenda," writes Richard Drayton:

They were, like public gardens at home, symbols of wise government. But we may also see in them spaces to which Europeans might retreat from the strangeness of alien environments. They often encompassed areas of wilderness, making islands of the same forest plants which encircled the boundaries of civility. They were theatres in which exotic nature was, literally, put in its place in a European system. This spectacle of the inclusion of the strange within the familiar comforted the expatriates and impressed the locals ... Indigenous nature, and aesthetic sense, were enclosed in an imported style.[23]

That "imported style" included the regularized rows of cultivated plants (for example, the rubber tree avenue), the roads (and later the railroad) which brought travelers to and from the garden's walls, connecting the maritime provinces to the less-accessible inland hills, as well as the vistas which were carefully planted to afford picturesque views. During the early part of the century in India, for example, "colonization by gardening" seemed to describe the British policy: new gardens were established wherever British garrisons and administrators were settled.[24] Paintings and drawings that depicted rare and unusual tropical plants also marked their fragility and called attention to their eventual disappearance under colonial expansion. As Joseph Hooker, the director at Kew, wrote in the introduction to a visitor's guide to the Marianne North Gallery,

these [species,] though now accessible to travelers and familiar to readers of travels, are already disappearing or are doomed shortly to disappear before the axe and the forest fires, the plough and the flock, of the ever-advancing settler or colonist. Such scenes can never be renewed by nature, nor when once effaced can they be pictured to the mind's eye.[25]

Charles Cameron's goal of "planting the germ of western civilization" in Ceylon was literally established when the Royal Botanic Garden at Peradeniya was established in 1822. The English Garden initially opened in 1810, remodeled from a version of an earlier Dutch garden on lands known formerly as "Slave Island." In its new incarnation, the Royal Botanic Gardens were charged with collecting and describing the largely unknown plants of the island, continuing the eighteenth-century practice of Linnaean scientific classification, a well-established convention at Kew. As early as 1821, though, much of the Garden's 143 acres were planted with coffee and cinnamon, plants that were thought to hold economic potential for the island. Although early scientific publications issued from Peradeniya enumerated many new species for the first time, from the middle of the century the Gardens adopted a new practice, known as "economic botany," or the cultivation of useful plants for their industrial exploitation and commercial profit.[26] "Wise government" was expressed by the containment of wild nature and the controlled direction of its vast productivity toward industrial ends.

Seed and plant transfers were one dimension of economic botany, which itself has a long history. Coffee, for example, is native to the highlands of Ethiopia, and was introduced to India by Arab traders; the Dutch found it there and planted it in 1659 in Ceylon and in 1696 in Java. In 1706, a plant was then transferred from Java to the Amsterdam Botanic Garden, from which its descendants were transported to Surinam in 1715, French Guiana and Brazil in 1727, and Martinique by way of the Jardin Royal de Paris in 1723.[27] In Ceylon, coffee flourished, at least initially. By 1850, when the Camerons planted Dimbula with young coffee plants, the country's coffee exports were worth

more than £500,000 annually; by 1860 that number tripled, and by 1870, another increase of 50 per cent more again.[28] The story of cinchona in Ceylon is a similar one, directly connected to the spread of Britain's Empire. Quinine, the drug extracted from the bark of the cinchona plant, was recognized as early as 1841 as an effective defense against the devastating effects of malaria and other fevers. With quinine in hand, new avenues of scientific, missionary, and economic exploration were possible, especially in subtropical Africa. Yet Spain, which controlled the source of cinchona in the Andean highlands, restricted its extraction and kept its price high. As Drayton has written, in their desperate attempt to gain control of the plant, Britain, Holland, and France began a competitive race to secure the best varieties of cinchona for plantation in their Asian colonies: "But the Dutch in Java stole the march: during 1853–54, Justus Charles Hasskarl, Superintendent of the Buitenzorg garden [on Java], traveled to South America in disguise to collect seeds." Kew responded in 1860, focusing "the systematic collection of the best varieties of cinchona in South America, the germination of seed in British greenhouses, their transport to botanic gardens in British Asia, and introduction into plantations." Hooker even enlisted Charles Darwin in the scheme, "and Darwin wrote to the director of the Ceylon Botanic Garden to suggest a technique of artificial fertilization, noting that, 'the growth of Cinchona is so important for mankind, that I am sure you will excuse me making this suggestion.'"[29] Responding to these imperatives, the director of the Ceylon Botanic Garden, George Henry Kendrick Thwaites, decided to plant the cinchona crop at Peradeniya's satellite garden, Hakgalla, the subject of another of North's paintings from Ceylon.[30] But by 1878, owing to unfavorable weather, the cinchona crop was in distress, as Thwaites dutifully reported to Kew:

At Hakgalla the Cinchona plantation has suffered very severely from the unusually wet season. Nearly all the large trees, 20 or 30 feet high, and about 12 years old, are dying; the stock plants and about 300,000 cuttings have been killed. We hope to recover ourselves in time, and by opening fresh nurseries, there is every possibility of being able to meet the demand for plants.[31]

While cinchona did not recover fully in Ceylon, Thwaites suggested introducing the cultivation of tea in the early 1870s, a plan that proved propitious. In 1873, for example, the island exported only 23 pounds of tea, but by 1895, Ceylon exported 74 million pounds, "representing about 40% of the tea consumed by Britain."[32]

Another definition of economic botany was the transfer of such plants from those areas of the world where a plant's cultivation was determined to be either too expensive or labor intensive to areas of inexpensive and plentiful labor, thereby enabling an efficient and inexpensive harvesting of the crop. The history of the rubber trees depicted by North illustrates how one such crop made its own travel narrative as such a form of transportable cultural

capital. During the 1850s, it was determined by Thomas Hancock in England and the Michelin firm in France that the Brazilian rubber tree produced a superior product as compared to other species. In 1876, the year of North's visit to Ceylon, seeds from Brazilian rubber plants were pirated out of the Amazon by Henry Wickham, aided by Tapuyo Indians. They were immediately transferred to the Royal Botanic Gardens at Kew, where Hooker gratefully received them. From there, he sent them to Calcutta, Singapore, and Ceylon, ostensibly to compare their growth patterns to other species of rubber trees transplanted there earlier. When North visited Peradeniya in late 1877, she met with George Thwaites and made a study of what he regarded the garden's chief asset, a stand of India rubber trees.[33] These trees had been transplanted from Assam, in Northern India, and represented a rival to the Brazilian tree. Meanwhile, researchers at the Botanic Garden in Singapore devised a new method of gently tapping this species to release the latex without killing the tree. In sharing this knowledge with administrators in Ceylon, therefore, Britain's colonial gardens effectively functioned as institutionally connected economic research centers, supporting global efforts to promote such economic use.[34]

North's painting of India rubber trees discloses two additional historical contingencies that are particular to the island colony but which are not readily apparent in the imagery: the first is the reality that India rubber was then being considered a suitable replacement crop for coffee on British plantations throughout the island. Since the mid-1850s, in fact, Ceylonese coffee plants were dying because of a fungus, an economic calamity which threatened many plantation owners, including the Camerons. The second is one of hidden conflict, represented by Britain's hostile views toward the native Sinhalese as indolent and obstructive laborers. Concealed, then, by this magnificent stand of trees was the history of the labor struggles between the island's native population and the British, which is unwittingly referred to in North's diary entry, as she described the extended view captured by two of her paintings representing the Garden's entrance:

There was a noble avenue of india-rubber trees at the entrance to the great gardens, with their long tangled roots creeping over the outside of the ground, and huge supports growing down into it from their heavy branches. Every way I looked at those trees they were magnificent. Beyond them one came to groups of different sorts of palm-trees, with one giant "taliput" in full flower. I settled myself to make a study of it, and of the six men with loaded clubs who were grinding down the stones in the roadway while they sang a kind of monotonous chant, at the end of each verse lifting up their clubs and letting them fall with a thud.[35]

The *Official Guide* to the Marianne North Gallery describes this painting in greater detail, paying critical attention to the role of the native men depicted: "The road-makers in the foreground are working in the native fashion, singing

a ballad and letting their rammers fall at the end of each verse only, with a long rest in between."[36] The visitor is therefore advised of the apparent indolence of workers, their "long interval" in the act of working a marker of their lethargy; and at the same time, the picturesque qualities of the scene are impressed upon the viewer: North's "monotonous chant" has become romanticized as if it were a quaint ballad. Cameron also used her camera to record native men standing erect and still in front of a similar stand of trees (a scrap-book image in the collection of the Royal Photographic Society), although there is no record of Cameron accompanying North to the Gardens. In both of these images, the Ceylonese men are portrayed as dwarfed by nature; they are inert and still, examples of the passive picturesque.

But in this painting of men in front of the taliput palm, North also depicted a chain-gang at work, the unforgiving facts of the scene erased from the *Official Guide*, replaced instead by a normalized description of ordinary labor. Yet in her painting, North captured one of the harshest chapters of the British colonial occupation of Ceylon, and one that involved Charles Cameron directly. In fact, together with his fellow commissioner, William Colebrooke, Cameron was instrumental in helping institute the system of wage labor on the island, bringing British law and customs to a native economy that was still steeped in feudal allegiances to chieftains and kings, with the Sinhalese holding a non-proprietary attitude toward the fruits of the land, a system called *rajakariya*. When the British first took control of the island in 1798, compulsory road-work was imposed under the *rajakariya* system, where workers received no wages, but only an allowance of rice. In one form or another, compulsory road-work was mandated as law under British occupation throughout the nineteenth century. In 1832, when the Colebrooke–Cameron reforms took effect, minimal wages replaced compulsory labor, but as the number of British plantations grew during the succeeding years, the need for more roads also increased, and in 1848, a new road ordinance was passed, requiring six days labor per year from every islander. Runaways were imprisoned, but then brought out to the roadways, again, to complete their work as part of chain-gangs.[37] As North observed, they endured their captivity in song, rhythmically chanting amid short periods of rest as they crushed their stones.

North finally met Cameron when she traveled from Peradeniya to Kalutara at the end of her visit to Ceylon. She made two paintings from their land, and in her diary, reflected upon their lifestyle:

[The Camerons'] house stood on a small hill, jutting out into the great river which ran into the sea a quarter of a mile below the house. The walls of the rooms were covered with magnificent photographs; others were tumbling about the tables, chairs, and floors, with quantities of damp books, all untidy and picturesque; the lady herself with a lace veil on her head and flowing draperies.[38]

North spent several days there, making it possible to share several experiences with her host. At least one encounter occurred between a peddler group and the two women, and the two artists produced very similar works, with three men displaying their wares while seated on the ground. In her diary, North described her experience with a similar encounter from her preceding week in Peradeniya: "[In the] morning at six I was at work on my sketch ... and breakfasted in the old palace, when a party of Indian pedlars came and spread out their gorgeous shawls and other goods on the verandah. They made a fine foreground to the flowers and palm-trees beyond."[39] (Figs 8.3, 8.4) Not surprising for the botanical illustrator, people take a back seat to plants in North's mind's eye. By contrast, in recording her peddler group photographically, Cameron focused instead on the men and their goods, while North regarded the peddlers as minor subjects, blending them into the overall composition of her painting.

North then described Cameron's efforts to photograph her as a subject, producing a result that neither of them pronounced a success. Speaking now as a photographic subject in front of Cameron's lens, North intriguingly wrote about witnessing how the photographer attempted to control both "nature" and the picturesque by carefully arranging both her guest and her subject's backdrop, all in the name of trying to achieve some unrealized "primitive" ideal, where the artificial pose would appear as somehow natural and uncomplicated:

She dressed me up in flowing draperies of cashmere wool, let down my hair, and made me stand with spiky cocoa-nut branches running into my head, the noonday sun's rays dodging my eyes between the leaves as the slight breeze moved them, and told me to look perfectly natural (with a thermometer standing at 96°F)! Then she tried me with a background of breadfruit leaves and fruit, nailed flat against a window shutter, and told *them* to look natural, but both failed; and though she wasted twelve plates, and an enormous amount of trouble, it was all in vain.[40]

According to North, Cameron found her subject, a Western outsider, did not "look natural" (or natural enough) before her lens when posed in front of her symbols of tropical nature, the breadfruit leaves and fruit. It seems that in order for that to occur, for a believable representation of "nature" to be recorded satisfactorily, Cameron required a native subject, one who was more convincingly portrayed as "at home" in her primitive surroundings. Or perhaps to the photographer, the "natural backdrop" surrounding North looked contrived and unnatural, or her props (or even her model) false and artificial. Either way, numerous contradictions complicate our understanding of what the photographer deemed a failure, particularly when compared to other photographs of native women sitters that she produced around the same time.[41]

In this imagery, native women are depicted in a predictable manner representing established Orientalist themes. In earlier photographs depicting

scenes of Tennyson's poetry, for example, or portrait heads transformed into allegorical representations depicting the mythic attributes of goddesses or Madonnas, Cameron did not hesitate to use props and costumes. Now in Ceylon, the native women depicted stand traditionally robed or half-dressed, representing both primeval fertility and "naturalized" essential "women" "madonnas of the tropics." If we accept this characterization of her imagery of Ceylonese native women, the symbolic naturalism which characterizes the women and their surroundings help to define them in conventional terms, while for the "unsuccessful image" of North, by contrast, photographed uncomfortably before a contrived tropical backdrop, the image becomes complicated as an uncomfortable and unworkable hybrid. In the former, Cameron has depicted the unadorned, uncomplicated, and primitive East; in the latter where the Westernized Other has been appropriated out of her "true context" and inserted into the "eternal present" required of primitivism, the illusion breaks down, because as Torgovnick reminds us, primitivism essentially requires that native societies are denied a past of their own.

We might trace this conflict to what Homi Bhabha has called an indeterminant, ambivalent world for colonialists, one in which imagery can only be reduced to the mining of a stockhouse of stereotypes. When representations are limited in this way, such imagery can only vacillate uncomfortably "between what is always 'in place', already known, and something that must be anxiously repeated ... [which] can never really, in discourse, be proved."[42] Cameron's apparent ambivalence toward her subjects certainly preceded North's visit, but her Western visitor helped to complicate her conventional attitudes toward nature and the picturesque. Throughout the different phases of her photographic career, Cameron largely portrayed women in uncomplicated stereotypes, epitomizing Eastern exoticism, portraying Western goodness or idealized holiness, or embodying essentialized femininity and the return to origins. Ironically, at the end of her career, Cameron could not bring herself to produce a satisfactory image of North according to these well-worn visual strategies, perhaps because their legitimacy had been called into question. Cameron's photograph of a native woman posed as a type of "madonna study" is similarly unresolved, perhaps another casualty of this crisis of representation. (Fig. 8.5) When seen critically from Bhabha's perspective, this portrayal represents a different kind of hybrid image. This photograph is unable to portray "the Madonna" convincingly in Western terms, because her evident native appearance complicates the subject, which thereby undermines, or at least challenges, Western norms and expectations. At the same time, the image unconvincingly symbolizes the so-called powerlessness of the female subject as a stock image representing submissive colonial primitivism, because its subject's self-possession and autonomy is evident through her direct gaze back at the photographer. In

Cameron's and in North's imagery, we have representations marking again and again the confrontation of Self and Other. As theorized by Bhabha, such articulations disclose the intermixture of fear and desire, mimicry and difference, and obedience and independence in the imagery, expressing the artists' constant struggle with their status as colonialist outsiders.[43] When conceived in these terms, both North's paintings and Cameron's photographs actually destabilize the narrative myths they supposedly represent: they become instead double articulations, or hybrid works. As a result, the mythic return to primitive origins, like the unquestioned superiority of colonialist power, is dramatically undermined by this work.

The theoretical concept that joins the idea of "going home" to the state of "going primitive" was an important one for Georg Lukacs, who, in his literary criticism, also examined the causes and the consequences of destabilized narratives. Most especially, in his *Theory of the Novel*, Lukacs wrote of "transcendental homelessness," a condition particular to exile but also to the social separation, psychological displacement, and spatial dislocation of distant travel. Such an affliction was often manifested as a restless and unsettled state of affairs, an inconsolable yearning for origins and home brought on by such displacement; for Lukacs, this condition found its more formal expression in letters, literature, and visual art. Cameron crystallized these competing yet compatible allegories of displacement in a photographic portrait of North, in which she included an open invitation for those who might purchase this image to speculate on the question of the return to origins and participate in the dream of claiming one's national inheritance. (Fig. 8.6) All of these qualities are contained within this image, one that has been otherwise overlooked in the literature as a plain and straightforward photograph presenting North seated at a table, glancing up from reading a book. But not just any book: Cameron's photograph shows North looking up from reading George Eliot's recently serialized novel, *Daniel Deronda*. The novel, published in installments between February and September 1876, helps us date the image while at the same time marking Cameron's deep connection to the recent cultural products of English society, and to her continuing personal interest in the literary work of Eliot.[44] Moreover, Cameron's inclusion of an installment of *Daniel Deronda* also transforms the meaning of this desktop prop into a resonant symbolic object because of the overwhelming significance of Eliot's work. The presence of *Daniel Deronda* not only grounds Cameron and North in place and time, but also metaphorically marks a suggestive sign of the colonists' conflict in terms of contemporary political debates, in particular, the broader search for a mythic return to origins as measured by reclaiming a "lost" foreign land, all in view of extending the nation's borders on the political map as an act of redemption.

Eliot confronts these themes directly in *Daniel Deronda*. In the third chapter of the novel, the author ruminates on the nature of home and belonging, the contented quality of feeling a deep connection to home and to family, and the negative consequences of being rootless in the world, both physically and spiritually. These interconnected themes are central to the novel; they describe the key hardships and source of internal conflict with which her two main characters, Gwendolyn Harleth and Daniel Deronda, contend throughout the novel, and indeed, which link together their personal yearnings, life stories, and ultimate destinies.

Pity that Offendene was not the home of Miss Harleth's childhood, or endeared to her by family memories! A human life, I think, should be well rooted in some spot of a native land, where it may get the love of tender kinship for the face of earth, for the labours men go forth to, for the sounds and accents that haunt it, for whatever will give that early home a familiar unmistakable difference amidst the future widening of knowledge: a spot where the definiteness of early memories may be inwrought with affection, and kindly acquaintance with all neighbours, even to the dogs and donkeys, may spread not by sentimental effort and reflection, but as a sweet habit of the blood. At five years old, mortals are not prepared to be citizens of the world, to be stimulated by abstract nouns, to soar above preference into impartiality; and that prejudice in favour of milk with which we blindly begin, is a type of the way body and soul must get nourished at least for a time. The best introduction to astronomy is to think of the nightly heavens as a little lot of stars belonging to one's own homestead.[45]

Jean Sudrann has noted how in this passage Eliot deliberately asks her reader to reflect upon Romantic expressions of the universal, where all things are "at home under the stars" and bound to each other in some meaningful but perhaps unknowable way.[46] And as Edward Said has written, the novel's

backdrop is a generalized condition of homelessness. Not only the Jews, but even the well-born Englishmen and women in the novel are portrayed as wandering and alienated beings ... Thus Eliot uses the plight of the Jews to make a universal statement about the nineteenth century's need for a home, given the spiritual and psychological rootlessness reflected in her characters' almost ontological physical restlessness.[47]

In the novel, Deronda's Romantic search leads him to self-discovery, to a sense of purpose and civic obligation, and to the recovery of his Jewish heritage, but his story is also one in which the character, who has lacked a true "homestead" as the adopted child of Sir Hugo Malinger, resolves to create one of his own making. Moreover, Deronda is able to achieve true independence as an adult by reclaiming land that had been "lost" by his unknown ancestors. By the end of the novel, Deronda's internal state of homelessness finds its corrective direction in his determination to leave England, the only "homeland" he has ever known. Responding to a powerful and overwhelming urge to be redeemed in a "native land" that he has never even seen, Daniel resolves to establish a new Jewish homeland in "the East." In the final pages of *Daniel Deronda*, the character finds his destiny in building a new nation, populated by

those like him who are similarly exiled and homeless. A future homeland waits, he says:

I am going to the East to become better acquainted with the condition of my race in various countries there … The idea that I am possessed with is that of restoring a political existence to my people, making them a nation again, giving them a national centre, such as the English have, though they too are scattered over the face of the globe.[48]

The colonial agenda is implicitly taken as a suitable model for this redemptive act, the sole possibility for healing the cruel displacement of homelessness.

Deronda's psychological redemption is accomplished through political means, therefore, where English imperialism, with its presumed intact national identity and spiritual connection to the universal, functions as the chief idealized model, where the colonies are seen to occupy solid, legitimate linkages to the imperial center, and in return where, from the edges of the Empire, their identity and association as occupying a mythic place of origins, the "true" homeland, are cultivated and nourished.[49] If Tennyson's *Idylls of the King* put forward the idea of reestablishing the earlier glories of an empire that had fallen in the past, *Daniel Deronda* advanced the idea of recovering that past, revitalizing the present, and laying the political foundations to establish a future of restored national identity, an empire with a restored and redeemed homeland. Cameron's avowed admiration for Eliot therefore found its most concrete expression in her portrait of North looking up from reading *Daniel Deronda*.[50] As we have seen, both artists found their own sentiments and actions replicated many of the fictional impulses and longings that were expressed by Eliot's hero, as well as her character's nationalistic compulsions. Cameron was enraptured by a sense of "going forth" in harmony with "all men under the sun;" she found her "return" to the East both redemptive and revitalizing. North, too, represented botanical specimens that had been scattered, like seeds, throughout the world, and was able to join them together literally and metaphorically, reuniting them in her Gallery at Kew, an elegant stand-in for the "national center."

Notes

Portions of this essay were presented in 1998 as "Encountering 'the primitive' in Ceylon," at the annual meeting of the College Art Association in Toronto, and in 1999 as "Desperately Seeking 'nature': Exploring Ceylon in 1876 with Julia Margaret Cameron and Marianne North," at the Victorian Arts Symposium, College of Visual Arts in St. Paul.

1. On the context of women as botanical illustrators, see Wilfred Blunt, *The Art of Botanical Illustration* (London: Collins, 1950), and Londa Schiebinger, "Gender and Natural History," in N. Jardine, J. A. Secord, and E. C. Spary, eds., *Cultures of Natural History* (Cambridge: Cambridge University Press, 1996), 163–77.

2. Mary Louise Pratt, *Imperial Eyes: Travel Writing and Transculturation* (London: Routledge, 1992), 104.

3. Nor were they "innocent," a claim made for North because of the supposed objectivity employed in scientific botanical illustration:

> North combines the innocence of the botanist with the innocence of the mimetic artist – viewing, not taking; recording, but not altering. She collected visual representations only, and brought them home and planted them in England. The seeming "innocence" of the cultural productions of a traveling artist calls into question the status of representation as imperial project – do her paintings participate in the appropriation of foreign resources and peoples?

> Antonia Losano, "A Preference for Vegetables: The Travel Writings and Botanical Art of Marianne North," *Women's Studies* 26 (October 1997): 423–6.

4. See Jeff Rosen, "Cameron's Photographic Double Takes," *Orientalism Transposed: The Impact of the Colonies on British Culture*, Julie F. Codell and Dianne Sachko Macleod, eds. (London: Ashgate, 1998), 158–86.

5. See Brian Hill, *Julia Margaret Cameron: A Victorian Family Portrait* (London: Peter Owen, 1973), 47.

6. See Rosen, "Cameron's Photographic Double Takes," 176.

7. Letter from Charles Hay Cameron to Julia Margaret Cameron, dated "Rathoongodde, Dec. 16, 1850," Julia Margaret Cameron Family Papers, The Getty Research Institute for the History of Art and the Humanities, Acc. #850858 (hereafter GRI), Box 1.

8. Quoted in Anne Isabella Thackeray Ritchie, *From Friend to Friend* (London: John Murray, 1919), 34.

9. Marianna Torgovnick, *Gone Primitive: Savage Intellects, Modern Lives* (Chicago: University of Chicago Press, 1990), 185.

10. Torgovnick, *Gone Primitive*, 187.

11. Letter dated "20th Nov. 1876," no salutation, closing, or signature, in GRI, Box 1; reprinted in Mike Weaver, *Whisper of the Muse* (Malibu: J. Paul Getty Museum, 1986), 68.

12. See Elizabeth J. Harris, *The Gaze of the Coloniser: British Views on Local Women in 19th Century Sri Lanka* (Colombo: Social Scientists' Association, 1994).

13. According to Edward Said, exteriority is by no means limited to expression in the verbal arts; rather, it encompasses virtually all forms of representation:

> Orientalism is premised upon exteriority, that is, on the fact that the Orientalist, poet or scholar, makes the Orient speak, describes the Orient, renders its mysteries plain for and to the West. He is never concerned with the Orient except as the first cause of what he says. What he says and writes, by virtue of the fact that it is said or written, is meant to indicate that the Orientalist is outside the Orient, both as an existential and as a moral fact. The principal product of this exteriority is of course representation.

> Edward Said, *Orientalism* (New York: Vintage, 1978), 20–21.

14. Homi K. Bhabha, "Interrogating Identity: Frantz Fanon and the Postcolonial Prerogative," *The Location of Culture* (New York: Routledge, 1994), 44.

15. Torgovnick, *Gone Primitive*, 187, n. 9.

16. Charles Hay Cameron, "Report of Charles H. Cameron Esq. upon the Judicial Establishments and Procedure in Ceylon [31 January 1832]," in G. C. Mendis, ed., *The Colebrooke-Cameron Papers: Documents on British Colonial Policy in Ceylon, 1796–1833*, 2 vols. (London: Oxford University Press, 1956), 1: 182.

17. See especially, V. G. Kiernan, *The Lords of Human Kind: Black Man, Yellow Man, and White Man in an Age of Empire* (Boston: Little, Brown and Co., 1969), esp. 46–62, 76–78, 211–20; George D. Bearce, *British Attitudes Towards India, 1784–1858* (London: Oxford University Press, 1961); and Henri Baudet, Elizabeth Wentholt, trans. *Paradise on Earth: Some Thoughts on European Images of Non-European Man* [1965]; reprint (Westport, Conn.: Greenwood Press, 1976).

18. Bhabha, "Dissemination," in *The Location of Culture*, 145, n. 15.

19. Ashis Nandy, *The Intimate Enemy: Loss and Recovery of Self under Colonialism* (Delhi: Oxford University Press, 1983), 10. According to Nandy, an almost logical extension of this "cultural consensus" was the way in which concepts of childhood irresponsibility, moral weakness, and immaturity were extended as a "positive" rationale by the colonizer to "solve" the problem of primitivism: "[C]olonialism dutifully picked up these ideas of growth and development and drew a new parallel between primitivism and childhood. [...] What was childlikeness of the child and childishness of immature adults now also became the lovable and unlovable savagery of primitives and the primitivism of subject societies." The circular reasoning of this racist stereotypical discourse is analyzed by Bhabha in "The Other Question," in *The Location of Culture*, 82–3.

20. Marianne North, *A Vision of Eden: The Life and Work of Marianne North* (New York: Holt, Rinehart and Winston, 1980), 115.

21. In his essay, "The Blue Guide," Roland Barthes writes that Christianity became the chief purveyor of Western tourism. Yet as we can see, in North we have another example of cultural tourism existing alongside expeditions to the "holy land" by way of economic impulses fueling the colonial connection throughout the world and linking Britain's botanic gardens. See Roland Barthes, "The Blue Guide," *Mythologies*, Annette Lavers, trans. (New York: Hill and Wang, 1972), 74–7.

22. One is tempted to draw a metaphor to popular fictional heroines, women who transgressed some moral or supposedly biological norm, to help explain the appeal of such exotic plant life to the popular culture of the time.

23. Richard Drayton, *Nature's Government: Science, Imperial Britain, and the "Improvement" of the World* (New Haven, Conn.: Yale University Press, 2000), 183.

24. Drayton cites, as examples, in the north, Agra, Cawnpore, Lucknow, Delhi, Meerut, Umbala, and Simla; in the northwest Provinces, Kussowlie, Dugshai, and Lahore; in the East, soldiers of the East India Company established a garden at Pegu; in the south, at Ootacamund. Drayton, *Nature's Government*, 182–3.

25. J. D. Hooker, "Preface to the first edition, June 1, 1882," Royal Gardens, Kew. *Official Guide to the North Gallery*, 5th edition (London: Eyre and Spottiswoode, 1892), iii.

26. See Lucile H. Brockway, *Science and Colonial Expansion: The Role of the British Royal Botanic Gardens* (New York: Academic Press, 1979).

27. Brockway, *Science*, 51. See also J. C. Willis, "The Royal Botanic Gardens of Ceylon, and their History," *Annals of the Royal Botanic Gardens, Peradeniya*, J. C. Willis, ed. (June 1901–September 1902), 1: 1.

28. Drayton, *Nature's Government*, 195, n. 35.

29. Ibid., 208–209.

30 Willis, "The Royal Botanic Gardens of Ceylon, and their History," 8, n. 39.

31. *Report on the Progress and Conditions of the Royal Gardens at Kew, During the Year 1878* (London: George E. Eyre and William Spottiswoode, 1879), 9.

32. Drayton, *Nature's Government*, 249.

33. In "The Blue Guide," Barthes also noted that a chief convention of travel narratives is to suppress history: "To select only monuments suppresses at one stroke the reality of the land and that of its people, it accounts for nothing of the present, that is, nothing historical, and as a consequence, the monuments themselves become undecipherable, therefore senseless." Barthes, *Mythologies*, 76, n. 33. The stand of India rubber trees, in this context, was one such "monument." When he visited the Royal Botanic Gardens at Peradeniya in 1875, Anthony Trollope met Thwaites and saw the same stand of trees; to Trollope, it was "a land of loveliness, surrounded by the most perfect scenery which the mind can imagine. If, as some say, Eden was in Ceylon, this must have been the spot." See Anthony Trollope, *The Tireless Traveler*, Bradford Allen Booth, ed. (Berkeley: University of California Press, 1941), 60.

34. For this history of the rubber plant, see Brockway, *Science*, 156–8, n. 32.

35. North, *A Vision of Eden*, 118, n. 32.

36. Royal Gardens, Kew, *Official Guide to the North Gallery*, 5th edn., #284 (London: H. M. Stationery Office, 1892), 42.

37. See Jean Grossholtz, *Forging Capitalist Patriarchy: The Economic and Social Transformation of Feudal Sri Lanka and its Impact on Women* (Durham, North Carolina.: Duke University Press, 1984), 63–5.

38. North, *A Vision of Eden*, 118–19.

39. Ibid., 118–19.

40. Ibid., 119.

41. See also Lori Cavagnaro, "Julia Margaret Cameron: Focusing on the Orient," in *Gendered Territories*, Dave Oliphant, ed. (Austin: University of Texas, 1996), 117–44. For a comprehensive overview of Cameron's photographs from Ceylon, see Julian Cox and Colin Ford, *Julia Margaret Cameron: The Complete Photographs* (Los Angeles: J. Paul Getty Trust, 2003).

42. Bhabha, "The Other Question," *The Location of Culture*, 72.

43. Bhabha, "Signs Taken for Wonders," *The Location of Culture*, 112–20.

44. Linda K. Hughes and Michael Lund, *The Victorian Serial* (Charlottesville: University of Virginia Press, 1991), 155. The connection between George Eliot and Julia Margaret Cameron has been made earlier in terms of Eliot's apparent interest in photography and her use of William Henry Fox Talbot's home, Lacock Abbey, as a model in her novel, but not in terms of this image of North by Cameron. See Kathleen McCormack, "George Eliot, Julia Cameron, and William Henry Fox Talbot: Photography and *Daniel Deronda*," *Word and Image*, 12 (April–June 1996): 175–9. Cameron sent George Eliot several photographs in 1871, which were gratefully received. See also *The George Eliot Letters*, Gordon S. Haight, ed. (New Haven, Conn.: Yale University Press, 1955), vol. v, 133.

45. George Eliot, *Daniel Deronda* (Ware: Wordsworth Editions, 1996), Chapter 3, 15–16.

46. Jean Sudrann, "*Daniel Deronda* and the Landscape of Exile," *ELH*, 37 (September 1970): 436.

47. Edward Said, "Zionism from the Standpoint of its Victims," *Social Text* (Winter 1979): 18.

48. Eliot, *Daniel Deronda*, Chapter 69, 669.

49. See Marc E. Wohlfarth, "*Daniel Deronda* and the Politics of Nationalism," *Nineteenth Century Literature*, 53 (September 1988): 188–210 and Monica Cohen, "From Home to Homeland: The Bohemian in *Daniel Deronda*," *Studies in the Novel*, 30 (Fall 1998): 324–54.

50. See n. 44.

Selected bibliography

A Vision of Eden: The Life and Work of Marianne North. New York: Holt, Rinehart, and Winston published in collaboration with Royal Botanic Gardens, Kew, 1980.

Adams, W. H. Davenport. *Celebrated Women Travellers of the Nineteenth Century*. London: W. Swan Sonnenschein & Co., 1883.

Allen, David Elliston. *The Naturalist in Britain: A Social History*. Princeton: Princeton University Press, 1994.

Baudet, Henri. *Paradise on Earth: Some Thoughts on European Images of Non-European Man*. Elizabeth Wentholt, trans. Repr. Westport, Conn.: Greenwood Press, 1976.

Bearce, George D. *British Attitudes Towards India, 1784–1858*. London: Oxford University Press, 1961.

Beaulieu, Jill and Mary Roberts, eds. *Orientalism's Interlocutors: Painting, Architecture, Photography*. Durham & London: Duke University Press, 2002.

Beaver, Donald deB. "Writing Natural History for Survival—1820–1856: The Case of Sarah Bowdich, later Sarah Lee." *Archives of Natural History* 26 (1999): 19–31.

Beer, Gillian. *Open Fields: Science in Cultural Encounter*. Oxford: Oxford University Press, 1996.

Bermingham, Ann. *Learning to Draw: Studies in the Cultural History of a Polite and Useful Art*. New Haven, Conn.: Yale University Press, 2000.

Bhabha, Homi K. "Interrogating Identity: Frantz Fanon and the Postcolonial Prerogative." *The Location of Culture*. New York: Routledge, 1994.

Bird, Isabella L. *Unbeaten Tracks in Japan*. 1880. Repr. Boston: Beacon Press, 1984.
——. *A Lady's Life in the Rocky Mountains*. 1879. Repr. London: Virago Press, 1986.

Birkett, Dea. *Spinsters Abroad: Victorian Lady Explorers*. Oxford: Basil Blackwell, 1989.

Blaikie, W. G. "Lady Travellers." *Blackwood's Magazine*. July, 1896.

Blunt, Wilfred. *The Art of Botanical Illustration*. London: Collins, 1950.

Brassey, Annie. *Sunshine and Storm in the East, or Cruises to Cyprus and Constantinople*. New York: H. Holt, 1880.

Brockway, Lucile H. *Science and Colonial Expansion: The Role of the British Royal Botanic Gardens*. New York: Academic Press, 1979.

Burant, James. *Drawing on the Land: The New World Watercolours and Diaries (1838–1942) of Millicent Mary Chaplin*. Manotick, Ontario, Canada: Penumbra Press, 2004.

Butler, Elizabeth. *An Autobiography*. London: Constable & Co., 1923.

Callaway, Anita. *Visual Ephemera: Theatrical Art in Nineteenth-Century Australia*. Sydney: UNSW Press, 2000.

——— . "A Broad Brush Dipped in Gold." In *Gold: Forgotten Histories and Lost Objects of Australia*. I. McCalman, A. Cook, and A. Reeves, eds. Melbourne: Cambridge University Press, 2001.

Canning, Charlotte. Papers and Journals of Lady Canning. Leeds District Archives, Leeds.

Casteras, Susan P. and Linda H. Peterson. *A Struggle for Fame: Victorian Women Artists and Authors*. New Haven: Yale Center for British Art, 1994.

Cavagnaro, Lori. "Julia Margaret Cameron: Focusing on the Orient." In *Gendered Territories*. Dave Oliphant, ed. Austin: University of Texas, 1996.

Cherry, Deborah. *Painting Women: Victorian Women Artists*. London: Routledge Press, 1993.

Christian, John. "Helen Allingham and the Cottage." In *The Markey Collection of Watercolours by Helen Allingham*. London: Christie, Manson & Woods, 1991.

Clark, Janet E. and Robert Stacey. *Frances Anne Hopkins, 1838–1919: Canadian Scenery*. Thunder Bay, Canada: Thunder Bay Art Gallery, 1990.

Colligan, Mimi. *Canvas Documentaries: Panoramic Entertainments in Nineteenth-Century Australia and New Zealand*. Melbourne: Melbourne University Press, 2002.

Cox, Julian and Colin Ford. *Julia Margaret Cameron: The Complete Photographs*. Los Angeles: J. Paul Getty Trust, 2003.

Cumming, Constance Gordon. "A Lady's Railway Journey in India." *Macmillan's Magazine*, 49 (May 1884): 301.

Dickinson, Violet. *Miss Eden's Letters*. London: Macmillan, 1919.

Dixie, Florence. *Across Patagonia*. London: Richard Bentley and Son, 1880.

Drayton, Richard. *Nature's Government: Science, Imperial Britain, and the "Improvement" of the World*. New Haven, Conn.: Yale University Press, 2000.

Eden, Frances H. *Four Sketching Albums*. 1837. Eur Mss c. 130, British Library, London.

Edwards, Amelia B. *Untrodden Peaks and Unfrequented Valleys: A Midsummer Ramble in the Dolomites*. 1873. Repr. Boston: Beacon Press, 1987.

Ellis, Vivienne Rae. *Louisa Anne Meredith: A Tigress in Exile*. Sandy Bay: Blubber Head Press, 1979.

Feltes, N. N. "Voy(ag)euse: Gender and Gaze in the Canoe Paintings of Frances Anne Hopkins." *ARIEL: A Review of International English Literature*, 24 (October 1993): 7–19.

Foster, Shirley. *Across New Worlds: Nineteenth-Century Women Travelers and Their Writings*. New York: Harvester Wheatsheaf, 1990.

Frawley, Maria. "Fair Amazons Abroad: The Social Construction of the Victorian Adventuress." *Annals of Scholarship* 7, no. 4, Nikki Lee Manos, ed. (1990): 501–22.

Fussell, Paul. *Abroad: Literary Traveling Between the Wars*. New York: Oxford University Press, 1980.

Gates, Barbara T. *Kindred Nature: Victorian and Edwardian Women Embrace the Living World*. Chicago: University of Chicago Press, 1998.

Gaunt, Mary. *Alone in West Africa*. London: T. Werner Laurie, 1911.

Ghose, Indira. *Women Travellers in Colonial India: The Power of the Female Gaze*. Delhi: Oxford University Press, 1998.

Godsell, Patricia, ed. *The Diary of Jane Ellice*. Toronto: Oberon Press, 1975.

Goodman, David. "Reading Gold-rush Travellers' Narratives." *Australian Cultural History: Travellers, Journeys, Tourists* 10 (1991): 99–112, 99.

Gordon, Lucie Duff. *Letters from Egypt: To Which are Added Letters from the Cape*. London: Macmillan, 1876.

Gould, John. *The Birds of Australia*. 7 vols. London: published by the author, 1840–48.

Harris, Elizabeth J. *The Gaze of the Coloniser: British Views on Local Women in 19th Century Sri Lanka*. Colombo: Social Scientists' Association, 1994.

Hartrick, Elizabeth. "Consuming Illusions: The Magic Lantern in Australia and Aotearoa/New Zealand 1850–1910." Ph.D. thesis. University of Melbourne, 2003.

Hill, Brian. *Julia Margaret Cameron: A Victorian Family Portrait*. London: Peter Owen, 1973.

Hirsch, Pam. *Barbara Leigh Smith Bodichon 1827–1891: Feminist, Artist and Rebel*. London: Chatto & Windus, 1998.

Hodgson, Barbara. *No Place for a Lady: Tales of Adventurous Women Travelers*. Berkeley, Calif.: Ten Speed Press, 2002.

Hussey, Mrs. T. J. *Illustrations of British Mycology*. London: Lovell Reeve, 1837–55.

Ibbetson, Agnes. "On the Nourishment Produced to Plants by its Leaves." *Philosophical Magazine* 45 (1815): 3–15.

Irwin, Francina. "Amusement or Instruction? Watercolour Manuals and the Woman Amateur." In *Women in the Victorian Art World*. Clarissa Campbell Orr, ed. Manchester: Manchester University Press, 1995.

Jameson, Anna. *Winter Studies and Summer Rambles in Canada*. London: Saunders and Otley, 1838.

Jardine, N., J. A. Secord and E. C. Spary, eds. *Cultures of Natural History*. Cambridge: Cambridge University Press, 1996.

Johnston, Judith. *Anna Jameson: Victorian, Feminist, Woman of Letters*. London: Scolar Press, 1997.

Jordan, Caroline. "Progress versus the Picturesque: White Women and the Aesthetics of Environmentalism in Colonial Australia 1820–1860." *Art History* 25 (June 2002): 341–57.

Julia Margaret Cameron Family Papers, The Getty Research Institute for the History of Art and the Humanities, Acc. #850858. Los Angeles, California.

Kent, Elizabeth. *Flora Domestica, or the Portable Flower-Garden; with Directions for the Treatment of Plants in Pots; and Illustrations from the Works of the Poets*. London: Taylor & Hessey, 1823.

Kerr, Joan, ed. "Emma MacPherson." *Dictionary of Australian Artists … to 1870*. Melbourne: Oxford University Press, 1992.

Kiernan, V. G. *The Lords of Human Kind: Black Man, Yellow Man, and White Man in an Age of Empire*. Boston: Little, Brown and Co., 1969.

Kingsley, Mary. *Travels in West Africa. Congo Francias, Corisco and Cameroons*. 1897. Repr. Boston: Beacon Press, 1995.

——. "Travels on the Western Coast of Equatorial Africa." *The Scottish Geographical Magazine* (1896).

Losano, Antonia. "A Preference for Vegetables: The Travel Writings and Botanical Art of Marianne North." *Women's Studies* 26 (October 1997).

Loudon, Jane. *Botany for Ladies*. London: John Murray, 1842.

——. ed. *Ladies' Companion at Home and Abroad*. London, 1849–50.

"A Lady" [Mrs. Allan MacPherson]. *My Experiences in Australia: Being Recollections of a Visit to the Australian Colonies in 1856–7*. London: J. F. Hope, 1860.

Macpherson, Geraldine. *Memoirs of the Life of Anna Jameson*. London: Longmans, Green, and Co., 1878.

McCormack, Kathleen. "George Eliot, Julia Cameron, and William Henry Fox Talbot: Photography and *Daniel Deronda*." *Word and Image* 12 (April–June 1996): 175–9.

Meredith, Louisa Anne Twamley. *My Home in Tasmania during a Residence of Nine Years*. London: John Murray, 1852.

——. *Notes and Sketches of New South Wales during a Residence in that Colony from 1839 to 1844*. London: John Murray, 1844.

——. *Our Island Home: A Tasmanian Sketchbook*. London: Marcus Wood, 1879.

——. *Our Wildflowers Familiarly Described and Illustrated*. London: John Murray, 1839.

——. *Some of My Bush Friends in Tasmania: Native Flowers, Berries and Insects Drawn from Life, Illustrated in Verse and Briefly Described*. London: Day and Son, 1860.

——. *Tasmanian Friends and Foes: Feathered, Furred, and Finned*. London: Marcus Ward, 1880.

——. *The Romance of Nature; or, The Flower-Seasons Illustrated*. London: Charles Tilt, 1836.

Meredith, Mrs. Charles. *Notes and Sketches of New South Wales during a Residence in that Colony from 1839 to 1844*. Melbourne: Penguin facsimile edition, 1973.

Mills, Sara. *Discourses of Difference: An Analysis of Women's Travel Writing and Colonialism*. London: Routledge, 1991.

——. "Knowledge, Gender, and Empire." In *Writing Women and Space: Colonial and Postcolonial Geographies*. Alison Blunt and Gillian Rose, eds. London: Guilford, 1994.

Morgan, Susan. *Place Matters: Gendered Geography in Victorian Women's Travel Books about Southeast Asia*. Brunswick, N.J.: Rutgers University Press, 1996.

Moyal, Ann. *"A Bright and Savage Land": Scientists in Colonial Australia*. Sydney: Collins, 1986.

Nandy, Ashis. *The Intimate Enemy: Loss and Recovery of Self under Colonialism*. Delhi: Oxford University Press, 1983.

Natural Eloquence: Women Reinscribe Science. Barbara T. Gates and Ann B. Shteir, eds. Madison: University of Wisconsin Press, 1997.

North, Marianne. *Recollections of a Happy Life*. London: Macmillan, 1890.

Nunn, Pamela Gerrish. *Problem Pictures: Women and Men in Victorian Painting*. London: Scolar Press, 1996.

Perkins, Mrs. E. E. *Elements of Botany*. London: Hurst, 1837.

Pratt, Anne. *Ferns of Great Britain, and their Allies the Club Mosses, Pepperworts and Horsetails*. London: Society for Promoting Christian Knowledge, 1855.

Pratt, Mary Louise. *Imperial Eyes: Travel Writing and Transculturation*. London: Routledge, 1992.

——. *The Flowering Plants and Ferns of Great Britain*. 5 vols. London: Society for Promoting Christian Knowledge, 1850.

——. *Wild Flowers*. London. Society for Promoting Christian Knowledge, 1852–53.

Prout, J. S. *An Illustrated Handbook of the Voyage to Australia; and a Visit to the Gold Fields Descriptive of the New Moving Panorama, Exhibiting Daily at 309, Regent Street*. London: Peter Duff & Co., [1852].

Rigby, Elizabeth (Lady Eastlake). "Lady Travelers." *Quarterly Review* 76 (1845): 98–137.

Ritchie, Anne Isabella Thackeray. *From Friend to Friend*. London: John Murray, 1919.

Robertson, W. Graham. *Time Was: The Reminiscences of W. Graham Robertson*. London: H. Hamilton, 1933.

Rosen, Jeff. "Cameron's Photographic Double Takes." In *Orientalism Transposed: The Impact of the Colonies on British Culture*, Julie F. Codell and Dianne Sachko Macleod, eds. London: Ashgate, 1998.

Said, Edward. *Orientalism*. New York: Vintage, 1978.

Schiebinger, Londa. "Gender and Natural History." In *Cultures of Natural History*. N. Jardine, J.A. Secord, and E.C. Spary, eds. Cambridge: Cambridge University Press, 1996.

Shteir, Ann B. *Cultivating Women, Cultivating Science: Flora's Daughters and Botany in England, 1760 to 1860*. Baltimore: Johns Hopkins University Press, 1996.

——. "Elegant Recreations? Configuring Science Writing for Women." In *Victorian Science in Context*. Bernard Lightman, ed. Chicago: University of Chicago Press, 1997.

Stodart, M. A. *Female Writers: Thoughts on their Proper Sphere, and on their Powers of Usefulness*. London: Seely & Burnside, 1842.

Suleri, Sara. *The Rhetoric of English India*. Chicago: University of Chicago Press, 1992.

Surtees, Virginia. *Charlotte Canning*. John Murray, 1975.

Taylor, Ina. *Helen Allingham's England: An Idyllic View of Rural Life*. Exeter, U.K.: Webb & Bower, 1990.

Thomas, Nicholas. *Colonialism's Culture: Anthropology, Travel and Government*. London: Polity Press, 1994.

Thompson, Patricia, ed. *A Lady's Visit to the Gold Diggings of Australia in 1852–53. Written on the Spot by Mrs. Charles Clacy*. Melbourne: Lansdowne Press, 1963.

Tinling, Marion. *Women into the Unknown: A Sourcebook on Women Explorers and Travelers*. Westport, Conn.: Greenwood Press, 1989.

Tonge, Mrs. O. F., *Sketchbooks of Mrs. O. F. Tonge, c.*1908–13, Library of the British Museum of Natural History, London.

Twining, Elizabeth. *Illustrations of the Natural Orders of Plants with Groups and Descriptions*. London: Sampson Low, Son and Marston, 1868.

——. *The Plant World*. London: T. Nelson & Sons, 1866.

——. *What Can Window-Gardens Do for Our Health?* London: S. W. Partridge, n.d.

Usherwood, Paul and Jenny Spencer-Smith. *Lady Butler, Battle Artist 1846–1933*. London: National Army Museum, 1987.

Wakefield, Priscilla. *A Family Tour of the British Empire, Containing some Account of its Manufactures, Natural and Artificial Curiosities, History and Antiquities*. London: Darton & Harvey, 1804.

Index